THE

EXISTENTIAL/ACTIVIST

PAINTER

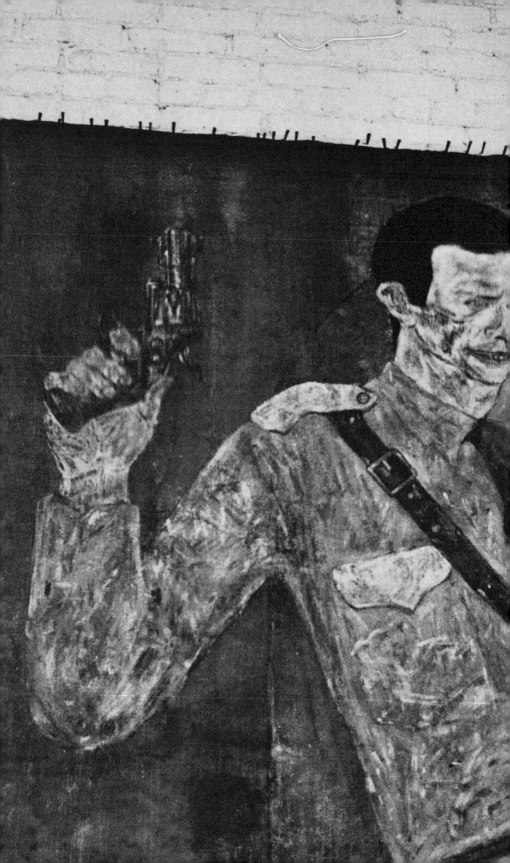

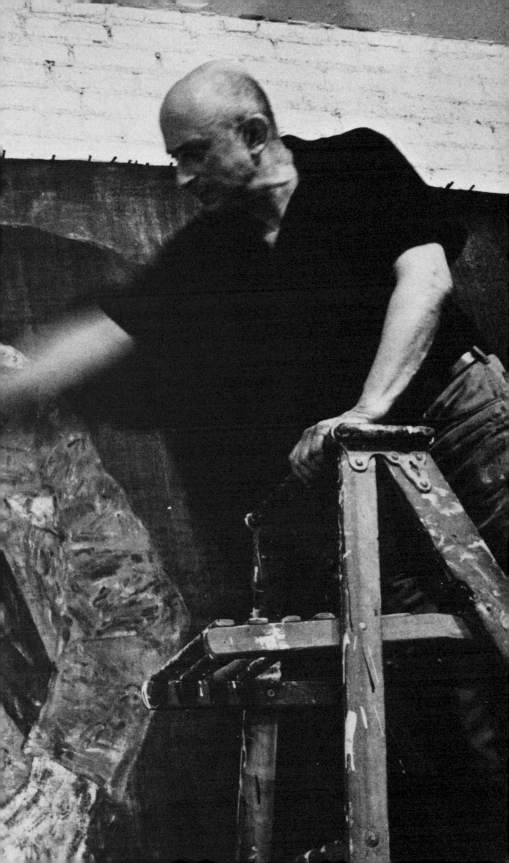

THE

EXISTENTIAL/ACTIVIST

PAINTER

THE EXAMPLE OF

LEON GOLUB

DONALD KUSPIT

Rutgers University Press

New Brunswick, New Jersey

I am grateful to
David Frankel for his editing,
and to Leslie Mitchner
for her encouragement.

Library of Congress Cataloging in Publication Data

Kuspit, Donald B. (Donald Burton), 1935–

The existential/activist painter: The example of Leon Golub

Bibliography: p.

Includes index.

1. Golub, L. (Leon) I. Golub, L. (Leon)

II. Title.

ND237.G6113K87 1985 759.13 84-26258

ISBN 0-8135-1124-0 (pbk.)

Pages ii–iii: Leon Golub working on *White Squad V*, 1984

For D.W., H.W., J.C.
moral support
in an amoral world

CONTENTS

LIST OF WORKS

Tell me as a Chekist, tell me as a revolutionary:
What good was this man for the society of the future?

Isaac Babel, "Froim Grach"

There would be little point of torturing an enemy
if we could not enter imaginatively into his agony.

Anthony Storr, *Human Destructiveness*

PREFACE

hat Leon Golub is a friend of mine makes writing about his art all the more difficult. It becomes harder to establish an independent point of view, to test significance by debate, which is the critical task. In an attempt to overcome this difficulty I have tried to set up a series of running arguments with the art, much like my conversations with Golub. I have sought to provoke the art as much as it seeks to provoke, to identify it by identifying the issues I see engaged by it—issues emerging not only from the art, but also from my own sense of the age. This is in homage to the spirit in which Oscar Wilde suggested that it is a necessary part of the critic's equipment to have as cogent a sense as possible of the age in which the art under investigation was made; the critic must demonstrate that the age—the world-historical—subsumes the art, not vice versa. The art is never as equal to the age as the age is to the art, a truth it is the critic's work to show.

Yet I know of very few oeuvres that are as "up to"—as imaginatively responsive and responsible to—the modern age as is Golub's. This is not only to the art's credit, but to the credit of the age, for it did not destroy one of its best witnesses. Every age has a dark side which it prefers to play down, to leave unrecorded and obscure. It is a sign that the world still has something about it that can be called "free" when it allows (even if it doesn't exactly encourage) the creation of an art profoundly critical of its inherent structure and kind of humanity. That structure must be unexpectedly uncontrolling to allow a Golub to emerge, or for that matter to give him publicity (the cover of the January 1984 issue of *Art in America*, for example) and continuous, if for a long period marginal, critical attention.

Harold Rosenberg once said that artists flourish like roaches in the cracks of society. Critical consciousness is the most annoying roach of all in a world that likes to think itself seamless. Unexpectedly, ignoring the cracks to caulk and the holes to stuff, a society makes possible its eventual reconstruction: it becomes overrun by critics of all kinds, which gives it a chance for rebirth. To add a simile, the critics of a society would prefer to be like the shedding skin of a snake renewing itself than like insects feeding on a carcass. Criticism is also art's only way of renewing itself, of continuing to live with the greatest intensity.

THE

EXISTENTIAL/ACTIVIST

PAINTER

In art, the criterion of success is twofold: first, works of art must be able to integrate materials and details into their immanent law of form; and, second, they must not try to erase the fractures left by the process of integration, preserving instead in the aesthetic whole the traces of those elements which resisted integration. Integration as such does not guarantee quality. There is no privileged single category, not even the aesthetically central one of form, that defines the essence of art and suffices to judge its product.

T. W. Adorno, *Aesthetic Theory*

Take a look at the widespread inclination . . . to perceive art in terms of extra-aesthetic or pre-aesthetic criteria . . . there is no denying that the tendency is promoted by something in art itself. If art is perceived strictly in aesthetic terms, then it cannot be properly perceived in aesthetic terms. The artist must feel the presence of the empirical other. . . . Without a heterogenous moment, art cannot achieve autonomy. Great epics that survive their own oblivion were originally shot through with historical and geographical reporting. Valéry, for one, was aware of the degree to which the Homeric, pagan-Germanic and Christian epics contained raw materials that had never been melted down and recast by the laws of form, noting that this did not diminish their rank in comparison with 'pure' works of art.

T. W. Adorno, *Aesthetic Theory*

INTRODUCTION

Leon Golub's painting is of enormous consequence for today's art, and for modern art in general. It is the effective climax—one might say the dramatic realization—of a number of tendencies within the modern tradition. Golub uses primitivism to make a political art; while his form of primitivism remains stylistically innovative, it is also clearly more involved with social attitude than with formal novelty. Golub "revises" expressionist texture into a social as much as a personal matter, registering explosive social forces as much as an unconscious response to them. *The Inferno* (1954) makes the point succinctly: the infernal is as world-historical as it is a major symptom of the psychology of the self.

It is through his creation of a double-edged expressionism—his interpretation of expressionism as a double entendre revelatory not only of historical forces but also of the self that suffers them—that Golub renews the original meaning of "avant-garde." In attempting to move beyond the irony and esthetic ambiguity so essential to modernist formalism's sense of what Clement Greenberg called the preconscious and unconscious order of effects, Golub explicitly restores "the idea of the interdependence of art and society" and of art's use as "a means of revolutionary propaganda and agitation."[1] These words were written three years before the revolutions of 1848 by Gabriel-Désire Laverdant, a Fourierist who was virtually the first thinker to speak of radical art as "avant-garde." For Laverdant, avant-garde art "worthily fulfills its proper mission as initiator," making it "the forerunner and the revealer" of "the most advanced social tendencies." It "must lay bare with a brutal brush all the brutalities, all the filth, which are at the base of our society."[2] It has been forgotten that the brutal revelation of brutal reality—a mimesis that necessarily employs brutal techniques—is the central idea of the avant-garde, which has degenerated into a notion of esthetic revolution. Such revolution has become commonplace—dubiously, banally "permanent," forever supplying pseudobreakthroughs and pseudosurprises; in this context, Golub's restoration of the traditional sense of "avant-garde" is radical and pertinent to the "progress" of art today.

What is crucial to avant-garde art, Golub's paintings remind us, is its power of revelation. Among a host of conventional conceptions of the dominant reality, avant-garde art is based on an unorthodox sense of it. Golub singlemindedly evokes the reality principle, the principle of principles that gives the everyday world its most determined appearances and makes those appearances symptomatic of the truth of the world as such. This is what makes his pictures profoundly political, a means of political agitation as well as of intellectual honesty. As Golub indicates, to agitate politically (in the deepest sense of the word) is to reveal the brutal, inhumane forces at work in the modern world, shaping it from the ground up—fundamental to it beyond any cause that might temporarily animate it. We tend to matter-of-factly acknowledge these forces, with a melancholy, helpless shrug of the shoulders; the brilliance of Golub's art is that it makes them horrifically explicit, overwhelming, until they seem to touch us so directly that we violently react, are shocked and taken aback. Golub's work brings history home to us as does no other art today, imaginatively transforming it until it is as unconsciously moving as it is physiognomically direct. We read the figures he renders as our own dream bodies in a nightmare world more real than our own everyday lives. Such "shock of recognition"—self-recognition, without any forcing of empathy—is of the essence of the best avant-garde art.

Authentic, profoundly realistic avant-garde art confronts the world with the world's own brutal inevitability. It is only out of this conflict with reality that revelation can come, a revelation whose visual rhetoric—and Golub's style is as violent as any modern "experimental" one—is the surface that sounds the depth of the conflict, the intensity of the confrontation. The physical surface of Golub's art is necessarily brutal, agitated, ugly, upset, and upsetting—far from esthetically pleasurable. This is because the conflict it "concedes" is unresolvable. Golub posits no possibility of peace between the witnessing avant-garde individual and brutal society, which does not want its raw reality preserved for posterity in art; it wants only its better side to be visible to eternity, and it expects art to serve that lie.

The premise of avant-garde art is that it refuses to do this. And Golub's art has always pushed its refusal with a vengeance, taking it to a limit from which the art seems to critically resist the society it seems to directly record. (Such directness, of course, is in and of itself a high form of criticism.) Golub's pictures offer no sense of physical, social, or psychological har-

mony, no sense of harmony of any sort, and in this they violate
every conventional expectation of a work of art. This is one
reason why his painting has endured much rejection; it has
been more critically than commercially well received and is all
but invisible in museums, which are generally still committed
to an obsolete esthetic revolution. Only recently have Golub's
activist works had a significant welcome based on something
other than the sense of their novelty, the ambiguous respect
for powerful regional or provincial art that was accorded his
early Chicago "monster" works. American society itself, in its
brutality and inhumanity, has changed the perspective of many
of the individuals who constitute it, creating a new critical con-
sciousness and self-consciousness; the surge of recognition for
Golub's art reflects that changed horizon of expectations, a
new ideology of personal commitment and social criticality.

For all the complexity of his development as an artist, Golub
has remained astonishingly consistent in purpose: he has con-
centrated on the single goal of the revelation and demystifica-
tion of power. He has revealed its ugly presence as responsible
for the structure of the self and of the most intimate as well as
the most public social relationships. This is the underlying rea-
son for the targeting of Golub's realism, like that of Courbet,
as self-indulgently officiating in a modern "cult of ugliness."[3]
Reality itself is ugly, and the power that makes it ugly is inher-
ently ugly, but art, supposedly, is beautiful, has nothing to do
with the "real" truth of life. For both Golub and Courbet, how-
ever, art means uncompromising truthfulness, not only in the
Zola-esque sense of a seemingly "artless" reporting of facts,
but as a demonstration of their dialectical appearance in indi-
vidual lives.

It is an old conflict of artistic intention, with us at least since
Caravaggio was thought to have violated all that art—codified,
ingratiating, academic art—was supposed to be and mean.
Caravaggio's "destruction of painting" prefigures that of Cour-
bet and Golub, and will undoubtedly continue to be necessary
as long as art is regarded as a superior form of decor, a way of
lying beautifully about reality in the name of a utopian possi-
bility of happiness. But the "promise of happiness" can hardly
be kept in the modern world. Utopian art once disclosed the
gap between the idea of what life should be and the miserable
practice that it is; in doing so it implied that the gap could be
closed. We no longer believe this today, which is why raw real-
ism is freshly necessary—a realism that will plunge like a dag-
ger to the heart of reality, in echo of its own destructiveness.
This realism must have as much will to power as exists in real-

ity itself. It must have as much will to overpower reality as exists in reality to overpower the self. It must be as threatening to reality as reality itself is threatening.

Abstract art is the grand finale of a utopian idealism that promised a life-world revolution that never occurred, a new attitude to being that never became normative. Increasingly, it looks like a paradisiacal, optimistic episode in the history of art, an episode that in its heyday, as Greenberg noted, reflected the optimistic materialism and technological/industrial innovations of capitalism at its most expansive.[4] Not only has history changed this pre–World War I and between-the-wars attitude—we no longer believe it is possible to fight the war that will end all wars—but our century, as we gain perspective on it with its passing, is beginning to look like the grandest triumph of death ever. Pessimism now seems more called for than optimism, indeed it is always the more realistic and authentic choice: it signals the irrational framework within which we make our small, comparatively trivial, rational achievements, which the larger irrationality always eventually corrupts. Golub's painting reflects the enduring pessimism in the modern tradition, which includes abstract art as one ironical moment. He shares the "tragic sense of life" that is the root of the most powerful avant-garde art. It is implicit in the work of Gauguin, explicit in that of Van Gogh; implicit in Analytical Cubism, explicit in the Expressionism of *Die Brücke* and *Die Neue Sachlichkeit*, especially Max Beckmann's paintings; and implicit in Abstract Expressionism, explicit in Robert Smithson's sense of the tragic dialectical landscape. The newly naked appearance of the tragic perspective in Golub's work not only shows his continuity with the greatest modern art, but also the bankruptcy, the increasing absurdity, of pure painting, and the impossibility of practicing it authentically today.

Friedrich Schelling has said that "the essence of tragedy is . . . a real conflict between the subject's freedom and an objective necessity, a conflict which is ended not by the defeat of one or the other but because both, at once victors and vanquished, appear in a perfect indifferentiation."[5] But in Golub's tragic revelation of reality this perfect indifferentiation does not occur. Because his realism is a recognition of the code of power underlying and unfolded through conflict, the conflict in his work is never ended by its idealization. His articulation of the will to power responsible for the tragic sense of life precludes the representation of conflict in the ideal, "classical" way that attains perfection of appearance through a seemingly divine indifference. There is no possibility of beautifying the conflict

in Golub's work, no way to read it allegorically as a pyrotechni-
cal display of abstract "cosmic" forces or symbolically as an ini-
tiation into the intractable inwardness of existence. The im-
possibility of "perfect indifferentiation" makes the conflict in
Golub's art all the more tragic.

Golub's development makes clear the difficulty of achieving
authentic realism. His art not only rises above the dead-end
formalism, however brilliant (can we call it subtly pessimistic?),
of a painter like Robert Ryman,[6] but also above such dead-end
formalist realism as that of Philip Pearlstein, who stripmines
the reality out of realism by a positivistic dependence on the
model and whatever is available to perception alone. Such
"thoughtless," unmetaphoric mimesis hardly begins to touch
the issues raised by authentic avant-garde art; its only revela-
tion is institutional. Roland Barthes has written that "the 'real-
istic' artist never places 'reality' at the origin of his discourse,
but only and always, as far back as can be traced, an already
written real, a prospective code."[7] In Golub's discourse the al-
ready written reality of power, the prospective code of power,
is available in classical art. There, however, it appears pre-
maturely idealized, mystified as a universal play of opposites
constitutive of normative unity. Golub "corrects" this misread-
ing, demystifies this interpretation of power, by making a con-
temporary copy of classical conflict. He reveals the will to power
in all the immediacy of its ugly, raw reality. The contemporary is
used to strip conflict of classical mediation. To witness the wars
in Golub's pictures is to peer directly into the abyss of power;
the old metaphysical sense of tragedy as the grand gesture of
a cosmos in search of its integrity perishes totally in his art.
From the "realistic" depiction of unrationalizable, irrepressible
power, a new, physical sense of tragedy emerges as an insolent
challenge to every art that thinks its own idealizing, rationaliz-
ing, repressive fiction is all-powerful.

*The deeper we sound, the further down into the lower world
of the past we probe and press, the more do we find that the
earliest foundations of humanity, its history and culture,
reveal themselves unfathomable.*

Thomas Mann, *Joseph and His Brothers*

*In the most high and palmy state of Rome,
A little ere the mightiest Julius fell,
The graves stood tenantless and the sheeted dead
Did squeak and gibber in the Roman streets. . . .*

William Shakespeare, *Hamlet, Prince of Denmark*

ONE

THE CLASSICAL/

CONTEMPORARY DIALECTIC

OF IDENTITY

More than once, Leon Golub has said that he has been strongly influenced by late classic art.[1] Golub's possession by the classic past is more than a matter of blind obsession, passive homage, or irresistible dependence: it is an acknowledgement of the rich soil of meaning in which his art is intentionally rooted. Does it receive the nourishment it needs there, the strength "to state something about man in the modern world"?[2] Do the ancient "stylizations of image and concept" help Golub cope with the "technological landscape" of the modern world,[3] "a cosmopolitan but mass society . . . beset by and conditioned through mass media," with its "oversimplified stereotypes"?[4] Will the classical stylizations or the modern stereotypes have greater power of "determination of individuality within the general conditions of man in our society"? Golub's attempt to "continue and enlarge the classic traditions of western civilization, the Greek humanist heritage," while simultaneously telling "the fearful truth"[5] about our civilization, establishes poles between which many such questions fall. One wonders whether the ancient "rhetoric of violence and conflict"[6] is really "a measure of contemporary reality,"[7] whether Golub's "recall to classic art in respect to scale, energy, action and history" can really be "joined to a barbaric realism, a raw tensioned art."[8] Aren't they antithetical? Perhaps this attempt at synthesis is fundamentally absurd: can an art that respects man, expects him to be heroic, conceives him, as the Greek philosopher Protagoras stated, as "the measure of all things," describe a world in which man is diminished, subservient to his own instruments, inherently pathological? Classical art grows out of

man's self-respect; it shows him at his most narcissistically suc-
cessful, awards him greater significance than other beings in
the cosmos, idealizes him to the point where it even questions
the importance of the gods. How can it make sense in a world
in which man has no more significance than any other crea-
ture—even less, for the modern world conceives him as a sick
animal?

Walt Whitman preferred unequivocal animals to humans, for
unlike humans they never whined about their condition. Fried-
rich Nietzsche tried to reconceive man as a healthy animal,
once more commanding a "classical" place in the cosmos, but
this was a fantasy with no effect—or the worst, Hitlerian
effect—in the modern world. Classic art shows men and women
as coherent, intact; for all their troubles they are unshakably
integrated beings, people in the true sense of the word, the
numinous "whole person" become existentially situated. In
modern art, on the other hand, for example in Van Gogh's and
Kokoschka's portraits, man is shown as peculiarly trivial for all
the artists' attempts to dramatize his depth of being. Despite
every effort to show him psychologically equal to society, fi-
nally it is his inadequacy that appears most clearly. Man be-
comes a case history. He is exhibited the way a psychiatrist
exhibits a mental patient, or the way a sociologist analyzes the
members of a social class—he is a specimen rather than an end
in himself. He is eternally convalescent, but there is no known
cure for his wound, not even his prosthetic technology; he is
ambulatory, but is never allowed to go unobserved—perhaps
the only freedom in the modern world, however ironical and
illusory. Analysis rather than apotheosis is the aim of modern
art, and for all the expressionistic fervor with which the analy-
sis may be carried out, the results consistently reveal a less-
than-classical sense of the human. Indeed, for all the expres-
sionist insistence on the uniqueness of the individual, human
beings are constantly revealed as primitive or close to animal
rather than heroic or approaching the divine.

How can these heroic and antiheroic, noble and ignoble im-
ages of man be unified authentically? Is Golub's attempt to rec-
oncile classical and modern consciousness an artistic sleight of
hand? I exaggerate the issue intentionally to make clear the
magnitude of his ambition, and the perhaps insurmountable
character of his enterprise. Yet even if Golub's art may be a
magnificent failure, or at best an equivocal success, from the
perspective it itself establishes, its revelation of the issue is
itself a major achievement. The problem of the disjunction
between the classical and the modern visions haunts modern

thought, which is desperate for a new sense of the integrity of humanity, and Golub's treatment of classical forms through a modern existential sensibility confronts it head-on. His merging of the two may be madness, especially when he professes to use each as an alembic or philosopher's stone to alchemically purify the other and reveal its true nature; yet his art accepts, in an intense and thorough way matched by no other art today, the challenge to modern thought to redefine man, and it does so without forfeiting the modern sense of the world as fragmentary and disjunctive. In Golub's Grand Guignol theater the classical is contrasted with the modern until the two seem inseparable and even interchangeable, and this new relationship, in which the violence of the contrast becomes the method of synthesis, proposes nothing less than a radical revision of our sense of both.

Yet the reconciliation is unstable, even volatile. Whatever imaginative correspondences are found, or passing resemblances vigorously affirmed, classical art and modern art conceive humanity differently and attend to it in clearly distinct ways. Is it that Golub, unable to rise to the opportunity of abstract, subjectless art (the quintessentially modern art he periodically abuses), falls back on classicism as the most unequivocal version possible of humanist figuration, of art with an obviously great subject matter? Is he an anachronism? His art is not unprecedented, but is it appropriate for the present, and will it be anything more than eccentrically academic in the future? Does Golub's strange, primitivist neoclassicism capture anything of the zeitgeist?

Hamlet, watching an actor creating "a fiction, . . . a dream of passion" by throwing himself into the classical role of Hecuba of Troy, exclaims, "What's Hecuba to him or he to Hecuba / That he should weep for her?" If the drama as a whole is a "conceit," the players' roles are "abstracts and brief chronicles of the time"; if the play is only theater, an ingratiating performance, it may also be the thing to "catch the conscience of the king," even of the people. Hamlet is one prototype of existential man, who dismisses the stereotype of universal man; is Golub, who thinks of himself as an existential artist, a new Hamlet, using a classical dramatic strategy to catch the conscience of contemporary society?

And yet Hamlet's question expresses as much disdain as admiration, for he doubts that the ancient figures move man as much as the human condition they portray does. It is not the classicism that matters, but the psychodramatic allure of the

theatrical as such, which seduces one into a universal identity, an existentially clear and distinct role. What classicism does is attempt to make that clarity emphatic, as though it were inevitable, as though the issues of the existential situation were completely comprehensible. Classicism insists that the existential situation embodied in the drama contains a describable essence. Hamlet, however, is not so sure.

Does Golub's art raise more questions than it can answer? Is the "Greek humanist heritage" really of use in modern man's understanding of his existential situation? The ancient image of man is an unchanging one; the modern world is in constant flux. Man was once seen as an absolute; now he is understood only in relation to his actions. Where the classical gods stood above the world, choosing or not choosing to enter it, modern man cannot be separated from his projects in it. Can the ancient, idealized image of man really guide us, as Virgil guided Dante, in a modern world that has nothing ideal about it? How can classical art contribute to the portrayal of a modern civilization that offers nothing remotely "classical," however pagan it may appear? How can an art that is the record of one civilization be used to record another?

Perhaps Golub is interested in classical forms because they seem to have a special authority by reason of their venerability. The power that stems from their age may make them the perfect convention for the representation of wholeness of being. Is Golub a Prometheus who steals the fire of the gods, the image of sanity, his art showing the suffering that comes of making a gift to ungrateful men of an ideal they are unequal and indifferent to? Or is he merely performing the past to touch up the nasty temperament of the present? Is he a revivalist, a traditionalist in contemporary existential disguise, or is he an innovator, using traditional forms to make a new point about modern anxiety?

Golub may have the sense of tragedy he says he has, but surely he is on the wrong track in his interest in the classical manner of articulating tragedy, a manner he has called "austere and architectonic."[9] He has measured himself against Picasso,[10] the archetypal modern artist, in the past; and isn't Picasso's manner in *Guernica*—in Golub's words, that of "rending violence" and "expressionistic distortion"[11]—a more fitting tragic mode for our era than the classic? We might "live in an age of creative degeneracy," as Golub believes[12] (and Picasso is no doubt a major figure in such an age), but it is hard to believe that the degenerate art of classicism, the Hellenistic sculpture created "when the classical ideal goes 'rotten' but becomes in-

fused with a new kind of introspective and implacable appear-
ance,"[13] can make better sense of our time than abstraction,
our own degenerate art. Golub seems to think a historical ana-
logue is a visionary alternative, and this is also hard to go
along with: our world, however decadent, is unprecedented in
that it comprises what Golub calls a "well-annotated electronic
milieu"[14] regenerating itself technologically. Golub himself as-
serts that the classic "philosopher as an arbiter of the measure
of man is an unfortunately regressive or archaic figure in a sci-
ence-fiction world."[15] In antiquity, technological mastery of the
world was a fantasy; for us, it is a troublesome reality.

Is Golub simply an old-fashioned artist, using "an existential
rhetoric of violence"[16] as a regressive, futile protest against
the fact that modern man not only "does not exert a moral
ego"[17] but hardly seems to desire one? Is Golub preemptively
exerting one for us, choosing himself as the martyr of our miss-
ing morality? Perhaps the classic is of value for Golub because it
seems to represent the moral. Again, he himself acknowledges
that "commonly, the artist sees little value in the classic" to-
day;[18] it may once have been one of "the great measurements
of man as hero (anti-hero) of his fate,"[19] but it is clearly no
longer so. And Golub cannot be completely happy with the
classical view that places man above his own history, tran-
scending the events he himself enacts, for Golub is obsessed
with "the symbol man,"[20] the "tragic image of man,"[21] with
finding "things which are greater than ourselves, which are
representative of ourselves and by which we measure our-
selves."[22] This need for self-measurement hardly accords with
the removed, distant perspective of the classical.

"History is missing," says Golub, "man in action is miss-
ing,"[23] not only from modern art but from classical art too.
Classical art mythologizes historical action, making it sublime
but obscuring its empirical origins. In a way, classicism shows
as little of historical action as does abstraction, for both are ab-
sorbed with the ideality of art. Classical art is not really con-
cerned with representation, for it shows man sharing in art's
ideality, becoming the means of articulating it. The more defi-
nite, sovereign, determinate beyond the contingency of histori-
cal action man becomes, the more he demonstrates the ideality
of art. The clearer his image becomes, the more he is shown to
have an ultimate logic to his being, the more confident art be-
comes of its power of transcendence. Classical man, heroic,
whole in his being, philosophically articulate in his very body,
is art's transcendental creation, proof that it can evoke eter-
nity without forfeiting insight into the worldly experience that

by comparison makes clear how ideal it is. Golub claims a realistic interest in man as a historical being, and thus as an existentially indefinite rather than classically definite entity; how can he seriously trust idealizing classicism to tell him the truth about human action and nature?

The classical and existential views of man are incommensurate, and Golub, Hamlet-like, is for a long time caught between them, his art stuck on the horns of the dilemma they pose. The question is whether he ever really reconciles them. Most of his imagery has a strange awkwardness which verges on the grotesque (out-grotesques the conventionally grotesque); this awkwardness may reflect his inability to reconcile what seems impossible to reconcile. When he states that "classic ideas of form are among the indeterminate factors operating on the open modern consciousness,"[24] Golub acknowledges, no doubt unwittingly, the indeterminacy of their influence on his own thought. He also acknowledges something else: that classic ideas of form are the creation of a traditional closed consciousness, which is exactly why they are indeterminate—really negligible—in their influence on the open modern mind. They are inimical to it, represent regression from it, and cannot be regarded neutrally by it. Classical man is self-sufficient and formally closed in his consciousness and being; he is well-known for his refusal of the "irrational" infinite. Modern man's awareness of the infinite forces on him a sense of insufficiency that opens his consciousness. While this insufficiency is a source of existential anguish, it is also the catalyst of ambition, of a limitless, relentless, Faustian will to power. Classical man has strength, not power—natural strength supernaturally justified rather than authoritarian power existentially apologetic. Again, Golub seems misguided in his preoccupation with classical form.

Yet if it is classicism's sense of bodily presence rather than its sublime meaning he is eager for, Golub may be on to something—the first dialectical step in an ironical disclosure of the devastating effect of modern man's sense of his ultimate meaninglessness, his absolute insufficiency, of his fundamental physical experience of being human. Modern man's self-punishing postulation of the meaninglessness of his existence is based on his experience of a threatened individuality, the loss of control over his destiny in a science-fiction world. Golub's art can be read, in all its phases, as an investigation of that threat, a profound demonstration of the effect of total technological administration on individuality. His figures look as though they are in search of a destiny they can never find; fruitlessly fighting

against their sense of existential meaninglessness, they are
victims of the detranscendentalization of individual destiny
implied by modernization, with its threat of total administra-
tion. Moreover, their embodiment of meaninglessness reveals
a peculiar combination of impotence, futility, and anger. Golub's
figures emanate an ambiguous power, flex the muscles of an in-
secure individuality clearly incommensurate with the classical
sense of man's potency. Their power is resentful rather sub-
limely commanding; where classical strength is self-confident
enough to idealize itself, Golub's figures exemplify in their
very flesh the distrust of the ideal, of anything not practical,
that is one of the leading traits of modern man.

The characters in these paintings are self-consciously not
sublime, reflect the tendency to deny even the possibility of
spiritualizing or idealizing existence. The "realism" of this
stance is less heroic and less a matter of choice than might be
thought, for it is the direct, involuntary expression of modern
man's sense of impotence. The antiideality or antispirituality
in the mangled flesh and grotesque bearing of Golub's figures,
in their aggressive attitudes and refusal of any sort of "de-
corum," is quite the opposite of the classical figure; it reveals
modern man's compulsion to demythologize, his supposedly
"enlightened," "honest," deliberately disenchanted point of
view. Modern man is unable to experience purely the enchant-
ment classical artists found in the idealized figures, and Golub
refuses to dignify his figures with "divine" form; in effect he
debunks classical figural idealizations and shows them as in-
herently inauthentic. He reductively bifurcates the human fig-
ure into its physiological functioning and its essential social
physiognomy, its raw bodiliness and societal functionality. The
figure becomes first the weird physical machine of the early
existentialist paintings, then the ruthless social machine of the
later activist paintings; these latter figures, if socially more
conventional than the early existentialist figures, retain some-
thing of their monstrous physiques. The logic at work in these
reductions, it must be stressed, is completely modern, com-
pletely anticlassical. Golub analyzes his figures on the one
hand as physical bodies, usually more robotic than organic,
and on the other as "symptoms" of a socially determined will to
power. They are understood deterministically, and show no
signs of the free will that is the classical basis for individuality.

One must note that this dissociation of man into physical and
social "destinies," eliminating any spiritual, ideal, or trans-
cendent trait (Golub's figures have no way of getting beyond
matter and history, no way of getting a perspective on them,

a perspective not conditioned by them), is exactly paralleled in Golub's sense of the work of art. Increasingly, he sees the artwork itself as no more than a material form and a social physiognomy, a material representative of a miserable social reality. And Golub, as we shall see, treats the painting "miserably"—cutting it, making it as crude and objectlike as possible. This is his version of the modern clinical reduction of the painting, which John Dewey had the idealistic temerity to call the "consummatory object," into an ugly and abstractly matter-of-fact thing, and a class-bound one. The disparity between Golub's sense of art and the classical idealization of it—the classical idea of the "fineness" of art—directly parallels his refusal of the classical physical stature of the human figure.

How, then, can Golub be said to be involved in a reconciliation of the classical and the modern? If we are at all to save the classical from Golub's clutches—from what seems to be his dubious claim to it—we must postulate that it stands in unconscious relation to his intention to show the modern world realistically, indeed to his own modern expressionistic esthetic of "barbaric realism."[25] In Golub, the classical sense of man's irreducible presence and dignity stands in unconscious relationship to the sense of inadequacy and "absence" from the self revealed in modern man's unstable and uncertain relationship to his body, his ambiguous, even violent conception of it. (The modern attitude to the body is given a paradoxical articulation in abstract art, with its depiction of amorphous or schematic bodiliness, and its creation of "disembodied" pictures; this is no doubt part of the reason Golub rejects it, using the classical sense of physicality to counter the rejection of the body implicit in abstraction.) Modern man's lack of morality and individuality results in his sense of being a failure to himself, despite the technological success that develops from his "pragmatism," and when that sense of failure becomes acute, classical man reveals himself as a distant goal, in a dialectical reversal or rebounding to repressed ideal selfhood. In the modern world it is the ideal that is resisted and repressed, that becomes the "shadow side"; the real is overstated as the matter-of-fact, the socially manipulable.

Golub shows us classical man, a scarred Lazarus, symbol of the lost and buried ideal, resurrected from the grave of the unconscious at a moment of crisis in modern man's awareness of himself. Golub archaeologically excavates classical man at a time when the very existence of man is threatened—when it is realistic to think that man may end his own history. In Golub's art our ability to predicate, in a very practical, technological

way, our own extinction, an ability toward which the modern
devaluation of man has been inexorably, "technically" moving,
is countered with an echo of the historical moment when man
seemed immortal, was posited as eternally present. The real-
istic idea of the end of man is confronted with the original vi-
sion of ideal man, however disguised; at the moment of the
approaching end, the beginning is brought to bear, forcing us
to rethink our conception of man and thus of ourselves. At
the moment when we complete our "willful" fall from grace,
seem most satanically self-destructive in our beliefs and his-
torical behavior, the resurrection of classical man reminds us
of the elementary value of being human, a value that seems
fundamental beyond any attempt to rationalize or justify it.
And Golub's incompletely resublimated classical man, sub-
merged yet insurgent, directly confronts abstract art, whose
emphatic materiality and esthetic sublimation of the will to
power into manipulation no longer seem to serve human self-
consciousness.

In general, not only can contemporary man be seen as su-
perimposed on classical man in Golub's paintings, but classical
man can be understood as still warm and alive inside contem-
porary man—a possible ideal within the sordid reality. It is
not clear whether Golub's classical man is a mythical butterfly
taking shape within a messy contemporary cocoon, or the un-
breakable backbone in the anguished flesh of the modern body;
but whether a frail ideal or an absolute armature, classical
man signals the enduring integrity of the human within mod-
ern man. For Golub, both prelapsarian—pretechnological—
classical man and fallen existential man do battle with the
technological landscape, which he sees as pervading the im-
pulses of abstract art. Golub's ancient and modern man both
find the utopian sensibility of abstraction a form of false con-
sciousness of modernity—a hyperbolic celebration of "tech-
nique" in which method becomes signature, the sign of individ-
uality. The substance of Golub's argument against abstract art
is that it posits individuality without humanity. In a sense,
Golub marshals the classical and contemporary conceptions of
man—conceptions in which man, whether conceived as heroic
or wretched, is central to himself—against the false techno-
logical conception of man that makes his instrumental mastery
of the world central to his self-definition. Such mastery makes
him "abstract" to himself, and denies him the possibility of
self-integrity.

Yet isn't it a form of "creative degeneracy" for modern man
to admire classical man, a form not of self-expression but of

self-repression? Doesn't regression to the classical, in the name of whatever new sense of ego, show the modern artist at a loss, unable to invent an appropriate means of formulating his or her modernity, of articulating the modern open consciousness? Isn't abstract art the archetypal modern art just because it is able to communicate modern man's sense of abstract possibility, the root of his Faustian sense of self? The dynamically open Faustian self may lead straight to hell (which, for Goethe, was full of technological wonders), and if so it must be dispensed with in favor of a more responsible one, but classical man, with his unequivocal, stable sense of his own meaningfulness and self-respect, hardly seems the appropriate alternative. Classical art can hardly lead us out of the technological wilderness, the amoral science-fiction world, for it understands nothing about the modern ambivalence toward the self and toward the world built by science. Abstract art is full of "technical" ambiguities and stylized inconclusiveness or uncertainty; it emblematically embodies this fundamental modern ambivalence, and may still offer the best context for modern self-comprehension and recreation. If so, doesn't Golub's preference for classical art show his consciousness to be insufficiently modern, nostalgically bound to a past sense of self rather than creative of an original, future one? Can his regression to a past, pre-Faustian model newly concretize contemporary individuality as effectively as might a progressive working out of the modern sense of dynamic, abstract, amoral self? Isn't abstract art still symbolic of modern self-realization, and isn't it the only arena in which our pride in modern technological feats can be shown as simultaneous with the modern sense of self-defeat and inadequacy? The fiction of abstract art reflects both the "selflessness" and the technological genius of the science-fiction world in a way that the fiction of classical man cannot begin to comprehend.

But in Golub's usage the classical image of man proclaims the tragic nature of modern man—what he is independently of his science-fiction world and his inherited ideals of human potential. Golub, like Hamlet, seems permanently pessimistic, maddened and angered by contemporary events he cannot begin to change (even though his political activities are an attempt, born of frustration, to do just that). History so enrages and threatens him (this has something to do with his collective identity as a Jew as well as with his nature as an individual) that he can hardly speak openly about it, and even his paintings have a peculiar tongue-tied look, the deliberate, necessary alternative to glib acceptance of rotten historical reality.

And so he speaks theatrically, in classical costume, about his-
torically real man. Golub is half attracted by the classical as an
end in itself, for it bespeaks the sanity missing from history,
but on closer inspection his version of it turns out to be a pessi-
mistic statement about humanity. Classical ideality of form
gives him a way not of veiling the reality of the human condi-
tion but of gaining the distance necessary to establish a per-
spective on it. He wants "a certain distance" from contingency,
wants "to throw up on the walls of our society paintings that
you can't get close to," whose rhetorical form gives one "the
measure of contemporary reality."[26] And in this his ambition
aspires to the condition, though not the form, of the classical,
for the classical, in its eagerness to gain perspective on the
human condition, implies resistance to the sense of human suf-
fering and ultimate impotence that emerge from a realistic ap-
praisal of man. Classicism's look of divine detachment actually
reflects a refusal, shared by Golub, of the seemingly fore-
ordained role of victim of history.

In the Renaissance, regression to antiquity was liberating.
It meant the freedom to investigate nature as well as beauty,
and to find each in the other. For Golub, regression to antiq-
uity announces a new dark age—enslavement to violence, de-
lusions of grandeur, and a Cassandra-like sense of foreboding
that nobody will openly attend to, for everybody experiences
its effect in unconscious dread. Golub uses the classical to focus
our sense of premonition and discontent, our civilization's ugly
inner mood and attitude. He inverts its meaning: no longer the
esthetic form of human integrity, it becomes consciousness' de-
fense against inner collapse. In classical art the ego insists on
balance, the forces it deals with are shown as tamed, inwardly
domesticated; the deep-rooted, disintegrative forces that frac-
ture in the modern psyche, denying it a foundation, are more
than that ego can handle. Golub's "heroic" figures are not
Olympians, then, but perhaps they may be seen as Titans, vio-
lent id that can never be turned into calm ego. Even more
decisively, they are the fragments of an exploded self, each
with the imprint of the whole—parts that do not cohere but
are related in a violent, directionless dialectic. They have not
simply lost control, but are beyond control. In a sense, they
are incredibly unfathomable figures, representing the torn
fabric of the psyche. Golub has found the archaic energy at the
root of classical form—not the constructive, idealizing energy
of completed being, ego with a sure sense of itself, but the
malevolent energy that comes from a powerful tendency to
self-destruction. Heroic classical man is not only outward-

looking, taking a stand in the world, but inward-looking, taking a stand against the chaos within himself. He is poised against regressive disintegration as much as for progressive integration of himself with the world. He resists the evil that appears within himself as much as he welcomes the good that might come from being in the world.

This archaic energy, this primitive malevolence of being which disrupts facile becoming, surfaces in the very skin of Golub's figures. Somewhat as Edvard Munch's men and women are reduced to sheaths covering a void, the malignant, diseased skin of Golub's characters becomes their actual substance, and suggests that they are hardly human. The "dehumanization" of the figure, the implication that it is barely able to rise to the level of the human, remains a constant factor in Golub's art. Even when his figures become more recognizably human in shape, they remain inhumane—inwardly opposed to being human. Representing the ever-present, tragic human potential for self-destruction, they suggest the difficulty of achieving constructive human selfhood.

For most of his career Golub is not a social-activist artist (however publicly political he is) but another kind of modern, narcissistic artist, one seeking a cohesive sense of identity. He is implicated in the Symbolist/Expressionist adventure at the root of modern art, the search for the most fundamental self. This self has come to him in strange forms—has come to him in "antiform"; nevertheless, he cannot completely accept the classical identity, which denies the inhumanity he experiences in himself—the experience of inadequacy that is the modern condition, and which makes the self seem monstrous. Today, the self inevitably looks monstrous in the eyes of the world; only as a monster does it most reveal its archaic grandeur. And, paradoxically, Golub reveals that ideal classical man is the most monstrous self imaginable in the modern world, just because he is so unrealistically human.

The integrity and validity of Golub's art depend upon the identity it gives man, not in its outward appearance as a sign of contemporary social awareness. In fact, his paintings are not obviously political until the late '60s, and even then, in my opinion, they remain more existential than political; to interpret them as symbolically political before that period is to sell their basic existentialism short. The influences that shape Golub's art must be understood psychosocially, not simply stylistically. Each influence represents an unrealized potential self more than a realized art, a problematic individuality

rather than a resolved style. Indeed, for many artists in the
modern period, disbelief in style is almost a credo. "Styleless-
ness," whether understood as the resistance to codification of a
de Kooning or as the decodification and dismantling of preexis-
tent styles carried out by a Picasso, is the route to authen-
ticity, the proof of seriousness of purpose. To be authentic is to
maintain a sense of individuality, or to recognize individuality
as a central problem of modern art-making, and any accep-
tance of a given style as "conclusive" prematurely solves that
problem. Indeed, such acceptance tends to make the problem
of individuality meaningless; to be identified with a style is
to have an unearned identity. The appearance of stylelessness,
of an indeterminate state of visual affairs, on the other hand, is
a demonstration of vital individuality. No doubt in a Sisyphean
way, the artist is working toward an unnamable identity, a rich
content.

Like Picasso and de Kooning, Golub takes existing styles
and makes them "influential" by revealing the problematic be-
hind them. Stretched to the breaking point, they become indi-
vidual in import—promise an individuality they never quite
deliver. The attempt to throw the style "off balance," in effect
recreating it as a process with an uncertain goal, is in itself a
sign of individuality; the "modernization" that the style un-
dergoes is in itself catalytic of individuation. In true modern
spirit, however, it never affords a solid, fixed identity. The
style ceases to be a style and becomes existential "expression."

Golub, as I have suggested, is an existentialist before he is a
social activist, an existentialist first and last. Social activism is
the latest (but not necessarily the final) phase in his search for
authenticity and individuality. To the extent that his social ac-
tivism challenges the authenticity and individuality of abstract
art, it is perhaps the most arrogant phase of his stylistic devel-
opment. One could argue that his art becomes explicitly social
activist out of a desperate concern to challenge the dominance
and value system of abstract art, which in effect had declared
his figurative art esthetically reactionary. Golub's work raises
a question of great import for the future evaluation of modern
art, the question of whether the best artistic means of record-
ing modern society are abstract or mimetic. Is the understand-
ing of modern society reflected in abstraction correct? Is it
more relevant that abstraction is materialistically successful,
because of the cunning of its abstract reason, or that it is inhu-
mane and exploitive in its "carelessness" about human exis-
tence in general? Golub proposes that an external, complexly
representational means is the best way of revealing the inter-

nal inadequacy of our society. Abstract art, supposedly originating in interior necessity, is in fact obsessed with the superficial formal aspects of art rather than with its visionary potential and world-historical implications. In this it accurately reflects the shallowness of modern materialistic success—an accuracy that does not constitute a redemption. Indeed, abstract cunning has created inhuman conditions, monstrous human beings in a monstrous world.

However, it can be argued that the value of abstract art lies in its reflection of our society's extraordinary power to manipulate mind and matter. Golub's neomimetic art reveals society's will to power nakedly, demonstrates its heavy-handed brutality; abstract art implies that society's exercise of power is seductive (abstraction is itself a refined pantomime of that seduction). Both points of view have something to be said for them. Golub's mimetic display of raw power, however, is intended to upstage abstract art's manipulative effects, and indeed, of all the confrontations his confrontational pictures stage, the confrontation with abstract art—especially with Abstract Expressionism—is most crucial to our sense of their credibility. Golub claims to be the true expressionist, the humanist expressionist, and his appropriation of what he calls the "dervish principle" of Abstract Expressionism in the name of his humanist expressionism invites direct comparison of the relative "truths" of each art. One can understand the relentless energy of Golub's tyrannical figures, whether that energy is explicit or impacted, as directly competitive with Abstract Expressionist gestures of pure painterly energy. It may be that each side wins a Pyrrhic victory against the other.[27]

The dialectic between the classical and the contemporary styles that Golub establishes is the matrix of his art and the source of his particular existentialism. It is the womb out of which all his figures are born. In this basic dialectic, the classical is the source/symbol of authentic individuality—existence in the deepest sense—in contemporary historical life, which exerts an "expressionistic" distortion on today's humanity. It is this distortion or deformation that Golub exposes, exaggerates to the verge of caricature, and stylizes. Golub classicizes deformation, as it were, transmuting the contemporary appearance of brutality into a social signature. His figures are an index not only of a social code of violence (the threat of violence being the binding factor in the modern social contract), but of a general will to power. Golub's social activist phase puts the final touch of historical realism on a previously established conception of primordial human nature, particularizing and

elaborating but not really adding anything essential to his original vision of its crude violence. By the "Gigantomachies" (1965–67), this conception is completely worked out—through an encounter with the classical.

What Lawrence Alloway has called Golub's "existentialization of Classicism"[28] is more accurately described as Golub's classicizing of expressionism. Art-historically, Golub's style is late expressionist—expressionism petrified into a grand manner. And it is from classicism that Golub learns his grand manner, learns how to standardize or universalize human expression. It is as though each of his figures were an expressionist gesture stopped in its tracks, preserved like the dead at Pompeii. Indeed, the Pompeian red background of many of Golub's social activist paintings, a tone borrowed directly from Pompeii's frescoes, is like a lava flow in which the figures are embedded, their energy and movement captured forever. They exist in a state of suspended animation which ironically reflects their own self-destructive and generally life-destroying character. The social-activist or realist works, the so-called "protest" paintings, exemplify historically what is for Golub an already profoundly grasped general truth, an indisputable principle in reality. The Pompeian red is its symbol, the sign of its dominance over life.

Every archaic style that Golub individualizes by allowing it to influence him represents his own uncertain consciousness of himself. The style is tried on for mental size, to see if it can create a clear and certain identity where there is none. It is worked and reworked until it seems to implicate a true self, though one can never be guaranteed. Golub takes art-historically validated and valued styles as modes of authentic selfhood, and he borrows their authority as the possible foundations for his own sense of an autonomous self. This is the same kind of relationship to the past as that established by Picasso and de Kooning. It is a relationship that has less to do with the much-discussed assumption that the modern artist feels threatened by the past (because it is so comprehensively available through mechanical reproduction) than with the fact that in the contemporary world there is no secure foundation for the self. There is no universal belief system to give identity roots, to give credibility to its pursuit of authenticity, to frame the pursuit in a self-justifying philosophy of life. Thus the modern artist, faced with the same narcissistic problem we all confront in the "groundless" modern world, is forced, in Van Wyck Brooks' phrase, to "invent a usable past" if he or she is

to have an identity in the present, an identity that can provide a perspective on contemporary life.

This identity, however grand the past it is rooted in, echoes that past hollowly. If only because it is not sustained by the larger world in which it finds itself, it seems inadequate and arbitrary. Contemporary society regards it as nothing more than a novelty, for individual identity today is not a value in itself but only "technically" useful. There can be nothing of inherent value in achieved identity—individuality created as freely as possible—unless it contributes to modern society's desire to become science fiction. Science fiction defines the ideals of today, and in science fiction the self is completely instrumental, an extension of instruments.

Golub, like Picasso and de Kooning, struggles to achieve a noninstrumental sense of self. He finds it in the classical identity, an identity that can never fit into the science-fiction world. Classical man is Golub's "strong man," affording him, in the words of Heinz Kohut, an "archaic grandiose self"[29] that is narcissistically secure—self-soothing, self-balancing, and essentially stable, however dialectical or bipolar it may be in structure. Such self-certainty cannot be allowed in a science-fiction world with technological ideals, for in such a world the inner self must be available for the manipulation that will make it socially serviceable; and classical man cannot be manipulated, cannot be operationalized as the epiphenomenon of sociopolitical control. This is why Golub inserts him into the contemporary world, to show that the self can endure, however manipulated or even tortured. In Golub's activist paintings, the victim (sometimes almost explicitly classical, as in *Interrogation I* and *Interrogation II*, both 1981) represents this enduring, if severely wounded, sense of self. The simple fact of the continued existence of this kind of being is an overwhelming criticism of today's technological, manipulative society, the morally irresponsible modern world. Golub's classical man can be destroyed, but not manipulated or "brainwashed," for he exists beyond all ideological control. He may have lost his freedom, but he becomes symbolic of critical freedom. The critical spirit is always in bondage. It always seeks to escape, and always exists in a tortured state, because it always questions existing values. What is valued in the modern world is manipulation, whether in crude or subtle form, and Golub's art can be understood as a critique of manipulation writ large— made radically explicit—as torture. When manipulation forces rather than "persuades" to conformity, or when it does not

succeed, it becomes torture, and destroys what it cannot "convince."

In general, Golub counteracts the science fiction of a technological world with the artistic fiction of a classical self. By adopting this constructive illusion of autonomy, he attempts to free himself from the detrimental effects of living in a world whose illusions are self-destructive. This artistic invention becomes a critical perspective from which the science-fiction world can be understood in its historical reality; Golub's revolutionariness consists in dispensing with modern illusions while at the same time recording their devastating effect. Simultaneously, the fictional classical persona approaches a solution to the narcissistic problem unavoidable in modern society: the classical self is cohesive, and opposes itself to the "openness" demanded by modern life. The openness the modern self is supposed to have—an openness central to its sense of itself as ideal—is exploited opportunistically by a manipulative society; the open self becomes the manipulated self, with no power of autonomy and cohesiveness. For Golub, the classical self represents the basic power of resistance to manipulation within the open self. Golub's mission in art can be understood as the attempt to establish, against all odds, a classical sense of autonomous self—to gain a foothold for an ideal integrity in a manipulative world which views integrity as a "technical" obstacle to total "openness." For Golub, only classical autonomy stands guard against the total receptiveness or porousness that makes one the ideal victim of social manipulation. Fictional classical autonomy becomes real inner resistance to appropriation by the powers that be. The real daring—heroism—of Golub's art is its willingness to assert the ideal of classical autonomy, however mangled or monstrous its form, in a manipulative, technological world.

Golub is either Jack the Giant Killer or Don Quixote charging windmills. The pathos of his position is inseparable from its actual heroism. From a technological point of view, his art is all too deliberately imperfect—unlike, to take an exemplary case, the art of Donald Judd, a masterpiece of technological expression, eagerly affirming and glibly embodying the technological ideology of our society. Judd celebrates our society's science-fiction ideology. The understatement of his style does nothing to detract from his social conformity; his art reduces to a sum of manipulations, their delicacy often only superficial. Golub, meanwhile, shows us the human victims of manipulation, the wounded condition of humanity and individuality in a world of

technological purpose. Judd's abstraction deals with an internalized universal ideology, while Golub's representation deals with only superficially rationalized personal suffering. Golub is forced to externalize the truth of inner experience, while Judd's matter-of-fact abstractness indicates his unthinking acceptance of technological ideology.

The vulgar look of Golub's figures reveals the effect of living in a science-fiction world on our sense of self; it is diminished, we appear tarnished to ourselves. The vulgarity also deliberately contradicts the polished, perfect look of modern technology, and of Judd's art and that of the minimalists in general, with their synthesis of esthetic and technological idealism. The slick look of technological perfection is the preferred one in our society, but Golub reminds us of the real, crummy look of many of the people who inhabit it. He offers us the look of the slumlike "alternate world" in George Orwell's *1984*, the world in which one can be dubiously, imperfectly human rather than unequivocally, certifiably machinelike. Golub shows us that technology and its esthetic mask rather than eliminate this alternate, vulgar world—fail to find a "final solution" for it, despite all their efforts. His figures reveal the vulgar form taken by individuality and conscience in the science-fiction world, their monstrous look from a technological point of view. They are ghosts haunting modernity, reminding it that its ideal of technological perfection—total "denaturalization"—is destructive of humanity. It may be, as in the epigraph from *Hamlet* at the beginning of this chapter, that such ghosts walk in the streets before a world disaster. They appeared before Rome killed its greatest hero, the man who most represented its humanity, and they may be appearing now in Golub's art as omens of the destruction of the last vestige of humanity in the American empire—in effect, of the "self"-destruction of the American world.

Yet for a long time, as I have said, Golub's art had little overtly to do with the history of the American empire, the history of the present. Golub spent great energy achieving identity as an artist/person. His apprenticeship to the classical tradition was as long and devoted as was Arshile Gorky's to the tradition of the new. The results are different—Golub creates a new history painting, Gorky creates a new abstract painting—but both artists are concerned with solving the basic narcissistic problem of being individual in the modern world of "relative selves." Past art fills an ego depleted by contemporary experience, gives it substance through a symbiotic rela-

tionship. To esteem past art becomes a form of self-esteem.
The art that follows from this self-esteem may show the cor-
rosive effects of contemporary life, but it can withstand them
sufficiently to reassert a general ideal of humanity. In Golub's
case the ideal is one of ethics, in Gorky's it is one of sensibility;
in both cases it is available indirectly, the implicit opposite of
what is actually displayed in the art. This is as it should be, for
in the contemporary world the ideal is invisible but felt, a dia-
lectical possibility infiltrating an ugly reality. Both Golub and
Gorky depict pain; our perception of it in Golub's work, how-
ever, is transformed not by the utopian promise of future plea-
sure that lurks in Gorky's paintings, but by the sense that the
tortured creatures we witness belong to the past, so that the
world that created them is not inevitable in the future.

The dialectical arguments in the previous sections should indi-
cate that while it is possible to spell out the sources of Golub's
imagery in precise detail, to do so matter-of-factly is to miss
the complex identity they imply. It is beside the point to name
Golub's sources in order—in T. S. Eliot's sense, to locate
Golub's "individual talent" in "tradition," to demonstrate "the
historical sense" that demands that every artist be "set . . .
for contrast and comparison, among the dead." That no artist
"has his complete meaning alone"[30] Golub knows well, but he
also knows the truth of K. R. Eissler's argument that "the
artist is reduced by the historian to an automaton-medium of
his predecessors,"[31] and that to avoid this it is necessary to
have some sense of the artist's psychology, of his personal re-
sponse to his experience of the world.

Golub has given us ample evidence, both verbal and visual,
of his psychology and understanding of modern life. It's true
that until he begins to depict the contemporary world explic-
itly, in social-activist, openly historical paintings, "not only the
best, but the most individual parts" of his work are "those in
which . . . his ancestors, assert their immortality most vig-
orously"[32]—namely, its classical elements. But in Golub's art
the classical exists only to disclose a world-historical idea, not
as an end in itself. Golub has always felt free to radically vio-
late the classical in the very act of articulating it; he uses the
classical to acknowledge what is antithetical to it, the modern,
and in his work the presence of the classical forces us to reex-
amine the modern against a context in which it stands out
more clearly than it otherwise would. What seems self-evident
is brought into question; the classical gives us sufficient

psychic distance from the modern world that we all inhabit to highlight meanings that are otherwise registered only subliminally.

Golub pulverizes the classical almost beyond recognition, distilling it into an essence, a kind of touchstone, that can force to its surface the inner idea of an existence that has nothing to do with it. Golub himself has said that classicism (and primitivism—classicism is a kind of primitivism for him) works as "metaphor," "works as idea." He is "dealing with man, dealing with existentialism" through classicism, but his classical figures are "a complicated series of ideas." None are meant to be "actual; they're mental things."[33] The immortality of Golub's paintings depends on the ideas they represent, not on the contemporaneity of his stylistic treatment of classical man. Even in the later, explicitly contemporary paintings, with their photojournalistic use of popular rather than art-historical language, what counts is the idea, not the style. This is not to say that the correspondence or appropriateness of style to idea is unimportant, but that Golub never uses stylistic sources in a formal way, as esthetic ends in themselves. Rather, in the language of the Thomas Mann epigraph at the start of this chapter, he uses such influences to "sound" the depths of the past, to "probe and press" it until a full sense of its unfathomable character emerges. To be unfathomable means to be fundamental, existentially inescapable, and it is this meaning that Golub seeks.

One can sense the unfathomableness of the past in classical works of art, art whose origins are old and obscure, and which is thus all the more seductive and influential. The world classical works were made in no longer exists, its history is all but forgotten; it is present only in formal signs, which, for us, have the status of abstract ideas. The contemporary newspaper photographs Golub works with in his war pictures are beginning to fade too; they have the look of memory, seem to belong to an indefinite if not yet entirely remote past. They are of value less for their look than for the idea they convey. Golub is preoccupied with the "potential longevity"—the physical longevity—of his paintings[34] to the extent that he tries to embed their images in their materiality, as if that would preserve the images forever in memory as in a tissue of the brain. This concern is reflected in his attempt to create works that have the look of belonging to an unfathomable past, and which are therefore all the more valid as ideas. Golub suggests that his paintings will endure because they deal with enduring ideas—inescapable truths about the human condition. His at-

tempt to establish continuity between his art and that of the past is really an attempt to assert that his art tells us an essential, timeless truth about man.

At stake in every stylistic choice Golub has made—classical and contemporary, art historical and photojournalistic, elitist and populist, narcissistic and activist—is his attempt to reach what is beyond style, to use the insights of influential styles in order to "re-cognize" a human reality that remains beyond the control of style (for all its availability through style): the reality of power. This subject to which history eternally returns is Golub's "great theme,"[35] and all his art orbits around it. It shapes every detail of texture and space in his paintings—determines every aspect of them, in an extraordinary economy of means that might almost be called reductivist. (The parsimonious use of influential past styles—a kind of conceptual collage of scraps of history, fallen signs of traditional wisdom—is a simple instance of Golub's tight stylistic control.) Alfred North Whitehead has written that "above style . . . there is something, a vague shape like fate above the Greek gods. That something is Power. Style is the fashioning of power, the restraining of power. But, after all, the power . . . is fundamental."[36] Golub chooses as influences only images that come as close as possible to mediating raw power—making it immediate, and demonstrating it as the power of fate, the power over life and death. He chooses images that communicate power as a pure presence and as the ultimate organizing principle of human existence, determining its meaning and form down to the slightest nuance. This sense of power as both macrocosm containing human existence and microcosm operating within it is crucial for Golub's art. He wants to show the pervasiveness of power, its fundamental influence on every level of human existence; he wants to indicate it as the "true" reality, the reality against which all other interpretations of human existence appear false, trivial, incomplete, and inconclusive. Rarely has an art concentrated itself so completely on a single task: single-handedly, and single-mindedly, Golub wants to disclose the ultimate truth of power.

Golub physicalizes the thought of power. His recognition of it is obsessive, he is spellbound by its revelation, becomes its oracular priest. His paintings put the spectator—however critically informed, however much interested in art as aesthetic spectacle—in a basic relationship to the reality of power: all theoretical meditation, all casual browsing, all attempts at ordinary appreciation, at edification and gratification, are pushed aside, dismissed by the force of Golub's art. The spectator is

riveted, his or her defenses overwhelmed, by the display of ultimate truth. The confrontational impact of Golub's pictures is greater than that of the typical expressionist picture, or even than the impact a mural-scale picture may gain through large size. The hyperbolic realism of the works is like what Heinz Kohut calls a "forward leap in the development of man's perception of the world." In Golub's art, to use the language with which Kohut describes such an event,

> we cannot . . . differentiate data from theory, . . . external discovery and internal shift in attitude are . . . one and the same, . . . the primary unity between observer and observed is . . . unobstructed and unobscured by secondary abstracting reflection. On this basic level of experience, the most primitive and the most developed mental functions appear to be at work simultaneously, with the result not only that there is no clear separation between observer and observed, but also that thought and action are . . . one.[37]

Golub's pictures establish us on this same "basic level of experience"; they have the grimness of this "concretized thought" or "action-thought"; unlike much abstract art, they cannot be dissociated into theory or entertainment.

Golub offers us neither "action painting," in Harold Rosenberg's sense of the term,[38] nor the "philosophical painting" of Baudelaire,[39] but the action-thought of power distilled through tough-minded perception of reality. The visual positivism of the activist painting displays the objective fact of social power, and at the same time imaginatively presents power as the root of the most intimate subjective logic, the logic by which selfhood is achieved. Everything primitive in Golub's pictures is complexly developed, and everything complexly developed makes the primitive point that the pursuit and exercise of power fundamentally shapes society and the self. Golub makes it clear that even the "technological imperative"[40] is simply another means of expressing raw hunger for power, indeed of asserting it with a kind of climactic finality: by rendering the most efficient, technologically sophisticated weapons as if soiled with ancient use, he makes them look like tribal artifacts in a primitive ritual display of the power drive. There is no sense of any secondary, consolatory reflection behind the scenes of violence in this art, no sense of the possibility of any amelioration, control, or domestication of the raw urge for power.

Golub's development, from the first, primitivist phase through the classically oriented works to the social-activist

works, shows an increasing "deintellectualization." As he frees
his art of art-historical allusions (intellectualistic, for all his
primitivizing treatment of them), it becomes more of a direct
demonstration of the power drive. In a parallel movement,
power is more and more clearly shown to operate equally in so-
ciety and in the self. The preactivist, existentialist works rec-
ognize that the self seeks to become a power, but they suggest
that that power is different in kind from and inherently rebel-
lious against social power; the activist works, however, show
the self no longer rebelling against social power, but actually
representing it. This new sense of the unity, the inextricability,
of society and self eliminates the existential myth of the self's
radical individuality, of the unique and independent develop-
ment that permits it to "abstract" itself, to resist and disen-
gage from society. For Golub, to encourage the self to resist so-
ciety in the name of abstract individuality is to draw a veil over
the social conditions of the self's existence, and in this sense
his overcoming of his belief in the uniqueness of the self (in
effect, his sacrifice of his own hard-won sense of individuality)
can be understood as the ultimate strategy in his war against
abstract art—an art that itself draws a veil over reality, a veil
not only obscuring reality but insinuating the idea of the alter-
nate reality of art as absolute in itself. For Golub, the notion
that what Baudelaire called the "artificial existence" of art
could usurp the significance of psychosocial reality is not only
absurd but personal and social suicide. Golub's elimination of
art-historical allusions in his work stems from his realization
that they foster the illusion of art's sovereignty and indepen-
dence from reality. It is out of this realization that the activist
works develop, and these paintings show the fundamental self
as monstrous not because of its unique nature, which art other
than Golub's apotheosizes, but because of its implication in a
monstrous world.

Golub opposes abstraction both as concept—he sees art not
as transcendent or otherworldly, but as rooted in this world—
and as method, as "contentless," "pure" painting. He also
comes to see both primitive and classical styles as abstract,
ahistorical, "arty" interferences in his historical representa-
tion of power. The result is a new sense of what concrete, pri-
mary representation means. Golub's "barbaric realism," with
its use of bodily gesture as the "muscular conclusion of stress
and emotion,"[41] and of figures as "abbreviated symbols . . .
conveyed in stringent simplicity,"[42] are all ways of establishing
his pictures on a "basic level of experience." His most effective
way of accomplishing this basic representation—representa-

tion of experience at its most basic—is by forcing the spectator to partially identify with the figures in his paintings; given the actions the paintings depict, this places the spectator in an impossible position. Golub's pictures war against the spectator, who must look at them not from some secure foxhole of perception, but from the no-man's-land between the monstrously real world and the all-too-real monsters shown. The works assault the spectator not only through their horrific imagery and increasingly grand scale, but also through their attempt to establish his or her complicity in the monstrous scene depicted. The spectator is invited into the picture, is pushed into an ambiguous, empathic situation. As an intimate witness, the spectator must question whether witnessing is a form of complicity.

The "pathos" that Golub has repeatedly said he wants to articulate is the pathos of his own determination to witness. Whether his witnessing is turned to the disintegration of the self in the modern world, or to its reintegration with that world as a pawn in one of its numerous games of power (Golub's pictures can be understood as "power plays" on the order of morality plays), he is a far from passive onlooker; but he knows that his record of events, no matter how reflective of them it may be (and it certainly surpasses any mechanical documentation), will not change them. Hence his pathos. Golub forces that pathos on the spectator by situating him or her both on the periphery of the scene and within it. The spectator is put in an ambiguous relationship to the picture, is unable to satisfactorily gain distance from it and regard it as merely a picture or fiction, and yet is unwilling to identify with the events in the "illusion." This is a frustrating, untenable position to be in, echoing the frustration that seems impacted in the pictures and is responsible for their angry texture and soiled, eroded grandeur. It is worth noting that by generating what might be called a "conflict of distance"—by putting the spectator in the impossible position of responding realistically to a picture and thus losing esthetic and even emotional distance from it, while also knowing that the picture is only a fiction—Golub's work epitomizes, with a vengeance, the problematic sought by authentic mimesis. Looking at these paintings, we lose control of our own distancing power; the work seems at once to double-cross and to cross-examine, to deceive and to reveal us to ourselves in an extremely uncomfortable way. Golub's works, like the greatest works of realism (such as those of Caravaggio), arouse extreme anxiety in the spectator, who, assaulted with

the drama of his or her own response to earth-shaking events, becomes implicated in the catastrophe called reality.

Golub's pictures give us a feeling of impotence perhaps even more contagious than the feeling of power, for the feeling of impotence is more universally experienced: we see ourselves more readily as victims of authority than as figures of it. To have power is to have authority, and, especially in the activist paintings, Golub gives us the sense of standing by, helplessly watching those who have authority wield their power. We cannot stop them. Moreover, we feel as though we are initiates at a ritual demonstration of power, and we implicitly join the demonstrators, the violent authoritative priests of power. We become soldiers and torturers, taste the blood—the most intoxicating taste there is—of the victim, and establish our "manhood." Golub's pictures are at once a powerful display and an analysis of masculine ("macho") ideology, which is why one critic has understood them as "Nazi";[43] in this context, however, one must note that the pictures invite one to be a "man" in the same way that the hero of William Faulkner's story *The Bear* is invited—by a private encounter with a publicly sanctioned violence, in effect an encounter with the principle of evil ("raw nature," or raw power) incarnate. In the "Interrogations" series (1981) the violence is secret, taking place in a "private" torture chamber far from public view, while in the "Gigantomachies" series (1965–67), the "Vietnam" series (1972–74), and the "Mercenaries" series (1979–84), it is up front, out in the open. But in both cases it remains social in purpose, and an everyday occurrence. And if the "Interrogations" show us torture as a kind of Dionysiac mystery while the other pictures show it as a far from mysterious public theater, yet the principle in both is the same: to draw in the public, to win their baffled acceptance of the events, to compel their intensely emotional participation in them, as if at a horrifying yet festive public execution. The faces smile at us, the open door invites us, the action seems about to leap beyond the picture plane into our laps, the feet of the mercenaries and interrogators are hidden just beyond a low fence of pictorial edge which we might easily step over: all this draws us in. Golub allows us no space for withdrawal, no wall to back up against, no place in which we can shield ourselves from the sight of the historical events. His pictures test the romantic premise that nothing human is alien to us.

The problematic, unpleasant position Golub's pictures put us in is reflected in the paradoxical fusion of classical and ex-

pressionistic methods he uses to achieve it. As already noted, Golub wants to make "paintings that you can't get close to," paintings embodying "the concept of distance," and thus "rhetorical in the old sense of the word."[44] In this his art emulates the classical at its most refined, for both seek to offer the "timeless, stripped down" look of the truth. But the "eroded form"[45] of late classical art, the ruined look implicit in its age, seems "to pierce appearances to some rawer reality,"[46] a reality quite unclassical; and similarly, while on the one hand Golub's work embodies the classical idea of the contemplative distance necessary to know the truth, on the other it displays an expressionistic grasping of the ultraconcrete. On the one hand, there is a sense of absolute objectivity; on the other, a driven subjectivity. Presumably, the two methods arrive at the same result; presumably, the "rawer reality" is the "timeless" truth. Yet the sense of the former comes through subjective engagement, of the latter through objectifying detachment. A good part of the brilliance of Golub's pictures, particularly the activist ones, is that they successfully fuse a sense of detachment—achieved through grand scale and gigantism—with a sense of engagement achieved through a physical texture that metaphorically reproduces the violence depicted. Both scale and texture, in their different ways, signify the great, searing truth of power.

The overall effect is rhetorical, but not in the classical sense that Golub imagines. The rhetoric here is rather the more powerful, complicated, modern one described by Kenneth Burke, who stated that rhetoric "considers the ways in which individuals are at odds with one another, or become identified with groups more or less at odds with one another." Rhetoric invites "identification . . . with earnestness precisely because there is division. Identification is compensatory to division."[47] Golub's very original synthesis of the classical and the expressionistic permits us to "identify with" or "unite with" his figures while surveying them as a group, with the detachment that comes from distance. We both have and do not have perspective in a Golub painting, both identify and do not identify with the figures. Our attention oscillates wildly from a god's-eye view of the overall scene to identification with the individual within it. The classicism tends to nullify the expressionistic effect of identification, the expressionism to nullify the classical effect of distance; the pictures exist on a "Dionysian/Apollonian" seesaw.

These paintings are also rhetorical in an even more complicated dialectical way. They depict individuals at odds both with one another and—centrally to their effect—with us, the view-

ers, and simultaneously they invite us to identify with these
individuals; in becoming one with them we become completely
divided against ourselves, we internalize the figures' aggres-
sion against us. We experience them as alien to us, but in re-
cognizing their humanity, however reluctantly, we become one
with them, and in so doing are at war with ourselves. This war
gets a good deal of its energy from the figures' war on us; the
cruelty they visit on one another, both physical and mental, is
implicitly directed against all members of civil society. And
this cruelty, coupled with Golub's inherent cruelty of handling,
is vital to the rhetorical effect of the paintings. Golub's pictures
are both rhetorical proclamations of "that ultimate *disease* of
cooperation: *war*"[48] and rhetorical recognitions that we are of
the same substance as the violent figures of war, that we
are ultimately as well as immediately inseparable from them.
Burke remarks that "rhetoric is *par excellence* the region of
the Scramble, of insult and injury, bickering, squabbling, mal-
ice and the lie, cloaked malice and the subsidized lie,"[49] and
this is the region Golub depicts. But it is also the region of self-
discovery, perhaps of the discovery of our own potential for
rhetoric.

Golub's pictures are hortatory to the extent that they "pro-
voke" identification with their warring figures, evoking the
Hobbesian war of all against all that undermines the social
contract—evoking our own aggressive, antisocial tendencies.
Moreover, their rhetorical character undermines our expecta-
tion of what a picture should be esthetically—of the distance a
picture should establish between itself and us. In Golub's case,
this is not simply another version of the overstated antipathy
between art and theater,[50] internalized in one oeuvre; rather,
Golub reinterprets esthetic distance as social alienation, so
that the distance one expects the picture to maintain is under-
stood to objectify the alienation one experiences as all too
human. In undermining esthetic distance, then, Golub per-
versely undermines alienation; yet since alienation has the sav-
ing grace of setting us off as individuals from other individuals,
he thus forces us into a "classless" society, in which there are
no individuals but only warring groups. The irony and pathos
of this are all the more remarkable to the extent that the rhet-
oric is un-self-conscious, that is, to the extent that Golub
thinks he is simply depicting psychosocial events, "classiciz-
ing" historical aggression.

Golub's pictures, I have argued, establish us in a kind of limbo
of involvement. This is exactly the state of everyday life, indif-

ferent to violent, "foreign" events it imagines are far from its nature—until they physically intrude upon it, even erupt within it as if generated by it. Golub's pictures exist in the no-man's-land between abstract, theoretical consciousness of the reality of violence, internal as well as external, and physical experience of its reality. They disrupt our speculative awareness of violence and demand moral consciousness of it. This is the way violence exists in the United States, a country that has never experienced a foreign invasion yet has had a fair amount of internal bloodshed, and has participated in foreign wars. Explicit social violence exists as a strong latent possibility here, and implicit personal violence seems almost to be a mental habit among many Americans.

Golub's figures threaten us with the stark revelation of the will to power behind their violence, which is personal as well as social. They exist so thoroughly in a violent state that they evoke our own unconscious will to power, the foundation of our own behavior and attitudes; they confront us almost too directly with it, making explicit its devastating effect not only on the world but on the self. We are at once drawn to and repelled by these figures, then, for they allow us no way out of our own deepest nature. They show the will to power uncontrollably, explosively dominant. They are in that deluded, dangerous, ultimately self-destructive state in which they think they can overpower anyone, lick any enemy—are invincible.

The classical, contemplative distance Golub utilizes is simply a filter to purify this very contemporary sense of power. The classical here is no longer a self-imposed restraint on the will to power, but a means of making clear its brutality when it thinks it is omnipotent, unstoppable. And the classical aura of the brutal figures also suggests that our dream of becoming "heroically" powerful in our own right is in a way justifiable, that we have a god-given right to be as powerful and as violent as Golub's characters. Their remnant of idealized classical form almost makes them heroic. Golub thus makes a mockery of the ideal of heroism, stripping it down to its brutal, violent actuality and showing the reality beneath classical refinements. His figures represent our dream of power run wild, come grotesquely true—a monstrous fulfillment of our wish for a powerful self. We have become like the Roman sculptural figures Golub admires: "'rotten' but . . . introspective,"[51] that is, outwardly monstrous or grotesque but inwardly aware of our hollowness and impotence. The monstrousness of Golub's figures is a facade masking their hollowness—a compensatory, perversely idealizing fantasy of powerfulness reversing an actual

experience of powerlessness, in the deepest part of the self as well as in the world. In the dream distortion we are all-powerful while in reality we are all-weak; in both cases we are peculiarly one-dimensional, we have no other being than that given to us by our possession of power, or our lack of it. We have no other framework in which to think of ourselves.

In the last analysis we identify with Golub's figures not because they offer us the gift of a powerful, proudly monstrous, Frankenstein/Golem of a self, but rather because their one-dimensional potency signals its very opposite: these forms are manic-depressive signs of the impotence of modern man. Their grotesqueness is too extreme, too exaggerated, whatever its empirical veracity. It betrays discomfort with power. Golub's figures must make a show of power to throw us off the scent of their feelings of powerlessness, must make such a spectacle of their power that we could never for a moment consider them unspectacular fools. But their relentless machismo display itself shows their folly. And their reflexive violence seems inevitable, a fate against which they are powerless, for only through the exercise of violence can they gain a sense of possessing substantial selves. Only absolute power over others can console them for the hollowness of their inner selves, temporarily stilling the pain hollowness brings. That Golub's hefty, swaggering figures are really hollow men doesn't mean they can do no damage—on the contrary, it means that they are completely destructive of others so as to reduce them to their own state. The nothingness of the victim becomes the paradoxical, distorting mirror of their own inner nothingness, and they have an endless hunger for victims. The dialectic between on the one hand the inner sense of hollowness and powerlessness of Golub's figures, and on the other their outer display of power and dominance, is perhaps the most intriguing dialectic in Golub, for it is the dialectic of identity. Golub's "heroes," undermined or corroded by the monstrousness that masks their hollowness, become as much a demonstration of a subjective fantasy of dominance as a representation of the objectively brutal reality of history. They are dramatic creations and historical representations in one. If they were only one or the other, they would lack both fictional presence and profound significance; without doubleness, they would not be authentically representational—"realistic," mimetic.

Dramatically, the aura of failure, dread, and death that emanates from these seemingly potent figures is central to our reading of them as existential.[52] Such themes evoke temporal contingency. One can say that Golub's figures force conscious-

ness of contingency upon us, demonstrating it to play the same role in modern thought and art that necessity, or fate, played in antiquity. Golub presents figural analogues for the dissociational effect accompanying the prereflective or unconscious sense of contingency that pervades modern life, the sense of the power of time that enters consciousness in the expectation of "change." This acute unconscious sensitivity toward time repeatedly brings the self to the verge of disintegration, for the modern world presupposes that there is no lasting sense of self (no "immortality"), and that there must be none if the world is to continue to be modern. The consequence is a sense of permanently fragmented selfhood. Always threatened with becoming out of date, passé (and the cruelest form of nonsurvival or living death in the modern world is the viewing of one's authentic selfhood as a relic of bygone times), the self divides into temporally distinct fragments, becomes divided against itself temporally. Golub's classical/contemporary dialectic is a direct reflection of this modern "self-division."

Golub's figures also reflect this fragmentation in the way that their violent display of power evokes a sense of the power of time. Golub gives a worn, eroded look to every part of his canvases, but especially to those parts that constitute the figures, which look as though they are disintegrating from the outside in. Their physical integrity is skin deep, and that skin, for all its coarseness, seems thin, in different stages of wear. Thus the figures' narcissistic display of power becomes not only an independent self-assertion, but also a protest against the powerful effect on the self of the modern sense of time as contingency and endless future change. In fact, their assertiveness increasingly appears as an attempt to keep the self intact, whether through the dominance of others or simply through the forceful display of body. The figures' display of power becomes their mode of resistance to and defiance of the modern world's threatening sense of time. It becomes their dubious immortality.

The allusions to past art in Golub's work function similarly. In the modern world the art of the past is unconsciously read as proof of the power of time and thus of power at its most "fateful," for what survives is entirely a matter of contingency. At the same time, such art appears as a timeless manifestation of the will to power, or, to put it another way, of the will to immortality in its most powerful, responsible form. There is a personally significant sense of the past as a series of fateful accidents that decide the conditions of one's own life, and a socially significant sense of the past as a cultural continuum of

human effort, but in neither case is the supposedly memorable
guaranteed as durably significant, and so as a satisfactory
basis for a lasting, consistent sense of self. Classical art is
Golub's spiritual parent, but it can sustain his sense of self as
little as any parent can. When he finally identifies himself as
unequivocally modern—and this is what his shift to a contem-
porary, photojournalistic basis for his art indicates—he al-
ready possesses a tragic sense of self stemming from his recog-
nition of the failure of the past, especially of its idealism and of
any idealistic vision of it he might have. Paradoxically, that
tragic sense of self comes from a modern sense of past time as
both ambiguously timely (topical) and ambiguously timeless;
whichever way one looks at it the effect is the same over-
whelming sense of contingent temporality, making any effort
at moral responsibility to oneself seem futile. Thus Golub's
shift to a photojournalistic, supposedly more impersonal style
in fact reflects and confirms his tragic sense of self and his
modern sense of time, which are correlate.

I tend to think that the most important thing about ancient
art for Golub is that it has to be excavated, and once unburied
exists only in devastated form—physically wrecked as well as
spiritually meaningless in the contemporary world. It conveys
the glory of being human, but in time-tarnished form. It reeks
of the death of man as much as of the dream of man. This
ambiguous state of living death makes it a suitable symbol for
the most elementary, hidden, and narcissistic sense of self, for
a nuclear self that also exists remotely, buried in a past. Like
classical art in modernity, this self exists in one's contempo-
rary life as a numinous rhetorical form, an exhortation to self-
consciousness coming from the unconscious itself. It is far
from accidental that Golub's major sources are among the most
mutilated and fragmented of classical sculptures, those from
the Altar of Zeus at Pergamon and from an excavation site in
ancient Memphis. The look of burial and excavation, the sense
of being seriously touched by time, of existing as perhaps
nothing more than its signature; the whole archaeological fog
in which Golub's characters move, like the ghostly personage
who appears and disappears and reappears in Eliot's *The
Waste Land*—all this is crucial to the figures, giving them an
existential dimension and an expressionist look which are
inseparable.

The look of time is deceptive in so far as it seems to soften
the figures, to make them more accessible, intimate, and easy
to identify with because less resistant to us as finished art. But
their appearance of being undone by time actually shows us

how closed these creatures are, how far from us. Their "un-finished" skins in fact say that they have been "finished" by time, and that they are very limited beings. Thus the super-ficially "romantic," antique surfaces of Golub's paintings have the unexpected unconscious effect of bringing us face to face with classical man as, in T. E. Hulme's words, "an extraor-dinarily fixed and limited animal whose nature is absolutely constant."[53] This constancy is paradoxically disclosed through Golub's consistent use of the aggressive rhetorical device of violently eroding the surfaces of his figures; this device, and the fact that the work is figurative, are the only constants of his art. It is a persuasive way of coercing the spectator into an ambiguous identification with Golub's characters; turning them into residues—"ghosts"—dematerializing them, it also gives them the aged look of ancient art, making them seem at once more venerable and vulnerable than they are. They are venerable and vulnerable only because they have a strong will to power and are pervaded by a powerful sense of time, of impermanence and insecurity. Both powers—the one to secure the self, the other to announce its suffering—show how limited they are, and how ordinary their existence is.

It is the deep metaphysical fear that the sense-comprehensible and present in which the Classical existence had entrenched itself would collapse and precipitate its cosmos (largely created and sustained by art) into unknown primitive abysses. And to understand this fear is to understand the final significance of Classical number—that is, measure in contrast to the immeasurable—and to grasp the highly ethical significance of its limitation.

Oswald Spengler, *The Decline of the West*

TWO

MEASURING THE

IMMEASURABLE PAST

EXAMPLES OF PRIMITIVE

DREAM WORK

The stink of decay and savagery—they go together—that emanates from Golub's figures is classical in origin, according to him, however much it appears to contradict what is conventionally understood by the classical. The ruined state of his art-historical sources not only confirms the underlying actuality of classical decadence or degeneracy, making it self-evident, as it were, but also suggests that the ordered, harmonious classical surface exists in dramatic tension with a disordered, chaotic classical depth. This is the usual tension generated by repression of uncivilizable passion—the tension between the externally civilized and the internally barbaric—but it is also a tension between two kinds of consciously held human attitudes: one that views nature as intelligible form to be followed as a guide to fulfilled life, another that sees it as a primitive, mysterious content that can never really be comprehended. One attitude posits an optimistic relationship to nature, which is implicitly understood as looking favorably upon and even actively encouraging human existence as its own highest point, its own form of self-realization and self-consciousness; the other posits a pessimistic relationship to nature, which is understood as explicitly indifferent to man. Man is simply another of its vulnerable creatures, randomly appearing at a certain moment within its flux, and likely to disappear. The unconscious may loosely be said to be built on this pessimistic attitude, while consciousness may presuppose the optimistic one.

The pessimistic attitude expresses itself in a sense of nature as primitive mystery, and of man as equally primitive to the extent that he is raw nature. To the extent that his sense of individual identity disintegrates, he becomes regressively raw, driven, and violent, and this violence marks him as "natural," for it suggests his disintegration back into the flux of nature. In Heinz Kohut's language, human destructiveness—with which Golub is so obviously concerned—is "a disintegration product,"[1] indicating a return to primitive nature. The optimistic attitude expresses itself in a sense of nature as beautiful and expressive, charged with highly subtle positive values that only art can articulate; these values are not only conducive to a respect for individual identity, but indeed constitute it. The conflict between primitive pessimism (shall we call it pessimistic primitivism?) and classical optimism determines Golub's early development, which can be understood as a dialectical move from primitive to classical form without forfeiting pessimistic awareness of human destructiveness. Indeed, Golub never loses that awareness; he formulates and reformulates human destructiveness in increasingly bold, unmistakable terms.

In the terms of the Oswald Spengler epigraph to this chapter, Golub moves from a sense of man or self as an unknowable primitive abyss, and so as "immeasurable"—uncontainable and uncontrollable—to a sense of man or self as measurable and "sense-comprehensible" through socially imposed ethical limitations on him. Yet for Golub these limitations do not make man beautiful, do not really help him transcend his destructiveness. They only make him tragic. Where he was an unprincipled primitive, he now cannot live up to classical principles and achieve the ethical beauty symbolized by classical beauty of body. Restlessly trapped between the primitive and the classical, Golub's man is especially tragic because he knows his failure: by intending to become ethical, he has become conscious of himself as an individual identity. Aware of his differentiation from nature, he is yet unable to separate from it completely, and this consciousness of his failure to be himself unequivocally, to become independently ethical and intelligible to himself and to the gods (to become godlike), is Golub's final vision of man as such.

In describing the effect of antiquity on Albrecht Dürer, Erwin Panofsky writes:

> The expressive power and the beauty of the human body—
> these were the two ideals which the Renaissance found

realized in classical art. But just as the Italian Quattro-
cento was impressed and excited by the 'tragic unrest' of
the Antique before it could appreciate and abandon itself to
its 'classical calm,' so was the young Dürer enraptured by
passionate scenes of death and abduction before he could
gain access to the beauty of the *Apollo Belvedere*.[2]

The mature Golub never moves from the young Golub's aware-
ness of classical art's "tragic unrest" to a focus on its "classical
calm." However, his formulation of tragic unrest—of the vic-
timization ("abduction") and destruction of human being, man-
hood, selfhood—changes from a primitive sense of the immea-
surable misery imposed on man by nature to a more measured
sense of man's suffering as self-induced, as inherent to his self-
discovery, his experience, and his attempt to creatively formu-
late himself. In never achieving the calm classical sense of the
beauty of humanity Golub may seem like a case of arrested
development, but such a "failing" is perfectly suited to modern
man's self-consciousness, his awareness of his "inherent" in-
adequacy. The peculiar thing about Golub (not at all peculiar
from a modern existential point of view) is that he has a "deep
metaphysical fear" and an awareness of "unknown primitive
abysses" before the classical becomes the mainspring of his
art. One can think of his development as an endless refinement
of this fear, which stands him in good stead when it comes to
articulating the miseries of contemporary history.

For Golub, classical calm and beauty are a betrayal of the
fearful, ugly truth about our civilization, are not part of its
record. Moreover, while beauty concerns the regeneration of
being, our civilization is degenerate; its tragic unrest is the
sign of its degeneration. In our civilization, belief in beauty has
been replaced by the "technological imperative." Machines
seem to have more "expressive power" for us than does the
human body. The ideal of technological perfection has replaced
the ideal of heroic beauty, which if it survives at all becomes
simply the quest for superior efficiency. ("That machine runs
beautifully.") To a great extent, Golub's art can be understood
as a description of the effect on the body of the modern refusal
to recognize it as ideal by nature. Golub shows us the gro-
tesquely distorted appearance of the body through the lens of
the technological imperative, its ugliness from the point of
view of machine efficiency.

Joseph Dreiss has pointed out, in his discussion of Golub's
use of the Belvedere Torso as the source of *Thwarted* (1953),
that Golub deidealizes the god's body to such an extent that it

can be said to be "derealized."[3] Golub in effect "primitivizes" his classical source. It is converted into an "expression," that is, a form of visual language partially codified, partially uncodified, but in any case deliberately indeterminate beyond ordinary ambiguity. As such, it stands outside ordinary visual conventions—indeed, seems to resist or defy them—and articulates a prelinguistic or prereflective experience of bodiliness. It is as though Golub's figures release a flood of flesh experience from behind the dam of reflective thought, a flood that threatens to engulf the ordinary sense of the body as "classically" controllable or, more modernly, as technically manipulable. Golub transmutes the beautiful, substantial, classical body of the god into an ugly shadow of a body, a dense, heavy thing too material ever to be transmuted into a beautiful living form. It resembles the waste product or slag of a modern smelting process more than either the raw ore that feeds the furnace or the pure substance technologically derived from it. For Golub himself, the conversion of the Belvedere Torso into a "thwarted" soul is the recovery of what Paul Schilder—a thinker whose influence Golub acknowledges as of crucial importance to him in the early '50s—calls the "body image." *Thwarted* reveals the body as the "libidinous structure" it is in our unconscious mind;[4] that is, the body is revealed expressionistically, disclosed as an "expression" not only beyond the conventions (beyond the pale) of classical art, but also technologically unmanagable, even inconceivable. Golub's primitive body image, then, which his work continues to offer to the present day, is neither intellectually nor socially administrable.

Golub's libidinous figures exist ambiguously between abstraction and representation. To the extent that they are not strictly descriptive renderings of the body, they can be seen as representative forms abstractly constituted, or as libidinous, nonrepresentative structures given realistic sculptural expression. But time has already placed the Belvedere Torso in a similar limbo. Its partially destroyed state has made it neither figurative nor abstract; it is oddly—one might even say grotesquely—expressive, and it is to this ruined condition that Golub responds. To him, it is the essence of the sculpture. Golub is fascinated by the way the Belvedere Torso seems to have destroyed itself, the way the figure seems to have become "unmanned." The process that once made it symbolic of the divine self seems to have been reversed by time. The statue is returning to its raw materiality; it exists in a state of "disappearance" rather than appearance, which makes it all the more real for Golub—more real than it could ever have been when

it was new, intact, and beautiful. *Thwarted* carries this pro-
cess of degeneration to its "logical" conclusion, showing the
irrational self within the rational god, the primitive being
within the idealized human. Golub has "modernized" the
Belvedere Torso; he has completed the process by which it was
already on the way to becoming modern man, shipwrecked and
disintegrated.

The frontality Golub gives the once-divine figure completes
its ruin by flattening it. Frontality finalizes the eradication
(the deconstruction?) that time has begun, completing its dirty
work by making the divine subhuman. Golub reduces the fig-
ure, which once embodied all that was godlike in man, not only
to the antiheroic and antiideal, but to a ghost that embodies
the absence—finally, the impossibility—of the heroic and the
ideal in the modern world. The classical has self-deconstructed
into the modern with a little prompting from all-too-willing
time. Golub can be said to accept the old myth of the decline of
the golden age into an iron age, the myth of the inevitable
decadence of man. But he accepts it without any belief in its
cyclic character, which traditionally ensures the eternal return
of the ideal. His pessimism is near absolute; civilization experi-
ences no rebirth. It remains stuck in a subtly decadent state.
While the figures are "descendentally" infernal—deliberately
antitranscendental, antiideal (the source of their decadent
character)—in their contemporary military guise they also
represent the confidence of American power as it moves across
the world stage. Their arrogance exposes America's will to ad-
minister absolutely. Golub's fiends reveal the energy that rules
an inferno of control from which there is no escape, not even a
utopian dream of one.

Thwarted links up directly with *Charnel House* and *Evis-
ceration Chamber* (both 1946), completing on a symbolic and
psychodynamic level what the earlier works began historically
and socially. It is interesting to realize that these early works,
which can be understood programmatically—they are the
first, primitive steps in Golub's arduous campaign to define
man as totally destructive and power-hungry/power-mad—are
based on then-recent photographs of Auschwitz victims. Thus
Golub begins with modern historical realism at its most hor-
rific. Almost immediately his work becomes subjective, as if
registering the impact of that real history, and creates an
original synthesis of allegorical (classical) and symbolic (primi-
tive) modes of articulating the self; finally, with the activist
paintings, it reemerges from the working through of an uncon-
scious content and returns to objective history. These last

works are deliberately simultaneous with the events they depict; it is as if Golub did not want them to be obscured by the idealizing, softening tendencies in memory. Put another way, Golub moves from the immediately past yet already generalized history of the Holocaust (generalized through the "memorialization" process that obscures the specifically modern character of that event), through an extended period of heroic adventure in the underworld of the self (the primitive and classical works of the '50s and '60s), to a new, sharply focused and particularized attention to the interplay or overlap between individual and collective history. The figures in the activist paintings are historically marked men, not simply because history has chosen them as its victims, but because they are consumed (as Golub is) by the desire to be historical—the upshot of the desire for power.

Charnel House and *Evisceration Chamber* are not as straightforwardly, objectively historical as the activist paintings; more explicitly than the later work, they are involved with Golub's historical identity as a Jew, his sense of himself as a foreordained victim of history. One can argue that his whole art is a rebellion against this socially imposed destiny of victimization, a rebellion using as one of its methods the exposure of the monstrous victimizers, and of the self-victimizers who implicitly accept their fate. (Golub reserves his fiercest treatment for these primitive figures, making them the most explicitly monstrous of all.) Golub offers us a variety of victims of history: obviously dead ones, primitive self-victimizing or masochistic figures, classical figures heroically resisting victimization, and sadistic, historically realistic victimizers, who are in their own way unwitting victims—puppets—of history. The destruction of European Jews catalyzes Golub's first artistic consciousness and begins the process of depiction. For him, that event is the major, most overt sign of the degeneracy of Western civilization, for it involves the use of advanced technology and advanced administrative methods to articulate profoundly subjective destructive forces. It does not so much control and restrain these forces as give them the means to socially express and realize themselves. And insofar as the Holocaust involves the use of modern methods of organization that seem to lend themselves "naturally" to inhuman purpose, it does not merely open modernity to intellectual question but casts serious moral doubt on it.

One can interpret Golub's art as Jewish revenge on modern Western civilization, revenge exacted by depicting that civilization's victims, its savagery. Through Golub's work, our time

will live in memory as monstrous and rotten. This art can also be interpreted as reflecting Jewish determination never again to become a victim of history, in part by knowing the oppressor so well that one can equal the oppressor's strength. Golub's pictures may often show the victim's identification with the victimizer, but also, if less typically, they show the victim using that "communion" to overcome. In every work since those first Jewish paintings, Golub's art seeks the power to overpower. It is mobilized to counteract. From this perspective the ugly figure in *Thwarted* is a concentration-camp victim haunting the world, a dead creature distorted with the lust for revenge— and finding some satisfaction through the ugliness his person forces on the world. No distracting, consoling, socially mollifying veil is offered for this world-historical monster, the ghost of world history itself.

Golub's transmutation of the Belvedere Torso is, then, far from arbitrary. It directly reflects "modern conditions"—the modern human condition. It is interesting to compare Johann Joachim Winckelmann's conception of this classical sculpture with Golub's "modernization" of it, his dehumanization of the heroic, which is itself a humanization of the divine. The Belvedere Torso is a statue of Hercules, the man of strength so great he seems a god (a type Golub repeatedly renews as if in an eternal yet temporary return to the abused ideal, for example in *Interrogation I*). For Winckelmann the work is "a lofty ideal of a body elevated above nature," showing the body not only as "a shape at the full development of manhood" but "exalted to the degree of divine sufficiency."[5] In contrast, Golub primitivizes the statue's refined, mature body at the peak of its power; he "infantilizes" it by reducing it to raw, crippled matter. More precisely, he brings out the primitive character latent in the classical sculpture by reason of its partially destroyed modern condition. It is as if the sculpture were the manifest content of a dream whose latent content cried out to be made clear by a vigorous act of artistic interpretation.

Dreiss further demonstrates how Golub uses specific sources in primitive art to reduce the heroic classical body to its underlying primitive character.[6] This device not only demonstrates the operation of what Golub has called the "dervish principle" in his art—a principle related to, even appropriating, the improvisational technique of Abstract Expressionist painting— but also makes clear his conception of the heroic as a dialectical reevaluation and revelation of the primitive. For Golub, the heroic is inseparable from the primitive; the two correspond to each other dialectically. According to the reasoning of the der-

vish principle, there are "intense pictorial equivalents" for "the prime elemental resources of the psyche,"[7] and these equivalents can be found in primitive art. The primitive is more symbolic of modernity than the classically heroic, for it is more symbolic of the underlying savagery and cruelty of modern man; in revealing the primitive through the classical Golub is struggling to indicate that there is nothing sublime about modern life, and that modern man understands nothing of the heroic self-balancing performed by the classical self. Golub desublimates the heroic, destroying its inward balance and letting the tension it controls violently loose. This desublimation is made in the name not of physical realism or of perceptual accuracy (which Golub offers only traumatically or expressionistically transformed), but in that of psychic realism, of truth to the primitive character of the psyche. Even in his activist works Golub never loses his sense of the modern psyche's primitiveness: he shows the technological refinements of the modern world as simply a sophisticated means of satisfying a primitive pursuit of power. Indeed, the weapons in his paintings have monstrous appearances, like a kind of somatic disturbance—the malignant tumors of some private pathology of the social body, flagrantly exhibitionistic in the ward of an insane asylum. There is not one Golub figure, not one Golub object, that is not somatically disturbed, and this disturbance is like a physical manifestation of the psychologically primitive. Golub tortures any figure that dares to be whole and "classical."

Like Rembrandt, Golub does not simply show an "anticlassical independence," although "the very violence of his reaction against the conventions of ideal art" indicates "a kind of horrible fascination" with and seemingly involuntary dependence on it.[8] Rather, Golub suggests that these conventions are not what they seem. Covertly, the classical includes subtle signs of the grotesque, which are impacted in it to suggest the enormous tension it controls, the enormous pressure concentrated into its dialectical self-balance, which we somehow regard as unequivocally "ideal." The incomprehensible tension of the human body's struggle for power over itself (a metaphor for the larger struggle to be civilized, to have self-control and so to be understandable to oneself and others) is signaled, but only indirectly. Kenneth Clark notes that in Rembrandt's work "some touch of the grotesque would heighten our feeling of the incomprehensible";[9] in Golub's work the grotesque is overt, so overt that it directly heightens not the incomprehensible but

the comprehensible. Classical balance is revealed as a sham comprehensibility, the tension it structures erupts, becomes an independent force, and the body is revealed as monstrous.

As Harold Rosenberg has written, "what makes monsters is the irreconcilability of the forces that produce them, and this ordains that every monster shall also be a cripple." [10] *Thwarted* is among the first of the long line of monsters that Golub creates. He seems to have limitless power to produce monsters— to find them both in pure classical and in everyday realistic form. Michelangelo saw heroic figures in raw material; Golub sees monsters in material both raw and refined, in actual life and in the "artificial existence" Baudelaire understood works of art to be. One cannot help thinking that Golub's grotesques are the revenge of the outsider on the ideal, that his articulations of the primitive are intended to undermine any preconception of the "higher" character of human nature. In Baudelaire's words, the grotesque "has about it something profound, primitive and axiomatic";[11] for Golub, these qualities are not passive but active. The grotesque in Golub's paintings is a dynamic force rather than a passive construction; in fact it is the sharpest form of the works' nasty, critical cutting edge. It focuses Golub's refusal of the "higher things" of civilization (the supposedly higher civilization of barbaric beings) and his determination to stir up its discontents, to reveal how central they are to its functioning. Above all, the grotesque is the form taken by the discontented will to power; Golub's monsters are allegorical personifications of power's unhappy consciousness.

Thwarted shows a "stump" of a figure. As Peter Selz has said, he is "incapable of using his power for he lacks the very instruments by which man assumes control of his environment" [12]—the arms and legs by which he can assert himself and move in the world; and the head with which he can think about it, lacking the support of a neck, is not elevated, giving the figure a demented look. The Belvedere Torso lacks head and limbs, but the statue's humanity is far from eliminated by its quadriplegic, "mindless" state. In and of itself, the torso is permeated with humanness. Consciousness ripples in its muscles, in every nuance of its bearing and every articulation of its body—in its very nakedness. In contrast, Golub's thwarted figure is annihilated, left without the slightest trace of the classical figure's gracefulness, without even the charm of modern awkwardness. It is a repulsive, disgusting personage, too much the monster to pity; yet finally we recognize our human-

ity in its inhumanity. It is the impossibly mournful residue of our debilitated humanness, the pitifully exaggerated form of our diminished state of being.

One of the most intriguing aspects of Golub's art is that he never depicts grief, suffering peculiarly aware of itself. For all his scenes of carnage and horror, he never conveys an air of sorrow, as if such an emotion would detract from the bluntness of the will to power. The inability to mourn is a traditional male trait—really a refusal rather than an inability, a refusal on the part of the self-styled "heroic" male. As I have suggested, Golub's art, permeated with masculine ideology, is one of the great modern revelations of pernicious machismo; later, this will be discussed at length. Here, it is sufficient to note that the inability to mourn contributes to the monstrousness of Golub's figures, which in part are monstrous because they are all too male. One might say, using Rosenberg's concept of the monster, that the conflict crippling them is that between on the one hand their refusal of the humanity implicit in grief and on the other their need for grief—the urgency of it in situations that seem existentially fated beyond usual historical contingency. Indeed, I would even argue that the frozen quality of Golub's figures comes from their exaggerated male determination not to express any of the "softer" emotions, the emotions growing out of being civilized or communal. Their archaic muralization in part makes a virtue out of the fact that Golub's modern sense of humanity as robotic makes him almost constitutionally unable to depict figures as organically animated; mechanical homunculi awkwardly imitating organic beings, their violent emotions are a sign of the grinding of their gears, an implicit acknowledgment that they are incapable of complex, self-conscious emotion, let alone a positive emotion toward others. Their mechanical monstrousness confirms their feelingless self-absorption, their dumb male narcissism.

One might even speak of Golub's figures as regressive. Their monstrousness is the sign of their reduction to helplessness. Like Franz Kafka's cockroach, they have metamorphosed into their self-imago. Golub turns Herculean adults into Kafkaesque bugs, showing in especially perverse form the "archaic grandiosity" of the primitive narcissistic self—the wounded self of the "hero."[13] Indeed, Golub shows us mature adults as immature monsters, helpless giants flailing away at each other. His figures appear as they might to a primitive, or are like fantasies in the mind of the primitive, whose own self-image is monstrous. Golub never loses this primitive but very modern viewpoint, the antidote and alternative to the classical

perspective *sub specie aeternitatis*. It remains even in the ac-
tivist paintings, which put one in the position of helplessly
looking up at monstrous adult activity.

Golub paints from the point of view of a primitive perpetu-
ally at war with the world. He sees everything in terms of
conflict. His pictures can be seen as metaphors for the struggle
of the fragmented self with itself—the inner struggle of in-
complete, "wounded" narcissicism. The violence of his figures
and scenes suggests the incoherence of a self that has not yet
come into its own, that perhaps never will be "self-possessed."
In his primitive pictures, Golub depicts the enemy within; in
the classical pictures this enemy is objectified, brought more
clearly into focus; in the activist pictures, the enemy within
becomes the other in the world. Here, in this most recent
work, the state of "being in the world" for the first time be-
comes an issue, because in political activism Golub is at last
escaping from himself, attempting to hurl himself out of him-
self, to bail out from an excruciating sense of hurt being. The
old sense of self, the old aura of inner disjunction, remains,
however; the activist pictures—the only ones that have been
unequivocally well-received—create an objective correlative
for the painful dialectic of identity in the primitivist and classi-
cal pictures, but they do not imply transcendence of pain,
which is exactly why they are powerful. In the activist pictures
Golub gives the suffering and conflict of the narcissistically crip-
pled self a socially acceptable and recognizable form.

In understanding the art-historical influences on Golub's sense
of artistic identity and destiny, I have argued, it is crucial to
recognize the dialectic between the primitive and the classical
that rages in his art until it becomes explicitly activist. Even
then that dialectic continues to exist, underground; it forms
the unconscious that determines the appearance of the paint-
ings, giving them their strange, indeterminate aura—the look
that makes them seem to belong to a decadent civilization.
This look of the past, or of a present about to become past,
casts its shadow over the activist paintings, making them sug-
gest a pessimism that no amount of revolutionary intention can
dispel. It is in the dialectic between the primitive and the clas-
sical that Golub works through the conflict in himself between
nihilism and humanism, each more of a tendency, a creative
possibility, than a dogmatic belief. I don't think this conflict is
ever resolved, or transcended toward a sense of ideological
optimism; it too appears in the activist paintings, where ni-
hilistic potential seems to exist in the very robustness of the

grotesque figures, whose vigor is also a residual humanistic form. Atavism is visited upon atavism, suggesting the anachronistic character of both the humanism and the nihilism in the paintings, yet the figures' "modernism" is also dissatisfying to Golub. Their strange compounding of the robotic and the monstrous, the mechanically progressive and the organically regressive, suggests the absurdity of both humanism and nihilism in the modern world, but offers no alternative to them. The debate between futurism and decadence continues in forms that show its futility. Primitivism in general is the substratum of all this: every figure and object in a Golub painting seems on the verge of spontaneously regressing to a primitive state, of collapsing into grotesque incoherence under the pressure of the futility of its situation. While the explicitly primitivist phase of Golub's art is somewhat shortlived—it ends in 1956—and the classical influence is dominant from then through the late '60s (the period of the first activist paintings, the "Vietnam" series), primitivist attitudes, almost ideological in their consistency, remain alive and well in Golub's artistic thinking through the present day. Primitivism is inseparable from his existential self-conception, which remains more fundamental than his sense of himself as a political activist.

The shift in value from primitive to classical in Golub's work does not represent a forsaking of the primitive; rather, the primitive fundament becomes classically re-cognized. The classical seems to add to the primitive rather than overcome it; Golub shows the classical as another, subtler form of the primitive—indeed, for Golub the classical reveals the primitive mentality at its most ingeniously narcissistic and self-assertive. Golub's classicism cannot transcend primitivism, since he generally disbelieves in the possibility of transcending raw reality. He may feel that classicism makes primitivism more publicly presentable, yet his talk of the softening "Mediterranean" influence on his development—supposedly echoing even in the garishly bright color of the "Horsing Around" pictures (1982–83)—is deceptive, perhaps even self-deceptive.[14] Golub's work nowhere shows Mediterranean smoothness or harmony, let alone elegance, of handling, for that would interfere with its primitive eloquence. It would especially intrude on the work's aura of general primitivist self-reliance even in self-defeat. Golub cannot afford to let the primitive be muted. He does allow it to be decorated, almost to become ornamental, but though the classical may be the means of making it more attractive, it presents no convincing alternative to it.

For Golub, primitive art, including the art of the insane, is an introverted form of the primitive mentality, while classical art, whether Greek, Etruscan, Roman, or generally Hellenistic, is its extroverted form. Primitive or insane art shows the primitive mentality in a raw, suffering phase, while classical art shows it more "advanced" and optimistic. The former is based on aggressive empathy with nature, to the point of possession by it, while the latter shows an acceptance of nature which seems to master it, to present man as the lord rather than the victim of creation. But Golub can never wholly welcome nature, for he is too involved with man's discontent. He is not at ease with the classical myth of nature as paradise, of a tame nature, existing for man's benefit and reflecting his hard-won harmony with himself. Nature is tooth and claw for Golub, the realm of a power struggle, and his portrayals of seemingly self-created classical man—as close as Golub ever comes to rendering the narcissistically complete nuclear self—always show a vicious, primitive side. His classical figures' wrecked, brutalized, incomprehensibly abused appearance reflects a tendency to regress to a primitive state. The "insane" or primitive figures, on the other hand, show no tendency to progress beyond their condition, to become "classical."

In both primitive- and classical-derived works Golub produces what can be described as "screaming images"[15]—expressionistic dramas concentrated, like all such dramas, to the point of seeming incoherent. But the paintings have an inner unity underneath their external dissonance, a depth that comes of insistently generalizing underneath a chaotic surface—and in fact the chaos itself is an instrument of psychodramatic coherence. These screaming images, with their unity which dramatically rises to overpower the observer from the depths where perception and conception are one, are modes of mourning for the humanity of a decadent civilization, allegorical personifications of its living death. In the activist paintings, which also scream their truth, Golub discloses this civilization's humanity at its "fittest" in specimens of well-armed soldiers. These works reflect modernity's unity of self-destructive purpose with the greatest succinctness that Golub has ever achieved—with the perverse brevity of the paradox.

The point is that Golub's deformed figures are paradoxically beyond any easy dialectical contradictoriness, for the synthesis of opposites they represent is the product not of an idealistic understanding of man but of a forced march through material history. Not only do they show the simultaneity of subjec-

tive and objective deformation that Maurice Denis speaks of as essentially—eternally—"modern,"[16] but they also represent a new existential type of man forged by historical conflict, the result not so much of a balance of forces as of a violent contrasting of them. Alfred North Whitehead has argued that "a contrast in general produces a new existential type,"[17] but Golub's art is a demonstration of just how hard it is to create a genuine contrast, one that concentrates in itself conflicting historical realities. It is in this sense that Golub's "existentialism" can be understood as "heroic," for the existential types he forges are created in an alembic of just such violent contrast. What Golub is in effect doing in his development from primitive through classical to contemporary manners is reproducing and contrasting the three ages of man and civilization: primitive (pre-historical) youth; adult classicism, with its history-making systems of self-control and world-domination; and the posthistorical condition of decadence, a state of psychopolitical stagflation in which the will to regulate pushes toward total administration—the imprisonment of universality which generalizes a particular societal system as inevitable, like nature. The violence evident at each stage has a different symbolic/ expressive connotation: from signifying narcissistically incomplete, even disintegrated selfhood, it comes to represent aggressive assertion, and finally becomes a socially descriptive display of dominance. Golub's ontogeny recapitulates the phylogeny of civilization, and exemplifies the truth of Kohut's assertion that a major artist "reflects the dominant psychological issue of his era"—in the present period, that of preserving civilization itself. (It is worth noting that the present always seems like a decadent, disintegrative period, since its imperfections are more obvious to one than those of the past, which one doesn't have to live with and has never directly experienced; but Golub doesn't set up any false perfection in the past, as his negative interpretation of two of its phases indicates.) Golub is playing hard and fast with traditional understandings of history, with traditional attempts to make sense of the growth of civilization. Each of the activist pictures compresses into itself the history of civilization, each detail is allegorical; Golub shows us the Western world closing itself down in American wars. By violently contrasting and forcefully uniting old symbols of opposite states of being human—primitively passionate, classically reasonable—he makes it clear that no new possibility of being human is forthcoming in our civilization; indeed, the very reason the artist is forced to use

old symbols is that there are no new ones. Only a new sense of being human might save our world from itself, but Golub shows us that it has only old ideas about what it is to be human, another reason why it is decadent.

Perhaps the central dialectic of civilization for Golub is that between power and control. In the face of the power he depicts, he is obsessed with control,[18] and it is not always clear which dominates in any given image. Most of Golub's figures are potentially out of control; Golub seems to relish the state of lost control, as if it perversely confirms decadence, demonstrating what assertive "individuality" might be understood to be in a totally administered society. One expression of lost control is violence, and there is a violent element in all of Golub's images, which he himself recognizes and objectifies when he speaks of the techniques with which they are made.[19] (Physical violence toward paint and canvas is an archetypal expressionistic technique, just as the archetypal expressionist figure articulates "native" psychic violence.)

If psychotic art can be said to be mentally primitive, and primitive art not only mentally but also physically primitive, both converge in what can be called Golub's "psychotic" primitivism or realism, a realism that bursts the boundaries of reality. In a way reminiscent of Max Beckmann, Golub shows us the seemingly unreal forces that determine the form of reality. Golub's work is, indeed, an extension of *Neue Sachlichkeit* (new objectivity). This style is *the* vehicle for communicating existential reality, especially in a decadent, "psychotic" civilization, out of touch with the reality of its own humanity. This kind of primitivism, which directly conveys the inner tension of our civilization, dialectically converges with the classical elements of Golub's paintings. Dreiss has pointed out that Golub prefers provincial forms of classicism to its cosmopolitan, more enlightened embodiments;[20] the classical in his paintings is decadent, is caught in the process of returning to its primitive origins as it degenerates. For Golub, this debased, disintegrating classicism is more revelatory of primitive power than heroic classicism. Grand-style classicism's deceptively easy articulation of power, its ennobling of the brute fact of being human, is suspect for Golub. He prefers classicism at its most "gross and bombastic,"[21] not simply for rhetorical reasons, but because power is more naturally gross and bombastic than calm and collected. Ironically, it is when a civilization subtly declines that it displays its power most exhibitionistically.

Thus Golub mixes his inimitable primitivist style, which I think is "original" or native to him, with partially primitive, and so partially demented and diminished, classical elements. Showing the classical as primitive and making the primitive classical, he weds "imperfect" primitive form to "perfect" classical figures to invent an apotheosis of wounded man. This existential depiction of man is a distorting mirror in which the science-fiction world can see its inner human reality. Golub's figures make its inhuman, dehumanizing effect transparently clear, dispelling its illusory belief in its self-perfection and in the perfecting of the self. Golub's obliterated self is both a protest against the inhumane science-fiction world and that world's victim. It signals the impossibility of "self-realization" within modernity, reducing itself to the primitive will to power necessary for elementary survival. Manifested through primitivist style, the will to power changes meaning: rather than summoning the power of conquest, it suggests a holding action, a primitive maintenance of being. It should never be forgotten that even in the activist pictures Golub's figures conquer no new worlds but try, through inhuman actions, to sustain an old one—to prop up Western civilization by protecting its periphery. Golub's "psychotic" primitivism is the appropriate style of decadent empire, of an imperialism that necessarily produces crippled monsters as a prelude to the holocaust it will eventually visit on us all.

The best way to grasp the dynamics of the interaction between primitive and classical in Golub's art is to compare works on similar themes in the different manners. Golub paints a primitive *Horse's Head* in 1953 and a classical horse's head (*Tête du Cheval*) in 1963. Perhaps the most noticeable difference between the two works is that the earlier image is more like a hollow skull than the later one, in which the head seems more solidly sculptural and thus less vulnerable and exposed. The later head seems more like a fortification than an elegant form. Golub has depicted skulls elsewhere; they are a standard Chicago subject matter. (A 1947 Golub skull is one of the images that led to his inclusion in the Chicago "Monster Roster" drawn up by one critic.[22]) In the 1953 image, however, we have a skull within what seems to be a still-living head—a death-in-life image. Also, the 1963 *Tête du Cheval* is more clearly identifiable as a discrete form; the 1953 *Horse's Head* is less differentiated from its ground than the later version, a lack of differentiation implying a loss of identity. This has less to do

with an Apollonian/Dionysian distinction than with the fact
that for Golub, as noted, the primitive carries with it the con-
notation of loss of control and thus of the dissolution of the self.
The license—arbitrary freedom—involved in that dissolution
dialectically correlates with the frustration resulting from op-
pression, such as that in a decadent society. Golub's 1963 *Tête
du Cheval* escapes this frustration, becomes more comfortable
with its form than the 1953 head, not through Apollonian con-
trol but through becoming less representative of man. The
horse, of course, has until recent times accompanied man and
shared in—symbolized—his power, its own power being sub-
sumed as the base on which human power mounts and exhibits
itself; but the 1963 *Tête du Cheval* is more a horse in its own
right than an expressionist symbol of man, such as the horse in
Picasso's *Guernica*, which Golub has described as having the
"paradoxical violence of a manufactured (robot-like) object."[23]

Whatever its other connotations, one of the functions of the
classical in Golub's development is that it moves him toward an
objective frame of mind. It sufficiently frees him from li-
bidinous structure that he can begin to incorporate histori-
cal structure. It is the beginning of hard-won objectivity, fi-
nally issuing in the photojournalistic activist paintings. Even
Golub's "insane technique" (his own ironic term) for producing
crude texture becomes a way of recording the cruddy surface
of the real world; however much the decayed-looking surfaces
of his paintings seem to connote the decline of civilization,
they describe real places. It takes Golub a long time to move
out of fantasy and accept a reality principle in his art. (When
he finally does so, it is with a vengeance.) Classicism signifies
his move toward a reality independent of himself. This may
seem a less imaginative step than that represented by his
primitivism—it involves no Baudelairean reconstitution of
world experience in subjective terms; but Golub had no deep
sense of the real world to reconstitute in the first place, only
his own deep experience of himself as the victim of something
he eventually came to call the historical world. The 1963 *Tête du
Cheval* embodies the objectivity classicism brings to Golub's
representational practice.

Golub paints a primitive *Burnt Man* (in two versions) in 1954
and another kind of primitive *Damaged Man* in 1955, and a clas-
sical *Burnt Man* in 1960. The same principle operates in the
comparison between these works as in that of the two horse's
heads, but there is one crucial difference, as obvious as it may
be: here Golub is dealing with heroic man, the mythical au-

thority figure, and his full wrath is brought to bear on these men in the world. Apart from this fact, I would also like to emphasize that the 1960, classical burnt man, however crippled, is not laid out like a dead body on an anatomy table or a crucifix, as the primitive forms from 1954 and 1955 seem to be. While in every case the body is barely contained by the canvas, in the '50s works this does not matter much, since the figures don't seem as if they could move, stand up, and stride out of or beyond the picture frame. In contrast, the later burnt man is on one knee, and seems to be trying hard to stand. His arms, if stretched, would break the boundaries of the picture and destroy the fictional illusion. Our sense of this possibility makes the painting more confrontational. The later man also seems more capable of extending into the real world because he looks more real than the earlier figures, which are like stretched skins from hardly human creatures no taxidermist could begin to reconstruct. Golub's classicized burnt man is still a crippled monster, a primitive "psychotic," but he also struggles to master his own destiny. However battered, he is still heroic. He has an integrity unfathomable to the earlier figures, who are pure victim, totally smashed.

Similarly, if one uses the perspective of the primitivist/classical dialectic to compare the various images in the "Priests" series (1951–52) with the later "Philosophers" (1957–58), as well as with such images of the hero as *Orestes* (1956), one observes the same shift from subjectivity to objectivity, and from the totally disintegrated to the incompletely integrated. Golub's classical figures, especially the armless *Orestes*, still have massive primitive wounds, but they have, as it were, accepted them as integral to their being. In some strange way they have compensated for them by becoming more objective—sense-comprehensible, to use Spengler's term—in appearance. Despite their condition, they are beings in the world; they no longer thrust out the wounds that visually screamed at us in the primitivist pictures, no longer really exhibit them, but present them matter-of-factly. Golub has no doubt swallowed some psychic pride to achieve his classicism, and his classical figures have lost the glamor of a full-fledged monstrousness, but the result—a calmer sense of self and a firmer grasp of reality—seems worth it. Golub could really have been a case of arrested development had he not discovered the classical as a means of articulating self-integration through action.

Priests and philosophers, in their different ways, are heroes of consciousness, intellectual figures standing in heroic rela-

tionship to the mind, taking their authority from their mental
powers. They are not exhibitionistic emotionalists like the
primitive, totemic figures, and yet they have an equally strong
presence. Golub gives them a certain bluntness of being,
perhaps emblematic of their inner determination. While the
priests tend to be more shamanistic than intellectual, both
qualities are forces for the control of power; this is true despite
the venomousness of the priests' self-display, and despite the
philosophers' somewhat brittle sense of bodily being. Golub
shows us the intellectual as it develops from magical to rational
thinking. Orestes (*The Victor*, 1957, is this painting's brother)
greets us with a smile; he doesn't just flare up at us, as the
priests do. The smile may be a non sequitur—this hero has no
hand to shake—and even a form of appeasement, although it is
clearly a rational form of greeting. The philosophers also have
a slightly optimistic look, despite their inertia. Reason seems
to have triumphed, however reluctantly and awkwardly.

It is important to notice that both priests and philosophers
show a consistent inertia, for this inertia is the umbilical
cord connecting the primitive to the classical in Golub's art.
The transmutation of priest into philosopher—apparently by
way of the athlete hero, who exerts a more physical type of
control—does not change the fundamentally primitive charac-
ter of the figure presenting himself to us, and this primi-
tiveness is reflected in bodily inertia, a sense of heaviness of
being. The priest has control—consciousness—of unconscious
forces, although he seems to be possessed by rather than com-
pletely master of them; the philosopher is conscious of con-
sciousness itself, and is thus able to reason, to be objective, to
have perspective on the world. (Golub's later insistence on a
public scale in his work, on establishing a large measure for
man, expands the beachhead of objectivity and rationality won
by the philosophers, with their objective if far from serene
glances.) Nonetheless, both priests and philosophers are prim-
itive for Golub, and so are inert, unmoving. They are not men
of action, and Golub seems to prefer his athletic figures to
them, even if the world in which the athletes act is an abridged
one. The line of Golub's development moves through the ath-
letes to the fighting figures, making the philosophers seem
anomalous, a momentary pause, in its course. Full rationality
for Golub means action in the world—even though the active
soldier figures he later shows are hardly rational.

There is good reason why the shift from the *vita contem-
plativa* to the *vita activa* is heralded by the awkward appear-
ance of the athlete, or rather of the crippled athlete. It has

been Golub's desire to be a man of action, a desire partially fulfilled by the public political activities from which he gains a strong sense of identity. Playing a socially active role is Golub's way of achieving the narcissistic satisfaction of the sane nuclear self. For him, the primitive state is really a passive, undeveloping state, for all its visual Sturm und Drang, and the contemplative, purely mental philosopher is peculiarly primitive because socially passive. The athlete is hardly without his primitive side, and indeed seems a more sophisticated rendering of the primitive—for Golub the essential type of man; yet he moves beyond both the straightforward primitive and the deviously primitive philosopher, clearing the way for the warrior type. How much of an advancement of civilization is this? One might say that Golub's priests show primitive man in a manic phase, while the philosophers show him in a depressive phase; do the warriors show him as simultaneously manic and depressive? Whether or no, they certainly make one doubt that Golub's regression to the primitive results in a humane sense of self—a true "humanism."

Whatever shape Golub's figures take, they reflect the Holocaust. His art may be the only one that mediates it in a measured way (the most measured way possible considering what is being mediated). The Holocaust is the primitive creation of the science-fiction world, the paradox that reveals the primitive beings that the science-fiction world demands we all become, whether as victims or as victimizers. This is why, whichever role a Golub figure acts, it remains fundamentally primitive.

It is as if art works were re-enacting the process through which the subject comes painfully into being.

T. W. Adorno, *Aesthetic Theory*

Destructive rage, in particular, is always motivated by an injury to the self. . . . The bedrock is a threat that to my mind is more serious than the threat to physical survival and to the penis and to male dominance: it is the threat of the destruction of the nuclear self.

Heinz Kohut, *The Restoration of the Self*

These comments permit us to define a primary characteristic of the critical experience: it goes on inside *the totalization, and cannot be a contemplative grasp of the totalizing movement; nor can it be a singular and autonomous totalization of the known totalization. Rather, it is a real moment of the totalization in process, insofar as the latter embodies itself in all its parts, and is realized, through the mediation of these, as the synthetic knowledge of itself. In practice, this means that the critical experience can and should be the reflective experience of anyone at all.*

Jean-Paul Sartre, *Critique of Dialectical Reason*

THREE

BECOMING AN ARTIST

THE EXISTENTIAL/NARCISSISTIC

PAINTINGS

I n the preceding chapters I have suggested the project of this chapter: to understand Golub's art as an exemplary demonstration of the existential/narcissistic project of becoming an artist. More precisely, it elucidates the problem of becoming an artist in the modern period, when there are no universally validated beliefs or values to fall back on, as on bedrock. Nor are the "classical" styles that once serviced and mediated such beliefs available as convincing modes of communication. They are simply one among many modes of articulation in a naive pluralism, under the umbrella of a general belief in the need to be popular—to communicate in one of the many dialects of the language of everyday life. Every high style sooner or later becomes adjusted to this democratic necessity. Its transcendental intention becomes not so much compromised as ever more distant, receding into a remote horizon of possibility. That possibility becomes the ultimate allure of the style, continuing to give it connoisseur appeal, but the art loses absolute validity, an unconditional right to exist. It exists within a critical context rather than a universal one, and its totalization, the attempt to understand or express it in sum, is a critical experience, much as it itself is a critical totalization of the modern experience of absence of universally accepted belief. Every modern art of any consequence gains its validity as a critical reflection on this condition of absence of universality in both art and life. Since there is no universal basis for self-totalization, the autonomy of art and of identity becomes critical, which means that both exist under perpetual threat of destruction.

Golub's "exploratory operations" on primitive and classical

art are foredoomed attempts to appropriate whatever is universal in them, whether an element of material style or of commonly-agreed-on value. Presumably, this might give him some bedrock in dealing with the modern situation; in fact, however, it shows how impossible it is to articulate the normative within modernity. The failure to do so makes Golub's art all the more existential, all the more a critical reflection on the modern threat of destruction of autonomy. Indeed, the issue subtly changes: the modern situation is critical not because autonomy is under threat, but because the very meaning of autonomy seems lost, impossible. It is not that autonomy can be easily destroyed, but that it is hard to create. The nuclear self is not easily established in a world that no longer inwardly believes in its own validity or normalcy. The technological imperative of the science-fiction world is hardly a basis for autonomous selfhood; on the contrary, it implies the robotization of the self as an instrument of the system. Any validity the self may seem to achieve through accommodation to the system is hardly that, since such accommodation implicitly denies the reality of selfhood. No universal norm can be achieved as a ground for identity when technological normativeness is not characterological but operational: the self has no character, it just follows rules.

Like many artists before him and no doubt like many after him (until what he has called a "normative universalism"[1] is recovered), Golub turns to expressionist style to show the critical condition of art, and, metaphorically, of the self, in a situation of nonuniversality. In such a situation the self is at the mercy of its own spontaneity (and thus of its own rage), and art becomes improvisational. This does not necessarily mean that it becomes "action painting," but that it has no foreordained point of origin, no guaranteed resources or clear necessity. The uncertainty and instability of identity that Harold Rosenberg attributed to de Kooning[2] manifests itself not simply through quasi-universal gestural activity, but through a sense of the inability to create a satisfactory illusion, a meaningful fiction. When the world's lack of universal values already makes it seem "fictional" in itself, it can hardly sustain a fiction that seeks to articulate what is universal in it. Golub's figures, whether primitive, classical, or contemporary, are the incomplete fictions of a quasi-universal humanity. They are a "grand gesture" of artistic thought in a period when modern thought in general has failed to invent a satisfactory fiction of autonomous identity.

Existentialism offered the last significant instance of such a
concept, and Golub acknowledges a great debt to it. Yet his existentialism offers a sense not simply of man, but of man as artist. I have said elsewhere that "all of Golub's figures can be read as self-images of the artist in 'critical' condition, in danger of being falsely and facilely dismissed as 'romantic'";[3] yet it is the romantic conception in which the artist proposes a mythical, miraculous, universal validity as a model for autonomy that Golub takes as his point of departure. His romantically autonomous artist, however, is subject to the modern world, which denies the universal validity and power of projection of his art. The grand physical scale of Golub's paintings, and their matching fictional attempt at world-historical comprehensiveness (such comprehensiveness can only be fictional), are his response to this negation of his art and his autonomy by the world. As I hope to show, the response is not what it seems. Golub demonstrates not autonomy, but its disintegration; not the redemptive power of fiction, but its power to negate reality without offering any utopian alternative; and not a new normative universalism, but a very contemporary sense of the abnormality of the particular, an abnormality that shows up every demonstration of the normative as absurd.

The romantic artist traditionally has a rather heroic position. For Friedrich Nietzche, as artist "man has once again become master of *'material'*—master of truth." Thus "he enjoys himself as power, he enjoys the lie as his form of power." The lie of art is "the great means of making life possible, the great seduction to life, the great stimulant of life," and art is "the only superior counterforce to all will to denial of life." It offers *"redemption of the man of knowledge . . . redemption of the man of action . . . redemption of the sufferer."*[4] For Nietzsche the problem of becoming an artist is the problem of learning to affirm existence, of overcoming the will to deny life. What makes the problem harder to solve is the recognition that in "the highest state of affirmation of existence . . . the highest degree of pain cannot be excluded: the *tragic-Dionysian* state."[5]

While the problem is the point of departure of Golub's art, clearly he has not solved it. A modern rather than a romantic artist, he can neither believe in nor experience art's redemptive power, the power of its lie, for he understands the greater power of the will to denial of life in the modern world—a will to denial that takes the subtle yet devastating form of disbelief in normative universalism. That disbelief is the source of "the

highest degree of pain," a pain that cannot be excluded from art but that cannot be overcome by it either. This may be appropriate within Nietzsche's concept, but what is not appropriate is that the modern tragic state is only ambiguously Dionysian, as Golub's own would-be-Dionysian dervish principle shows. The will to denial of life remains implicitly uppermost in modern art. In romantic terms, modern art fails; it redeems no one. Yet for Golub to record a civilization is in some way for him to redeem it, not simply by making it part of the eternal record. To record is rather to create a fictional essence, a magical source of power. It is to affirm a possibility for the civilization, if not to say that the civilization affirms existence.

The postromantic artist has two options: either to celebrate the science-fiction world, or to articulate the state of the self—the possibilities of selfhood—within it. For Golub, the significance of the choice is clear. It means, in Nietzsche's words, either to become one of the "artists of decadence, who fundamentally have a *nihilistic* attitude toward life, take *refuge* in the *beauty of form*," or to show "the *terrifying*, the *evil*, the *questionable*."⁶ Golub can either "halt shortsightedly at what is closest at hand," celebrating "those *select* things in which nature has become perfect, in which she is indifferently *great* and *beautiful*," or he can become a "tragic artist," accepting, even having a *"preference for questionable and terrifying things."* For Nietzsche, such preference is "a symptom of *strength.* . . . *Pleasure* in tragedy characterizes *strong* ages and natures. . . . It is the *heroic* spirits who say Yes to themselves in tragic cruelty."⁷

I have deliberately used quotations from Nietzsche to describe Golub's dilemma—what choice he has made is clear—because while he is not a romantic artist, he understands modern art romantically. Rather than seeing it in conventional art-historical terms as a period of so-called experimental style, he locates it on a horizon of romantic expectations. Golub understands art not as a stylistic phenomenon but as a visionary one, and he sees modern art as the opportunity for a vision of the modern world—in fact, he understands all art as one way or another offering a vision of its world, if only metaphorically. Thus, for Golub, Donald Judd is the technological artist par excellence: Judd takes "refuge" in the "beauty of form," but it is the beauty of technological rather than natural form, as is appropriate in a science-fiction rather than a romantic world. On the small scale of his "specific objects" Judd realizes the indifferent perfection and nihilistic attitude of technology. He articulates the technological imperative in

ideal terms, and his sculpture fits seamlessly into the tech-
nological landscape. It does not look out of place in the science-
fiction world, as Golub's paintings do. The two oeuvres might
be said to articulate the choice offered us by the science-fiction
world: become obedient, technologically manipulated and em-
powered, or suffer, and futilely and stupidly (however heroi-
cally) seek a power of one's own.

Golub's development occurs in two grand phases. The first
runs from the early '50s to the late '60s; it offers an exis-
tentialist, "suffering" Golub, slowly (sometimes one thinks re-
luctantly) overcoming an experience of self-disintegration in
the course of articulating it. The second occurs from the late
'60s, when the Vietnam war becomes Golub's objective correla-
tive, to the present day. It is in this phase that Golub finally
achieves true tragic consciousness and becomes as much of a
tragic, modern American artist as he will ever be, and perhaps
as it is possible to be considering the lack of tragic romantic
thinking in this country since the 19th century. The existen-
tialist paintings of the first phase explore the cruelty of the self
in the situation of self-loss, while the activist paintings explore
the cruelty of history in the situation of American decadence.
From the overt disintegration of the self Golub turns toward
the covert, more subtle sense of disintegration experienced by
our society, which hardly knows how to connect events occur-
ring on its periphery, the foreign war through which it thinks
it affirms its power, with its feelings of self-erosion and shame.

Ideologically, I distinguish these two major phases as exis-
tentialist and activist; stylistically, they can be seen as pre-
theatrical and theatrical. In the first phase Golub struggles to
build a sufficiently strong sense of self to create tragic theater,
a theater that operates on the "world stage." He can only move
to the world-historical, activist phase when he has created a
stage across which the monstrous self he pictures can move, as
on cothurni. The pretheatrical works are somewhat stilted
in comparison to the theatrical works; Golub's attempt to
dignify—classicize—his monstrous figures is a bit forced. Yet
the classical offers Golub a stage for the self, and becomes a
stage for the world—a stage on which the world first appears
in its most elementary form, in the "everyman" kind of produc-
tions represented by the "Vietnam" paintings. Here Golub
creates tableau theater. I think it worth noting that the origi-
nal title of this series was "Assassins"; Golub moves from
a generic to a historical title, suggesting the double, transi-
tional function of the works. On the one hand, the figures in
these paintings are the first successful—integrated—selves in

Golub's art, soldiers though they may be. On the other hand, they represent the first truly objective paintings in Golub's production. While they certainly continue to show the self as an issue, they are oriented outward rather than inward.

Only with the "Mercenaries" does Golub create authentically dramatic theater, involving conflict between individuated characters instead of just members of a tragic chorus. The figures in the "Vietnam" pictures seem to have little sense of identity apart from their social identity as soldiers, but in the "Mercenaries" Golub moves beyond this depiction of types, offering men with greater complexity of identity. For one thing, their roles are ambiguous: part civilian, part soldier. This ambiguity gives them a richer content than the "Vietnam" soldiers possess, and it is also the secret to Golub's sense of self when it finally arrives on the world-historical scene. Golub's self publicly fights others to establish its private identity, and it finds its individuality in belonging nowhere, in no fixed social role. It is a highly competitive, exaggeratedly masculine self that knows itself only in action—that integrates itself through aggression. It forges its unity in violence.

Heinz Kohut has written:

> A person must possess a modicum of stable self cathexis in order to be able to give himself over to the artistic reality of the make-believe. If we are sure of the reality of ourselves, we can temporarily turn away from ourselves and can suffer with the tragic hero on the stage, without being in danger of confusing the reality of our participating emotions with the reality of our everyday lives. People whose reality sense is insecure, however, may not be able to abandon themselves easily to artistic experience; they must protect themselves, e.g., by telling themselves that what they are watching is 'only' theater, 'only' a play, 'not real,' etc.[8]

For the near-twenty years of his pretheatrical phase, Golub struggles to move from "the stage of the fragmented body self, i.e., the stage of psychologically isolated body parts and of their functions (auto-eroticism)," to "the stage of the cohesive body self (narcissism)."[9] He effects this change through a "Theater of Cruelty," to use Antonin Artaud's term, and I think it is worth quoting Artaud at length to show just how dependent on him Golub is, just how completely Golub means to realize Artaud's idea of theater as an "excruciating, magical relation to reality and danger."[10]

Everything that acts is a cruelty. It is upon this idea of
extreme action, pushed beyond all limits, that theater must
be rebuilt. . . .

The theater must give us everything that is in crime,
love, war, or madness, if it wants to recover its necessity.

Everyday love, personal ambition, struggles for status,
all have value only in proportion to their relation to the
terrible lyricism of the Myths to which the great mass of
men have assented.

This is why we shall try to concentrate, around famous
personages, atrocious crimes, superhuman devotions, a
drama which, without resorting to the defunct images of
the old Myths, shows that it can extract the forces which
struggle within them.

In a word, we believe . . . that the image of a crime pre-
sented in the requisite theatrical conditions is something
infinitely more terrible for the spirit than that same crime
when actually committed.

We want to make out of the theater a believable reality
which gives the heart and the senses that kind of concrete
bite which all true sensation requires. In the same way
that our dreams have an effect upon us and reality has an
effect upon our dreams, so we believe that the images of
thought can be identified with a dream which will be effi-
cacious to the degree that it can be projected with the
necessary violence. . . .

Hence this appeal to cruelty and terror, though on a vast
scale, whose range probes our entire vitality, confronts us
with all our possibilities.[11]

It is only when Golub offers us pictures of war crimes, the
myth of man as monstrous and criminal, that he achieves a
narcissistically satisfactory sense of identity, a vital sense of
integrated self. Golub wants the concrete bite of true sensa-
tion. Only through his theater of cruelty and terror, by staging
what Artaud calls "a spectacle of temptation"—temptation to
violence—does he realize the assertiveness through which the
self integrates its disparate parts, acquiring an elementary
sense of significance. It is because this sense of significance is
so hard to come by that the self has to manifest itself dramati-
cally through atrocious historical crimes, extreme circum-
stances that project it as hero (antihero). Such heroism, am-
bitious to be mythical, holds within itself a very simple drama
of self-recognition, of narcissistic self-discovery.

In his pretheatrical phase Golub produces a theater of frag-

mented bodies and thus of fragmented selves, figures dismembered to show their narcissistic suffering. His works from this period, which includes the classically inspired preactivist works, depict the change from a sense of the body as amorphous and broken into parts to one of a body that is more rather than less whole. It and the sense of self bound up in it, the "body self," are never really complete in Golub's work until it moves onto the historical stage, and even then it shows signs of its previous disintegration, especially in its continuing grotesqueness. During the classical phase Golub's figure gradually acquires limbs, a head, and a torso that, although it falls short of being truly classical, still has a tendency toward balance. The body looks as if it will catch itself before any fragmenting fall. Nietzsche has said that "to be classical, one must possess *all* the strong, seemingly contradictory gifts and desires—but in such a way that they go together beneath one yoke," demonstrating "the classical power of equilibrium."[12] Because Golub's classicism is, in Nietzsche's distinction, "reactive" rather than "conclusive," it sometimes seems that he is deliberately undermining classical equilibrium, that his fragmentation of the classical body self is a painful, spiteful demonstration of the impossibility of its existence in the modern world. I believe that this resentful display is one reason that Golub had such a long and difficult time finding his way to the explicitly historical.

Resentful fascination with regression is a necessary consequence of what I would call the principle of maximal, cynical frustration, which is central to Golub's entire first phase. I conceive of this principle as derived from yet contrasting with Kohut's conception of the "principle of optimal frustration." Kohut has written that "tolerable disappointments in the preexisting (and externally sustained) primary narcissistic equilibrium lead to the establishment of internal structures which provide the ability for self-soothing and the acquisition of basic tension tolerance in the narcissistic realm."[13] But intolerable disappointments lead to a pessimistic or cynical attitude, which precludes the restoration of basic narcissistic equilibrium. Instead, tension is aroused, explosively fragmenting the self. There are no internal psychic structures to hold it back, to channel it, to let it displace itself. The monsters of Golub's first phase cannot handle tension, which is why they fragment, and their fragmented state is an essential part of their monstrousness. Golub's figures, maximally frustrated and thus unable to control tension, become permanently crippled by reason of their fundamentally disappointed state.

They are so regressive that they are "psychotically" unreal,
"insane" in their very bodies.
Each of the monstrous figures of Golub's first phase, includ-
ing those in the "Gigantomachies," is a "self-object," that is, an
object "either used in the service of the self and of the mainte-
nance of its instinctual investment," or "experienced as part of
the self,"[14] which is presented in all its narcissistic vulnerabil-
ity. This vulnerability is articulated through a sense of the
body as a set of fragments that are only loosely cohesive. Of-
ten, a temporary fixation on certain parts of the body enlarges
them into a momentary dominance, "spoiling" them with the
illusion of power; such unexpectedly central fragments are
an important factor in the sense of grotesqueness generated
by the figures. This is particularly evident in the "Colossal
Heads" series (1959–60) and in *Colossal Torso* (1959). Inci-
dentally, a comparison of the "Colossal Heads" works, includ-
ing a *Head* from the late '50s, and a 1963 *Head* shows, like
the *Horse's Head* and *Burnt Man* pictures examined in the
last chapter, a shift from primitive (inalienably regressive
and frustrated) to classical style (reluctant progress to self-
integration). This can now be clearly understood as a change
from a state of near-chaotic disintegration to one of pos-
sible but not quite actual narcissistic equilibrium or self-
centeredness. Complete equilibrium, of course, is not a social
possibility in the modern world.

Nietzsche has pointed out that the truly tragic artist achieves
amor fati (love of fate), "a Dionysian affirmation of the world
as it is,"[15] only by overcoming nihilistic pessimism, with its
cynicism-engendering depressive affects.[16] Golub's "Mediter-
ranean-colored" paintings, of which the "Horsing Around" se-
ries is the latest manifestation, superficially articulate this
Dionysian affirmation of the world as it is; but for all his talk of
the (narcissistically) soothing effect of the Mediterranean ex-
perience on him,[17] the fact of the matter is that since these
paintings do not deal with the historical world as it is, they can
hardly show tragic-Dionysian acceptance of it. For me, Golub's
Mediterranean-colored works are anomalous—except when
they become garish and thus grotesque, as in the "Horsing
Around" series. It is just because they do not show the world
as it is that they belong to the first phase of Golub's develop-
ment, the pretheatrical phase of crippled narcissism. The
work of the first phase shows an incomplete overcoming of the
pessimism wrought by narcissistic vulnerability and the lack of
an integrated self. In the later, classical stage of this phase,
the mutilated self-objects of the primitive works become more

idealized; Golub's classicism can be understood in terms of what Kohut calls the *"passage through the idealized self-object."*[18] But Golub seems deliberately determined to wreck any sense of ideality, and to demonstrate its illusory character. In part this abusive disruption of the ideal is a means of achieving a historically real, functional, cohesive self by dismissing any mythical model of identity. Such models obscure the everyday problems of self-integration and -realization. Indeed, it is only when Golub fully accepts the reality principle, in his activist pictures, that the self-objects he paints become truly cohesive, though they remain vulnerable to violence—the violence of their own moods, and that of the situation of war in which they have chosen to enact their destinies. Their vulnerability and violence show how subject to disintegration they continue to be, from within as well as from the world.

Sometimes one thinks of these later figures as thinly disguised overlays on Golub's earlier monsters, showing in their contemporary physiognomies signs of the more explicit vulnerability and fragmentation of the earlier figures. These signs include the potentially dismembering cuts with which Golub marks his theatrical paintings. The cuts give the works the buried, excavated look of the classical sculpture that so interests Golub; it is as if the paintings had been recovered from the past in a broken, fragmentary condition. They seem to have emerged from the depth of myth, to be as unfathomable as the ultimate. The cuts are also another aspect of the works' "staginess," making them theatrical in Artaud's sense—evocative of cruelty and terror, physically "criminal." Finally, they show what might be called a regressive auto-eroticization of the painting. If, following Kohut, we assume the autoerotic character of the broken-off fragment, which is what the cuts make these paintings resemble, we can understand all the more why there are so few women in Golub's art, and why they appear as monstrous and victimized as the men—completely equal. Golub's pictures are imbued with a spirit of masculine self-referentiality, the self-love of the male spirit. His cuts are like ritual scars initiating his works into tribal manhood. As Joseph Dreiss points out, even Golub's sphinxes are male;[19] the female must be kept out, even eradicated, because she interferes with male self-esteem. (There is one female sphinx, the exception that proves the rule: that Golub's is a male-dominated, male-celebratory art.) Kohut has written that when the superego does "not possess the requisite exalted status," self-esteem can never be adequately raised.[20] Golub is savagely struggling to exalt himself, to be-

come his own father, and the peculiarly hypochondriac pic-
tures of the first phase proclaim a frustration of self trying to
cure itself through male egomania.

In 1887 Nietzsche described the modern art of the time in these terms:

> [It is] an art of tyrannizing—a coarse and strongly defined logic of delineation; motifs simplified to the point of formulas; the formula tyrannizes. Within the delineations a wild multiplicity, an overwhelming mass, before which the senses become confused; brutality in color, material, desires.[21]

Describing Freud's *"petite bourgeoisie"* attitude to modern art, Kohut remarks:

> It seems likely that Freud's rejection of modern art goes hand in hand with his reluctance to immerse himself in archaic narcissistic states . . . and with his failure to recognize the importance of the vicissitudes of the cohesion and disintegration of the self—topics that, as the leading psychological tasks of our times, had entered into the work of the pioneering artists of the day long before they became targets for the investigative efforts of the scientific psychologist.[22]

Combining Nietzsche and Kohut one recognizes Golub's figure, whatever its variations, as a simplified, tyrannizing formula articulating an archaic narcissistic state. A brutal, sensuously confusing, obviously material mass within a logic of figural delineation (a logic tending to caricatural simplification), it represents the disintegrated state of the self. Golub continues the fundamental work of modern art—the disclosure of the vicissitudes of the self in the modern world. While he is not a pioneer in his treatment of the theme, he has the courage of the pioneer in continuing to attend to it at a time when most art has turned away from it. Along with the neoromantic or neo-expressionist European artists who were also neglected until recently (in my opinion because of the dominance of the technological ideal of art, whether in Pop, minimalist, conceptual, or innocently photographic form), Golub is one of the few artists dealing directly with the modern sense of self. To articulate that disturbed sense of self is likely to remain, overtly or covertly, the task of art until a new universal myth of normative humanity is created.

Golub's technique is an essential part of his investigation of

"the vicissitudes of the cohesion and disintegration of the self." Established early in his development, the technique remains essentially the same: a primitive brutalization of the pictorial surface gives a disintegrative appearance to all forms depicted on it. Golub's perverse version of "alloverness," this essentially corrosive technique, together with the fragmenting cuts, give us a painting whose materiality is powerfully self-evident, but also a painting with extraordinary symbolic potential, unusual metaphoric carrying power. It is really a traditional expressionist technique, but it is carried to an absurdist extreme.

Golub once quoted Franz Kafka's response to the assertion that Picasso was "a willful distortionist." "'I do not think so,' said Kafka. 'He only registers the deformities which have not yet reached our consciousness. Art is a mirror, which goes fast, like a watch—sometimes.'"[23] Golub's technique distorts from inside outward rather than, as one often feels with Picasso, from outside inward. In this way Golub can register not only the profound deformities that have not yet reached our consciousness (yet which we take for granted in everyday life), but their unconscious personal significance. Golub has said that "the contemporary artist must structure a personal art in what is ever more evidently a technologically advanced mass culture."[24] His calculated crudity is a grotesque sign of the personal in mass culture, a dirty gesture of resistance— like graffiti, a kind of visual guerilla warfare in a society seeking technologically clean living. It is an essential part of Golub's sense of "the provocation of art,"[25] an instrument in his search for the "rawer reality that science and institutional instability have seemingly divested us of."[26]

Here are some of Golub's own descriptions of his technique.

My methods are reminiscent of carving techniques, the removal and chipping away or carving out of surfaces, rebuilding (repainting) and then carving into the surfaces again. This effect is achieved by heavy overlays of paint which are then reduced by solvents, carved by sculpture tools. What remains is a 'sculptural' image of man, ravaged and eroded but still retaining its essential existential structure.[27]

My process then involved building up in heavy lacquers, cutting down with solvents, rebuilding, etc. I might spend several months doing this. Eventually I got what I wanted: an extremely eroded form that still retained a resemblance to an organic human form, but was quite implacable in the fact that it was eroded. . . . Now that color has, in a sense,

a certain kind of ornamental look, but it's stripped down and inflected in a particular way so I don't view it as ornament but as a structure of the thing seen in an attempt to put the figure into stasis; that is, to make a kind of monumental sculptural form. . . . I'll tell you what I did in that instance. (This is the first time I'm revealing this terrible secret.) The painting has an extremely complex surface. It looks like there are bits of color stuck in it throughout. Well, you just can't stick bits of color in, so what I did was, I would work on two paintings simultaneously. They wouldn't necessarily relate, and while they were wet I would stick them together! Then I would try to pull them apart! Well, I tell you, many a morning or afternoon, I would spend hours trying to pull them apart, because I would let them stick for hours first and the paint would really congeal. In pulling them apart pieces from painting A would stick to painting B and pieces of painting B would stick to painting A. Eventually I would wrench them apart. Then I would throw on this solvent I use, turn on the fan to get rid of the awful odor and scrape off more of the paint. When I got through, which might be some weeks later because that was only part of the process, I would end up with a very complex surface. What did I get? The 'Seated Burnt Man' shows a kind of burnt figure and that color in it is actually in a curious way a kind of physical analogy to burnt flesh. I was able to get it through this insane technique.[28]

I painted a series of large single figures, athletes, warriors, philosophers, etc. The paintings were constructed in lacquer, thick coats of paint, rebuilt and cut down (eroded with solvents) many times until they resembled large sculptured fragments. What had once been iconic or totemic was largely resolved within the structure of these monolithic figures.

Since 1962, I have principally been engaged in setting these figures in motion, often a violent encounter of two men. I attempt to indicate some kind of history or action, man in time, man under stress. The technique has changed accordingly, the paint (now Liquitex) is more broken, more inflected. . . . [29]

There are other descriptions, but they all make the same point, show the same fascination with painting "in a rather rough way," as Golub has said approvingly of James Ensor.[30] Such a technique is clearly part of Golub's interest in the primi-

tive, his attempt, to use the language in which he has described Picasso's *Guernica*, to have "primitive elements coincide and jar with sophisticated usage."[31] It is not clear to what extent Golub is aware of precedents for his technique; he doesn't seem to realize that his "terrible secret" of sticking together, then pulling apart, two paintings is a version of Surrealist decalcomania. His methods, however, are historically acceptable within a context going back to the origins of modernism. Thus Gauguin advised a friend: "Don't polish too much, the subsequent hunting out of endless refinements only impairs the first draft; that is the way to let the incandescent lava grow cold, to petrify your foaming blood."[32]

Of course, Golub carries his technique to an extreme—he invariably does whatever he does with an existentialist sense of the extreme—but he still doesn't seem far from Kokoschka's description of himself working on the "black portraits," painting "'with the scalpel,' in an attempt to liberate the inner self from the encumbrance of the fleshly surface."[33] Kokoschka gives us a scarred surface while Golub's surface blisters as well as scars, but the essential effect is the same. Golub has come to scrape his paintings down with a meat cleaver—a very macho gesture. The result is a fleshly surface that in and of itself signifies the disintegrated, eroded inner self. Indeed, Golub seems to update Kokoschka but not to be essentially different from him. If Kokoschka's polychrome clay bust *Self-Portrait as Warrior* (1908), executed when he was 21 but depicting a much older man, may be said to have been made during the heyday of Expressionism, perhaps Golub's figures, still relentlessly pursuing the same point, belong to its old age. Henry Schvey has described the work:

> The face is distorted with bumps and hollows and the mouth is agape with an impassioned cry similar to the faces of the actors in his first play. With its sunken eyes, blue-veined cheeks, and hostile yet terrified expression, it conveys the same mixture of confusion, fear, and brutality as the Man (also a 'Warrior') in *Murderer Hope of Women*.[34]

This same mixture of confusion, fear, and brutality is evident in Golub's warrior figures, who are obsessed with nothing but their own power and who exist, in frustration, in a world that makes them feel they have none.

One last quotation, from William Blake's *The Marriage of Heaven and Hell*, makes the romantic/expressionistic origins of Golub's technique transparently clear:

This I shall do by printing in the infernal method, by cor-
rosives, which in Hell are salutary and medicinal, melting
apparent surfaces away, and displaying the infinite which
was hid.

Compare this with Golub's description of the technique he used
to make prints early in his career, from 1949 to 1951 and from
1953 to 1956: "a very complex technique—drawing, redraw-
ing, destroying with acid or blade (considerable cutting into
the surface), redrawing, etc."[35] He acknowledges that this
technique antedates his painting technique by several years.
For Golub as for Blake, the corrosive technique reveals the
infinite, but for Blake the infinite displayed is positive; with
the same negative technique, Golub finds a negative infinite.
Blake sees the technique of disintegration as a means of re-
generation, but Golub uses it nondialectically to confirm the
disintegrated character of what the technique helps depict.
Blake always had a greater sense of paradox than other ro-
mantic artists, of course, but even so, times clearly have
changed. The "infinite" that Baudelaire said was the goal of
romanticism[36] has been made finite by history; its modern ver-
sion is the vertigo experienced by the disintegrating modern
self. Corrosive technique has come to mean lack of cohesion
rather than the possibility of a cohesive new identity. For
all their contradictoriness, Golub's abnormal surface and "in-
sane technique" make sense in modern art. As an antidote to
the modern world's secretly insane, technologically smooth,
"ideal" surfaces, they are perfectly sane.

Nietzsche has written that "the priest wants to have it under-
stood that he counts as the highest type of man, that he
rules—even over those who wield power—that he is indis-
pensable, unassailable—that he is the strongest power in the
community, absolutely not to be replaced or undervalued."[37]
Replace the word "priest" with the word "artist," and it be-
comes clear that the priest is a kind of artist—a surrogate
artist. Nietzsche continues:

What gives authority when one does not have physical
power in one's hands (no army, no weapons of any kind—)?
How, in fact, does one gain authority over those who pos-
sess physical strength and authority? . . . Only by the
belief that they have in their hands a higher, mightier
strength—*God*. Nothing is sufficiently strong: the media-
tion and service of the priests is *needed*.[38]

It is worth noting in this context the perennial claim that the priest is God-like, divine in power. Nietzsche also writes:

> The psychological logic is this: When a man is suddenly and overwhelmingly suffused with the *feeling of power*— and this is what happens with all great affects—it raises in him a doubt about his own person: he does not dare to think himself the cause of this astonishing feeling—and so he posits a stronger person, a divinity, to account for it.
>
> *In summa*: the origin of religion lies in extreme feelings of power which, because they are strange, take men by surprise: and like a sick man who, feeling one of his limbs uncommonly heavy, comes to the conclusion another man is lying on top of him, the naive *homo religiosus* divides himself into several persons. Religion is a case of '*altération de la personalité.*'[39]

So is philosophy—for Nietzsche, the philosopher is "a further development of the priestly type"—and so is art. The artist is originally a priestly type, laying claim to special, divine power in order to intimidate and gain authority over physically strong communal authority. Golub's obsession with the image of physical strength can be understood within this context as an important example of the artist's *ressentiment*.

For me, Golub's self-images—self-portraits in disguise, with the artist revealing himself as the prototragic man who has not yet achieved *amor fati*—begin with his pictures of priests. Their most codified, articulate expression is in the sphinx pictures (1954–56). With the "Birth" pictures (1953–57; these depict birth as a disintegrative rather than a creative act), the "In-Self" pictures (1953–54), and other affiliated works, the spiritual self-portrait reaches an ironical preclassical climax. The classically inspired works—from the "Philosophers" through the "Colossal Heads," the boxers (1960–61), the fighting figures (beginning in 1962), and the "Gigantomachies"— seem to me transitional to the explicitly world-historical activist pictures. They are anticlimactic, too, since they do not decisively stop the disintegrative process the primitive works describe, and may in fact just show it in a more refined, estheticized, and so inauthentic way. Looked at from the perspective of what was to come, the classical works do suggest the buildup of power within the archaic narcissistic states they render; but while the principle of cynical frustration seems to be less operational in these figures than in the earlier primi-

tives, that doesn't mean the figures are whole in themselves.
They simply look less "thwarted" or physically frustrated.

The disparities between the primitive and classical styles of
the pretheatrical phase clearly go beyond their obvious formal
differences, but both sets of figures can be understood as suf-
fused with an uncontrollable feeling of power, a feeling that
makes them monstrously double. They seem to become the
strong self they in fact are not. They generally possess all the
attributes associated with strength (mass, size, a ferocious
bearing), but what they really represent is the self disinte-
grated by its sense of power. "Naive" in more ways than one,
these characters have nothing of the knowing attitude of the
theatrical figures who act on the stage of the world-historical.

The pretheatrical figures are Golub's first artistic creations.
In a sense, his exploration of primitive and classical art is
undertaken in order to experience the most elementary forms
of art-making, as well as the sense of mastery—coming from
rudimentary mastery of material—that making art can give
one. Primitive art, it should be recalled, is understood to be
the root of art per se, while classical art is understood to be
the root of Western art. Golub's first monstrous figures, then,
represent his root experience of the power of art. In a way,
they are almost too much the artistic creation—obviously in-
vented, weirdly decorative, self-consciously "art." Clearly,
artmaking for Golub is the powerless self's last-ditch attempt
at power. It is an act of no real authority in the world, but of
some authority for the individual. Thus it has a pessimistic or
"cynical" element, a built-in frustration and disappointment at
the lack of real worldly power.

This feeling of frustration is most evident in Golub's primi-
tive paintings: *The Bug (Shaman)* (1952), *The Princeling*
(1952), *Torsion* (1953), *Thwarted, Bird Man* (1953), *Anchovy
Man I* (1953), *Tomb Figure* (1953), the "In-Self" series, *Bone
Fetish* (c. 1953), *Hamlet* (1954), *Crawling Man I* and *II* (1954),
The Prodigal Son I and *II* (1954), *Entombed* (1954), *Family
Group* (1955), *Dead Bird II* (1955), *Damaged Man,* and *The
Violin Man* (1954). For all their variations, these primitivist
works have the same fundamental construction. First, a con-
frontational frontality is involved. The figures are so close to
the picture plane they seem able to step through it. As though
to force the issue, some of them become colossal in relation to
the picture space. Second, a raging, ragged surface is often
created, involving disjointed lines, crude texture, and a gen-
eral sense of dissolving substance. The harsh texture creates

an aura of destructiveness around the figures; like their confrontationism, this aura violates our sense of pictorial integrity. Finally, the figures tend to be incomplete, fragmented. This finalizes not only their misshapenness, but also our sense that they don't belong in a picture. They remind us of broken sculpture, and to the extent that they are sculptural, they belong in real space. More importantly, they are so grotesque that they defy our unconscious sense of pictorial fiction. As ugly as reality, they violate our basic sense of art as soothing. In their narcissistic rottenness, these creatures undermine any idea of the closure (the "unity") of fiction; they carry out Artaud's program of "alchemical theater" as a "mirage" of communication in the disguise of a "spectacle" that engulfs its audience rather than sealing itself off. The figures become a "'dialectical' sequence of . . . aberrations, phantasms, mirages, and hallucinations."[40] Their ambition is to overwhelm rather than to become the sacred idols in a sectarian cult of contemplation.

"In self," Golub finds a primitive monster, a metaphorical presence self-indulgently physical. Yet to me, the figures of the '50s are compromised by the relatively conventional size of the canvases (ranging from 2 to 2½ feet high by 5 to 6 feet wide). The size seems to confirm the "infantilistic" character of these pretentious monsters. Their retarded look suggests that their grandeur is a delusion, their monstrousness pretend, their sense of omnipotence the classic infantile illusion. The canvases of Golub's theatrical phase are theatrically scaled (and freely hanging, like curtains for a world stage), as if to confirm that the figure has at last grown up to recognize the reality of its powerlessness. It is as though Golub goes from one extreme to another, from representing a feeling of absolute power to a feeling of complete impotence, the one illusory, the other realistic. He is unable to regulate the feeling of power, which is what finally keeps him from Dionysian *amor fati*, or makes it a reluctant, un-Dionysian accomplishment. We might say that the artist's form of power is the feeling of power invested in the making of art, in which it becomes numinously distant, a surrogate sense of power over the world. This is perhaps the ultimate artistic delusion. It does, however, allow Golub to reconcile the "allegorical" presentation of the infantile feeling of omnipotence (a fantasy concocted to overcome the painful feeling of disintegrated self) with the reality-oriented recognition of impotence. Paradoxically, it allows self-integration. The postarchaic state of the activist paintings

suggests an everyday sense of self within a grandiose artistic
context, signaling the union of opposite feelings of power.

Stylistically, Golub's presentation of the sphinx is varied. He
offers long, horizontal images, such as the sexually alert
Poised Sphinx (1954) and the proud *Prince Sphinx* (1955); vio-
lently textured images, particularly *Riddling Sphinx* (1955);
and the more conventionally scaled, monstrous images of twin
or doubled sphinxes, such as *Siamese Sphinx* (1954), *Prodigal
Sphinx* (1954), *Siamese Sphinx II* (1955), and *Ischian Sphinx*
(1956). It is worth noting, incidentally, that Golub's own father
died when the artist was fourteen; Golub grew up to "become"
his father, arrogating to himself a patriarchal identity as well
as a sphinxlike wisdom. (This wisdom is based on the fact that
the sphinx is an unsolvable mystery in itself, inherently in-
comprehensible in its very body.) Obviously, the sphinx paint-
ings deal with a mythical subject matter; but Golub tries to
give it a mythical import in Artaud's sense of the term, that is,
to make the sphinx symbolic of the determining force of ines-
capable primitive life forms. But where Artaud wanted the
myth to disrupt everyday consciousness by generating self-
consciousness—to confront everyday life with its primitive
substructure—Golub uses the mythical sphinx in a quasi-
Symbolist way, namely, to point to the unconscious content
without naming it, thereby keeping it tantalizingly mysteri-
ous. This is why, for me, the sphinx paintings are not quite to
the general point and confrontational method of Golub's art,
for all the novelty of his use of the sphinx image.

The sphinx pictures readily lend themselves to depth psy-
chological interpretation, but one does not have to go to any
great depth to recognize their belligerent character. Bellicose,
they become emblems of the warrior self through which Golub
first and enduringly becomes integrated. (Perhaps this is his
only real self; he is so desperate for a durable, manageable
feeling of power that he has to limit himself to a warrior iden-
tity.) But maybe the most important aspect of the sphinx is
that it is obviously monstrous, a hybrid of animal and human.
It has systematized its fragmentation, reconciled its opposites.
Golub's sphinxes show no sign of achieving a new sense of co-
hesive self, however; their act of synthesis is accompanied
by no transformative transcendence. The synthesis these
sphinxes effect is not dialectical, but simply codifies a state of
affairs in which the animal and the human coexist in the self, in
a dubious equilibrium in which neither dominates. The self has

not yet realized that "hierarchy of goals" or ideals, as John E. Gedo has called it,[41] that makes it a self—cohesive. The sphinx is perhaps Golub's most ferocious image because it symbolizes the stalemated, disintegrated self, the self frozen into its own bipolarity. And the doubled sphinx compounds the paralysis, articulating the frustration of the split self even more agonizingly. These are excruciating representations of what is conventionally called the dissociation of sensibility, a phenomenon that is seen as modern but that is in fact a split within the archetypal self—the archetypal split out of which the cohesive self may perhaps be born. At least these paintings show the self as split rather than fragmented in pieces, divided against itself rather than chaotic; in this way they represent an advance in self-esteem.

Golub makes explicit his interest in animal existence, totemically understood as representative of an element in the human psyche (he acknowledges the great influence of Freud's *Totem and Taboo* on his early thinking), in such pictures as *Bird Man, Anchovy Man, Dead Bird,* and *Female Rouge* (1953), a picture of a strutting dog. (A bitch, suggestive of Golub's patriarchal conception of women.) *The Bug (Shaman)* is a quasi hybrid. These animal images reach a kind of climax in the hybrid sphinx pictures. The sphinx images, I believe, are intended to act on the viewer in the same way as the violent texture of Golub's paintings: to generate immediate, shocking cathexis with the picture as self-object (and the sphinx is the ultimate self-object). This is a typically expressionist ambition, and an inherently risky one. The image is a kind of provocation of the unconscious, which may not respond—may read it as an obvious artifice of consciousness. It means to generate emotional engagement (and thus to exercise power), but may only arouse a feeling of curiosity, an elementary intellectual awareness. Golub's primitivist figures are always in danger of being read cognitively as freaks rather than responded to emotionally as symbols. They risk being reduced to historical curiosities, anachronisms, rather than growing into emotionally catalytic stimuli. In other words, it might be argued that the sphinx pictures fail because, unlike the classical figures, they are insufficiently "deantiquated." They may not have been made contemporary enough. Rather than becoming ambiguous modern presences, sufficiently existential to be truly evocative, they may be too clearly symbolic.

The point of the sphinx story, however, is not simply the sphinx's riddle, but its monstrousness. The inhumanness of the sphinx proposes the human as a mystery, and the creature's

riddle—about a being that walks on four legs at dawn, two
legs at noon, and three legs at dusk—describes man as an absurd, inhuman monster. Golub is interested in the sphinx because, indirectly, it is a way of getting at man the monster— the mythical being who changes pointlessly as life "progresses." Time and meaninglessness are evoked through the riddle, and the sphinx's violence is met by Oedipus' implicit violence, when she dashes herself to death after Oedipus has correctly given the riddle's answer. The story is of course one of human self-recognition and narcissistic self-discovery. The sphinx is the mother who gives birth to man in violent labor, and Oedipus the man who frees himself from her by identifying himself. The situation is archetypal, but the result is an "artistic"—narcissistic—success.

Hugo von Hofmannsthal has said that humanism, including the humanism of antiquity, will eventually come to "seem to us a paradisiacal episode, but absolutely an episode."[42] When that happens, the animalistic monsters that humanism repressed by asserting man as the measure of things will return, overwhelming the human self. The sphinx is one of these monsters. The fact that Golub's sphinxes are typically male not only shows that he himself identifies with the monster, is victim to a disintegrative feeling of monstrousness, but also, in a patriarchal view which sees the male human as emblematic of the species, asserts the monstrousness of being human in the contemporary, posthumanistic world. Hofmannsthal thought that humanism would become merely historical under the impact of the modern technological world, the science-fiction world that is being created. Paradoxically, Golub's male sphinxes are not only victims of this world, but symbolize it. In the original story, the sphinx is the predatory, phallic woman seductively consuming her lovers with an incomprehensible riddle which suggests that man himself has no place in the world, is a fiction from a scientific, cosmic point of view; the sphinx takes this scientific viewpoint, studying man as though he were a case history, reducing him to his biological destiny. In this light, man has as strange and unholy a physiognomy as the sphinx. He seems an inefficient, unmodern being indeed. Thus the sphinx reveals meaning upon meaning. It is among those artistic creations of antiquity that signals for all time the unfathomableness of man. Golub restores the sphinx to its full archaic grandiosity, both by doubling it and by presenting it as a tarnished dream of narcissistic thought.

Whatever else they might be, Golub's sphinxes represent self-division. As noted, they show us the self somewhere be-

tween fragmentation and cohesion. The sphinx is a protoclassi- cal image, taking us back to the Hittite/Egyptian world which stands to classical Greece and Rome as we stand to them; it is perhaps the most ancient self-image of man, showing him viewing himself as a monster barely separate from the animal. He is monstrous because he is neither clearly animal nor clearly human—and perhaps never can be clearly human, for the human is always secretly animal, uncivilized. Golub's sphinx images reveal that his art is finally about the sense of the past as it stands in relation to the present. It is a psycho- logical past as well as a historical past. It has been said that ontogeny recapitulates phylogeny, but Golub shows us that on- togeny reverses phylogeny, returning to the most unfathom- able and primordial to assert individuality. He seems to be say- ing that this is the only way individuality can exist today; one's humanity and individuality can take only perverse form in a science-fiction world.

From being hybrids Golub's figures become look-alike fight- ing giants and then aggressive soldiers. In whatever state, they act out their animality. From being inhuman monsters, they have become pathological humans, which is an advance of sorts; but for all the social reality of the activist work, its fig- ures remain primitive creatures. However institutionalized, they remain barbaric, and there is nothing in their social condi- tion to inhibit their savagery. Nonetheless, as I have argued, there is a kind of progress in the sense of the self in the activist pictures. And while the pretheatrical works identify man as divided between animal and human possibilities, from the '60s fighting figures on Golub's dialectical humanism also shows him as divided between solitary possibilities and communal ones. That is, the figures seem to be facing a choice, which they find it hard to make: to work out their self-integration alone, in inward isolation, for all the events surrounding them; or to achieve it through communal feeling. The conflict is clear in a number of the men in the "Mercenaries" series, who waver between fellow feeling and insular pride. This kind of ambiva- lent social contract shows that for all these figures' contempo- raneity, the demonic nature of the primitive monster is alive and well in them.

Speaking of the poet Mayakovsky, Trotsky said that his megalomania was so complete he became objective.

Harold Rosenberg, *Discovering The Present*

I learned to be hyper-alert to attacks from other men, and good at dodging them; I also learned that it is extremely important to avoid being conspicuous in the male war of all-against-all.

Joseph Pleck, *"My Male Sex Role—And Ours"*

There has been no change in fighting methods since Cain threw the first stone with intent to kill. Nevertheless, the actual and potential destructiveness of the atomic bomb plays straight into the hands of the Unconscious. The most cursory study of dream life and of the phantasies of the insane shows that ideas of world-destruction (more accurately, destruction of what the world symbolizes) are latent in the unconscious mind. And since the atomic bomb is less a weapon of war than a weapon of determination, it is well adapted to the more bloodthirsty phantasies with which man is secretly preoccupied during phases of acute frustration. Nagasaki destroyed by the magic of science is the nearest man has yet approached to the realization of dreams that even during the safe immobility of sleep are accustomed to develop into nightmares of anxiety. The first promise of the atomic age is that it can make some nightmares come true. The capacity so painfully acquired by normal men to distinguish between sleep, delusion, hallucination and the objective reality of waking life has for the first time in human history been seriously weakened.

Edward Glover, *War, Sadism and Pacifism*

The century might have been a good one had not man been watched from time immemorial by the cruel enemy who had sworn to destroy him, that hairless, evil, flesh-eating beast— man himself. One and one make one—there's our mystery. The beast was hiding, and suddenly we surprised his look deep in the eyes of our neighbors. So we struck. Legitimate

self-defense. I surprised the beast. I struck. A man fell, and in his dying eyes I saw the beast still living—myself. One and one make one—what a misunderstanding! Where does it come from, this rancid, insipid taste in my mouth? From man? From the beast? From myself? It is the taste of the century.

Jean-Paul Sartre, *The Condemned of Altona*

FOUR

MASCULINE AND

MILITARY PSYCHOLOGY

THE SOCIAL ACTIVIST PAINTINGS

With Golub's social activist pictures—fragments of an epic, details of a modern Iliad with an inconclusive plot, a narrative with neither beginning nor end—we witness his shift of attention from the self to society. First and foremost, he becomes the witness of the contemporary world. His witnessing of the eternal problem of selfhood is not renounced, however, but is subsumed as one of physiognomy: in the activist paintings one can speak of the dialectical physiognomy of Golub's figures, for their bodies are vectors that summarize the conflict between self-individuation and social necessity. (In the existential paintings the bodies are predialectical expressions of the pathos of narcissistic disintegration.) While Golub no longer flaunts the neurosis of modernity in the activist paintings, his figures still fight their own disintegration—but that disintegration is put in a worldly context. Just as the existential paintings are made under the sign of the Jewish Holocaust, the activist works are made under the sign of the nuclear holocaust. Its threat dissolves the difference between self and society, for the destruction of the body and that of the body politic become one and the same. The dead can no longer be subsumed in social history when no society exists any longer to give them symbolic immortality. The elementary state of being in the world is undermined; not only the self is now threatened with disintegration, but also the world that contains it. The threat of nuclear holocaust injures the world in its self-esteem, poses it a narcissistic problem that is insoluble, for there is no other world to mirror it satisfactorily. (Our world, it must be remembered, has no true, universal religion; we are too enlightened to be-

lieve in a mirroring and narcissistically satisfying heaven.) Golub's soldiers—allegorical personifications of pure, distilled aggression—are the disintegration product of a narcissistically self-injured society existing under the threat of total destruction.

They are also allegorical statements of masculinity, particularly in its most aggressive personification—the military man. Golub's activist paintings are perhaps the most profound demonstrations of masculine and military psychology in art today. In this respect, they are deeply significant from a feminist perspective. The works articulate—sometimes, one feels, sardonically—the myth of manhood with all its attendant rituals, especially that of proving one's maleness through battle, drawing blood to demonstrate one's strength. Golub shows how, in the very moment of doing so, one's aggression is socially appropriated. His activist pictures are "classic" male art, just as classical art can be understood as archetypally male, at least that part of it Golub draws on. One can speak of Golub's classically inspired art as the self-conscious beginning of his obsession with masculinity, with the "strong man."

This is especially the case in the "Combat" pictures (1962–65) and the "Gigantomachies," including the "Napalm" pictures (1969). In describing Golub's development it is customary to separate these '60s pictures from the '70s activist ones, which are seen as beginning with the "Vietnam" works. For example, two "cut" heads of the late '60s and the relatively abstract *Napalm Gate, Pylons* (both 1970), and *Shield* (1972) can be regarded as transitional. (It is worth noting that the "abstract" works, of objects—archaic still lifes, in effect—mark a pause between different figural types, namely the classical warrior monsters and the contemporary victimizing soldiers. The "abstract" works are Janus headed, looking back to the ruins of the classical and forward to the evils of the modern.) However, the real transitional works are the political portraits (1976–79). Compared to the rabidly destructive contemporary scenarios, the classical images are relatively satisfying narcissistically; yet their self-integration is only partial, and self-integration seems about to be swept away by the modern soldiers, who wear it like a light veil over their unrelenting destructiveness. Only in the political portraits does Golub present his first true "strong men"—men who are strong because they are completely self-integrated. Completely at one with the societies they represent, they are power incarnate.

To me these portraits, in which the emphasis is as much on the individual men as on the political power they symbolize,

are in part a reaction to feminism. They are inseparable from
the work of Golub's wife, Nancy Spero, a major, feminist artist
who depicts men as moral monsters. (Among other means, by
quoting their verbal attacks, often presented as "metaphysi-
cal" analyses, on women.) At the same time they remind me
strongly of Géricault's portraits of the insane, but where
Géricault focused on specific moments of madness, which he
capsulated into types, Golub depicts the progressive develop-
ment of a pathology—the pathology of power, or, more pre-
cisely, the pathological effect of the possession of near-absolute
power, power so absolute as to be utterly undisturbed by its
critics. These works are based on photographs, their depic-
tions heightened by caricatural tendencies toward the gro-
tesque. The sequences have a cumulative dramatic effect,
helped by the subtly staccato relationship of each portrait to
every other; in this respect, the series of Francisco Franco and
Nelson Rockefeller (all 1976) seem particularly successful.
Each man is shown from youth to old age and death. After a
youthful feminine appearance—less so in Franco's case—each
becomes more overtly masculine as he becomes more socially
powerful. His consolidation of social power means his consoli-
dation of masculine selfhood. Rockefeller, however, does re-
tain a certain "feminine" self-consciousness.

In a different if no less dramatic way, the soldiers in "Viet-
nam" and in "Mercenaries" and the police in "Interrogations,"
White Squad IV (El Salvador) (1983), "Horsing Around," and
Riots (1983–84) show the simultaneity of masculinity and ag-
gressive social power. Golub's activist creation of the powerful
male self completes his debunking of the classical ideal of
humanity. Or, rather, it shows a new tolerance for frustra-
tion. Disappointment with the ideal hides disappointment with
oneself for being unable to incorporate the ideal in oneself.
Strength must come another way: Golub's figures become in-
struments of social power, and so delude themselves into
thinking they are strong in themselves. The activist pictures
are not only the final kiss of death to the humanist ideal of
selfhood, but demonstrate the military mode of masculine self-
formation in modern society.

Three features become central to Golub's stylistic develop-
ment more or less from the "Gigantomachies" of the mid '60s
on: increase in scale; the creation of groups of people rather
than singular, totemic figures (the monstrous figure not only
gains a more everyday appearance, but is socialized); and the
increasingly violent handling of the art object itself, signified
by the use of cuts, for example in *Napalm IV* (1969). I have al-

ready discussed the cuts; here let me add that they suggest a potential integration of the picture and the environment, heightening the work's "barbaric realism." In *Napalm IV* the cut on the right and especially that on the bottom seem to signify the intrusion of the world. In view of Golub's preoccupation with his work's physical and conceptual longevity, the cut has an ambiguous meaning—partially masochistic, partially mithridatic. It is as though Golub makes a gesture of self-destruction to preempt the censorship he expects, and yet at the same time to experience a hint of it, and so to fortify himself against it. He implicitly expects his works to be censored because he expects his authentic, revelatory realism to be prohibited as socially destructive. It certainly attempts to destroy the old order (if not knowing exactly what a new order would be), and Golub enacts this nihilistic potential literally with his creatively destructive cuts. Yet in mutilating the painting, he is mutilating himself, or his substitute. The cut is a form of atrocity. It is a kind of literal trace of both the atrocities of the world in general and the atrocity the world might perpetrate on the work, censoring or destroying it to forbid its truth, its negative narcissistic function. (The picture becomes the mirror in which the world is seen darkly; it becomes whatever light there may be to make seeing possible.)

For all the superficial, neo-Mediterranean glamorousness of many of the activist pictures, with their Pompeian red grounds (and the motley crew in the "Horsing Around" pictures wear garish tropical holiday shirts), the cut dominates whenever it appears, which is often. Signaling the larger sadomasochism the work is about, the cut is even more seductive than the Mediterranean colors, for it is less incongruous; yet it is more jarring. The cut is like the coldly conceptual anamorphosis of a death's head within a warm paradisiac environment with all the right conditions for the fertilization of life. It is like the anamorphic skull in Holbein's *The Ambassadors.* Unconsciously, Golub is interested in Vietnam and El Salvador not only because they are especially scenic moments in the decline and fall of America, but because, like the Mediterranean, they could be such wonderful places to live if the political conditions were right. But of course they never are. The mark of Cain's knife has forever destroyed them as possible paradises.

Golub's activist pictures are not simply war pictures, but concern the sadomasochistic interaction between alien groups of people. (The sadomasochistic moment, I think, is inseparable from authentic expressionism, which is self-tortured art at its most dramatic.) These groups experience each other as

foreign, almost nonhuman, and so feel free to victimize each other, to treat each other inhumanly. The causes they fight for are usually evident: figures in the "Vietnam" pictures wear American uniforms, so presumably their purpose is clear, and the Latin American pictures are politically specific in meaning, their reportage a form of protest. But what seems to me more crucial is the works' psychosocial urgency—the degree of disturbance experienced by the human beings depicted, and the degree to which their social situation is disturbing, which correlate.

Edward Glover sees war "as a mental disorder of the group mind" originating in sadistic impulses, and regards it as a kind of "mass insanity, if you like, provided you remember that insanity is simply a dramatic attempt to deal with individual conflict, a *curative process* initiated in the hope of preventing disruption, but ending in *hopeless disintegration*."[1] As noted, the activist paintings do not escape the threat of disintegration. To contain his work, in a sense to clarify it, Golub expands it to theatrical scale, as if to give the chaos room to breathe. The transitional '60s' fighting figures and "Gigantomachies" are explosively disruptive, an effect brought under partial control by the expansive space in which it occurs. This continues in the activist paintings. They generally have more empty room than the existentialist pictures, suggesting a more manageable disintegration. But this is only an illusion. The most final disintegration possible occurs when Golub's figures fall in near empty, relatively unstructured, abysslike space, for that emptiness proclaims the groundlessness of their existence. Especially when it takes the shape of the Pompeian red wall, it is a strategy of artistic management that, however much it seems to make the figures seem etched in relief, so that they terrify us with the threat of coming completely into our world, unexpectedly confirms their psychosocial disintegration and "insanity."

Sadomasochism is simultaneously an enactment of self and one of social disintegration. It has been interpreted as the individual's social response to his or her loss of a feeling of personal humanity, to the experience of dehumanization. Every one of Golub's activist pictures deals with the sadomasochist response of the individual to the dehumanizing experience of war and use of power. The brilliance of the pictures is the way they trace that response as it becomes more explicit and universal, as it achieves almost normative status. In the "Vietnam" pictures we find it in hardened soldiers; later we find it in those who make, in Golub's phrase, "irregular use of power"—in

rioting civilians, for example. Here the sadomasochistic regression, initially reluctant, becomes complete, in a situation of rout such as that depicted in Goya's *Panic*. From dealing with a disciplined army Golub moves to dealing with increasingly undisciplined, paramilitary types (the irregular soldiers of the "Mercenaries" and "White Squads," 1982–84), and finally with the completely undisciplined mob. Mob rule shows the effect of the feeling of power on individuals perhaps most explicitly. Golub offers us what might be called psychohistorical paintings, in which the disintegrative effect of the feeling of power on human beings is depicted. In contrast, the figures who embody representative power in the political portraits do not fragment. They are, as I have said, completely self-integrated. Yet even these men cannot contain the power they seek. It overwhelms them, they become its creatures. They may remain entire, but they lose control, because they carry power beyond its socially sanctioned use.

Chaim F. Shatan has described the "deliberate sadism" of military training, "whose purpose is to inculcate obedience to command" and to generate "attitudes conducive to indiscriminate killing or being killed." Shatan states:

> Coercing someone to do something in obedience to another's order brings the *classic sadistic* dividend to the enforcer: the humiliation of the victim, who is being broken by his tormentor, his so-called trainer. . . . Incessant humiliation and degradation are at the core of the successful transformation of raw recruits into 'disciplined soldiers' who behave only as 'reflex actions,' or expendable cells, of a supreme organism, the Corps, soldiers described with satisfaction by military leaders from Hadrian to Napoleon as 'broken to military discipline.'[2]

Shatan calls this "the inevitable authoritarian reflex." Soldiers are "robbed of their masculinity, pillaged of their individuality," and "offered bogus manhood, counterfeit trappings of pseudo-virility, to paper over their reduction to utter powerlessness."[3] This reduction, as Shatan writes, means "nothing less than the dissolution of their ego boundaries," "regression and deindividuation" to the point of "infantilization." Private soldiers, by taking orders from unquestioned parental-type authority, forfeit their critical spirit.[4] In sum, the soldier-to-be endures "an assault at the roots of his civilized existence."[5] The resulting "naked and impotent rage, . . . frustrated ambitions, . . . hatred and despair" are "allowed only one outlet:

an implacable, relentless thirst for revenge."[6] By victimizing
where he has been victimized, the soldier recovers his stolen
manhood.

In a sense, Golub can be understood as trying to describe
the moment that transforms man into soldier, approaching it
through the reflex action in which the newly disciplined soldier
transfers to the enemy his own feelings of humiliation and deg-
radation. Through depictions of the behavior made possible by
this secondary transference, Golub recovers the original trans-
formation. He pinpoints the moral issues at stake both in mili-
tarism and in becoming a man in general. For generally speak-
ing, all men are broken to social discipline—to social use—in a
way that women seem not to have been. In showing the com-
plex process through which society breaks men by giving them
the power to kill, Golub offers not history pictures in the
conventional sense—panoramic scenes of "great moments in
history"—but history in Alberti's sense of *historia*, the nar-
rative whose descriptions hold implicit morals. Golub's kind of
history offers a revelation in which matter-of-fact historical
events disclose their moral meaning.

The activist pictures seem almost like illustrations for Sha-
tan's description of Basic Combat Training (BCT) and Counter-
Guerilla Training (CGT).

(1) In the controlled and manipulated environment
of 'Today's Action Army,' recruits 'identify with the ag-
gressors' (their trainers) and exchange their individuality,
for a feeling of *corporate* strength.

(2) Authoritative permission to do harm, and diffusion of
responsibility (up and down the chain of command), legiti-
mate violence and killing ('combat').

(3) *Separation from women* during training channels
the unfocussed sexuality of young recruits into *counterfeit
group manhood.* Among its central ingredients is a readi-
ness to act, with instant violence and without compassion.
(Such requirements facilitate the 'natural dominance of the
psychopath' in modern warfare.)

(4) The recruits' personalities are so re-integrated that
they perceive events through the prism of this new '*mili-
tary reality principle.*' Aspects of this new 'reality prin-
ciple' include the siege mentality and paranoid position of
combat—postures which enable soldiers to stay alive when
reality is psychotic and charged with death. Tenderness
and grief are discouraged by BCT and CGT. For grief and
tenderness are the most anti-martial sentiments: They do

not promote the unit's survival, much less its fighting strength, during warfare.[7]

The only difference—and it is a major one, giving great subtlety to Golub's activist pictures—is that by his handling of "gut language," or "body language," Golub suggests the possibility of grief and tenderness. Shatan observes that "war lords are adorned, embellished, triumphantly crowned, with the life stolen from the slaughtered,"[8] but Golub focuses not on the war lords, who have all the honor—Shatan points out that honor "has never been separate from rank"—but on ordinary soldiers. As awkwardly stated as it may be, Golub shows an equivocal humanity struggling to break out "expressively" in these men, and subtly demilitarizing them (if hardly rehumanizing them). Though this mood is never allowed to become explicit, from "Mercenaries" on it comes more and more to the fore.

Shatan remarks the military "tradition of removing civilian idiosyncracies and imposing a new [military] conformity."[9] Golub retains "civilian idiosyncracies," but only in the abbreviated form necessitated by military conformity. They become weird, idiosyncratic to the point of grotesqueness, and serve to register the profound effects of military conformity on individuality. Golub shows us how far the militarization of man can go toward turning individuals into psychopaths and sociopaths—toward creating "the man of 'ready violence,' unburdened by compassion, who advocates 'wanton destruction.'"[10] The demonstration of regression under the impact of the military situation becomes increasingly subtle as the activist paintings proceed. In the "Vietnam" pictures Golub shows youthful soldiers; Shatan notes that "the fluidity and instability of the adolescent superego" makes young recruits particularly susceptible to aggressive psychopathic behavior. From the "Mercenaries" on, Golub tends to depict older, even middle-aged soldiers, professionals for whom psychopathic military behavior is a way of life. These men are potentially sadomasochistic even in their personal relations, even in their erotic ones. So pervasive is the potential for psychopathic violence that it infects women, who victimize as much as they are victims in the "Horsing Around" pictures. Yet in *Interrogation III* (1981), the greatest feminist picture ever made by a man, woman is unequivocally victim.

Military ideology is intimately connected to masculine ideology. That is, the ability to be violent is a proof of masculinity as well as a proof of power. Marc Feigen Fasteau suggests that

"the male sex role may well have been the largest single factor
in determining why" American men "were ordered to go" to
Vietnam.[11] Lucy Komisar has shown how essential violence is
to the male self-image,[12] and Kate Millett has shown how war
is sexual for men.[13] All of Golub's figures exhibit not simply
rugged pseudoindividuality but rugged masculinity, deliber-
ately offering an "outward semblance of nonfemininity."[14] For
men, Joseph Pleck has argued, war is a natural extension of
athletic competition[15]—recall Golub's interest in athletes, par-
ticularly his boxers. Golub's figures are determinedly male,
even when they seem to show sexual interest in one another.
As the "Horsing Around" pictures suggest, they are clearly
more at ease—or as much at ease as they will ever be—in each
other's company than in the company of women.

Military and masculine ideology is the analytic center of
Golub's rhetoric of barbaric realism. To recognize this is to re-
turn to his sense of the classical, about which a final point may
be made. Golub has stated that certain passages in the third
chapter of Erich Auerbach's *Mimesis* meant a great deal to
him early in his development, but I believe these passages re-
main influential throughout his career. Auerbach's description
of late classical representation, which he sees turning away
from idealizing fiction toward vulgar reality, is operational in
the activist pictures, and I would even argue that it helps us
understand them more than it helps us understand Golub's di-
rectly classical works.

Analyzing the writing of Ammianus Marcellinus, a Roman
historian and high-ranking army officer, Auerbach singles out
a description of a mob riot in Rome. In this description, Auer-
bach notes, "human emotion and rationality yield to the magi-
cally and somberly sensory, to the graphic and gestural,"[16] that
is, to the expressionistic, a style that registers trauma. Ex-
pressionism also creates the impression of being enclosed
within a world rather than witnessing it from without, from a
perspective that doesn't belong to it. Early abstraction, or ab-
straction before it is codified into formalism, is a desperate
attempt to achieve such a detached perspective and so to tran-
scend the world. From the abstract viewpoint as from the clas-
sical, and, incidentally, as from that of the Renaissance, the
world seems whole, rational, while from the expressionist/
existentialist perspective (or rather lack of perspective) it is
disclosed as a problematic, numinous totality that can never be
completed or grasped by the projects that constitute it and
seek to comprehend it. Like all true expressionist art, Golub's
paintings collapse the Renaissance picture space, show it in

ruins; they mutilate the classical; and they offer no abstraction to "rationalize" the world, to "humanize" it by making it tolerable. It is because expressionism exists "between rationalizations" of the world that it is so disputed and disliked, so suspect. It articulates the world as always on the verge of disintegration, for there is no perspective to view it from. Or, rather, expressionism articulates the world ambiguously as neither entirely integrated nor entirely disintegrated, because while one can never transcend it one is always struggling to achieve a perspective on it, a quasi-divine point of view from which it would seem "fit" in itself as well as a fit place to live. Expressionism, of course, shows us that it is neither.

It is this expressionist mood of contiguousness with the world, and of the world's inhospitality, that overtakes the classical writer Ammianus. In passages that Golub has singled out as pertinent for an understanding of his art, Auerbach observes that "a whole gallery of gruesomely grotesque and extremely sensory-graphic portraits can be culled from Ammianus' work."[17] "The persons treated live between a frenzy of bloodshed and mortal terror. Grotesque and sadistic, spectral and superstitious, lusting for power yet constantly trying to conceal the chattering of their teeth—so do we see the men of Ammianus' ruling class and their world."[18] So, we might add, do we see the subjects of Golub's political portraits, the power-hungry ruling types of our world. In the last analysis, these types are supported by Golub's mercenaries, which is why they are nervous. For, as Machiavelli wrote,

> if any one supports his state by the arms of mercenaries, he will never stand firm or sure, as they are disunited, ambitious, without discipline, faithless, bold among friends, cowardly among enemies, they have no fear of God, and keep no faith with men.[19]

That is, they are neither disciplined soldiers nor peace-loving civilians, but idiosyncratically in between—the perennial borderline types Golub favors.

Auerbach remarks that in Ammianus' "strange sense of humor,"

> there is always an element of bitterness, of the grotesque, very often of something grotesquely gruesome and inhumanly convulsive. Ammianus' world is somber: it is full of superstition, blood frenzy, exhaustion, fear of death, and grim and magically rigid gestures; and to counter-balance all this there is nothing but the equally somber and pa-

thetic determination to accomplish an ever more difficult,
ever more desperate task: to protect the Empire, threat-
ened from without and crumbling from within. This de-
termination gives the strongest among the actors on
Ammianus' stage a rigid, convulsive superhumanity with
no possibility of relaxation.[20]

There is no more apt description of Golub's activist pictures,
even down to the detail of the protection of empire—for while
the soldiers in his paintings wear no uniforms, they may be
easily understood as the numerous mercenary defenders of the
American Empire, their very existence a symptom of its inter-
nal decadence. Sometimes Golub's figures even appear con-
vulsively rigid and superhuman, like the soldier in the flak
jacket, his weapon ready for action, in *Mercenaries IV* (1980).
The male figure in blue sunglasses and yellow shirt in *Riot II*
(1984) has the same superhuman look, only in his case it is be-
cause he is robotically brutal, the "technical" creation of an in-
human society. In fact Golub often achieves a superhuman look
by conveying a robotic presence—a soldier may seem like no
more than a fighting machine, covered with human skin to
make it seem "natural." Weapons also have a more-than-human
look. They are not simply objects, but slightly larger-than-life
emblems of the power that gives the impression of superhu-
manness. Certainly, by giving power over life and death, the
weapon confers a temporary divinity on its bearer.

Auerbach writes that in Ammianus' history,

the material increasingly masters the stylistic intent, until
it finally overwhelms it and forces the style, with its pre-
tension to reserve and refinement, to adapt itself to the
content, so that diction and syntax, torn between the
somber realism of the content and the unrealistically re-
fined tendency of the style, begin to change and become in-
harmonious, overburdened and harsh. The diction grows
mannered; the constructions begin, as it were, to writhe
and twist. . . . Against its will, as it were, the style
renders a greater sensoriness than would originally have
been compatible with *gravitas*, yet *gravitas* itself is by no
means lost, but on the contrary is heightened. The ele-
vated style becomes hyperpathetic and gruesome, becomes
pictorial and sensory.[21]

Every idea here is applicable to Golub, from his writhing and
twisting figural constructions, their strange "diction," to the
"hyperpathetic" gravity and "gruesome" character of the over-

all scenes. But in Golub's case the "pictorial and sensory" reveal the historical and literary. The issue is not to make history sensuously vivid, but to show how the fabric of sensation itself is imbued with history. Golub's history paintings are perhaps the most profound of our epoch because he is able to show how the sensuous appearances of our world emanate history, almost as if they were magically self-conscious about time.

I would like to quote Auerbach more extensively, particularly when he offers what amounts to a description of Golub's style. Auerbach writes that "in Ammianus the sensory, the perceivable, runs riot; it has forced its way into the elevated style, not by vulgarizing it popularly or comically but by exaggerating it beyond all bound."[22] By using photographs as sources, and subjecting their imagery to his classically elevated style, Golub both causes the sensory, the literally, mechanically perceivable, to run riot, and exaggerates his style beyond all bounds. Many of his source photographs are of explicitly sadistic subject matter, and unconsciously he conceives of the photograph sadomasochistically: it offers a sadistic vision of a masochistically experienced world. All the photographs show what Max Kozloff has called the "dream of power" over subject matter: they capture their subject at its most vulnerable or awkward, giving it no chance to put its best face on.[23] Golub often uses figures with odd expressions or gestures that cannot easily be read consciously, making them all the more valuable as symbols of an unconscious content.

Auerbach states that Ammianus' "placing of nouns, especially of subject nominatives" (Golub's equivalents would be his figures), and "his broadly construed use" of the "appositive," "testify to his endeavor at all times to suggest a monumental, striking, and usually gestural perception."[24] And Auerbach's conclusion seems tailor made for Golub's paintings, particularly for an understanding of his paradoxical use of the classical:

Ammianus' world is very often a caricature of the normal human environment in which we live; very often it is like a bad dream. This is not simply because horrible things happen in it—treason, torture, persecution, denunciations: such things are prevalent in almost all times and places, and the periods when life is somewhat more tolerable are not too frequent. What makes Ammianus' world so oppressive is the lack of any sort of counter-balance. For if it is true that man is capable of everything horrible, it is also true that the horrible always engenders counterforces and

that in most epochs of atrocious occurrences the great vital forces of the human soul reveal themselves: love and sacrifice, heroism in the service of conviction, and the ceaseless search for possibilities of a purer existence. Nothing of the sort is to be found in Ammianus. Striking only in the sensory, resigned and as it were paralyzed despite its stubborn rhetorical passion, his manner of writing history nowhere displays anything redeeming, nowhere anything that points to a better future, nowhere a figure or an act about which stirs the refreshing atmosphere of a greater freedom, a greater humanity.[25]

These remarks are equally true of Golub's activist paintings. The point that must be made emphatically is that Golub's vision of history, like Ammianus', is that of a disillusioned militarist: it is a masculinist vision of endless, exhausting war to which there is no alternative. This vision—"a somber and highly rhetorical realism which is totally alien to classical antiquity"[26]—is paradoxical, for it originates in a world with pretensions to idealism. Like the classical world, our world believes in a certain kind of "normative universalism"—but only superficially. From the depths of classical humanism, Ammianus' profoundly antihumanistic vision arises; and Golub, naively eager to "continue and enlarge . . . the Greek humanist heritage," produces a sophisticated, antihumanistic vision of modernity. By carrying his vision to the bitter end, presenting "atrocious occurrences" without any balancing sense of the human soul's search for "a greater freedom, a greater humanity," Golub uncovers the completely rotten state of the humanist vision of man. That vision is the heroic ghost that haunts Golub's antihumanist world, but can do nothing whatsoever to change it—can't even frighten it with its own image. The modern, antihumanist world is haunted by no conscience.

What Auerbach describes as the "invasion of a glaringly pictorial realism into the elevated style"[27] of Ammianus' writing is in fact humanist suicide. Golub's source photographs duplicate this "glaring pictorial realism": their documentary format offers a "styleless" content, a content intended as a record rather than as a reflection of artistic choice, and thus indicating a dominance of life over style or art. Stylelessness and the aura of glaring life has been, as noted, a modern ambition from Picasso to de Kooning. Golub carries it as far as it can go within the confines of a traditional sense of the picture. He shows how difficult it is to achieve authentic stylelessness, and how akin

the search for it finally is to "the paranoid position of combat: the constant fear of being harmed by someone other than [the soldier's] true persecutor,"[28] his trainer. The persecutor/trainer of the artist who would produce ambitiously styleless work is life, whose disciplines must be learnt and which the art must deal with. But the artist is in constant fear of being harmed by art, of being forced to live out a role within it, of having the work codified as an elevated style. Golub has made the best of this position, for he has shown how art (the classical art of the past) persecutes one as much as life does, by reminding one of possibilities that were once part of life. Such art was once true to life, or life was once true to it. Whatever else he does, Golub shows that art and life can once again be profoundly true to each other.

Golub's history painting is not theodicy; it does not try to justify the evils of history in terms of some higher good. It is ugly. Evil is not the paradoxical path to redemption in Golub's history painting, nor is it an end in itself, depicted for the novelty of its grotesque appearances. Photography has made such appearances far from novel, indeed all too commonplace, and one of Golub's artistic problems is to get rid of this sense of the banality of evil. He attacks the issue by showing the power principle behind evil, a principle that operates throughout reality but that has become so deeply a matter of the unconscious as not to know its own name. That name, however, is unmistakably a male name. History is the creation of men for Golub, and evil men show no mercy, have no compassion, refuse any display of humanity, because to do so would be to be feminine. The "counterforces" to atrocity that Auerbach expects, and that are not forthcoming in Golub's or Ammianus' work, are feminine, are all that is meant by feminine sensibility and morality. The art of Spero, Golub's own feminist wife, until recently has had no such femininity either; if one cannot find the feminist counterforce emerging from within its horrible record of female history (and such a record is the only context in which it might make an authentic appearance, for it cannot exist independently, with no acknowledgment of the past), then one wonders whether one can find it anywhere in the modern world.

Shatan writes that the bogusly masculine soldier refuses to "appear weak," and that his refusal leads to "impacted grief."[29] Golub does not really accept the history he records either, and the "affective energy" of his refusal is, in Shatan's words, "channeled back toward *combat*." Golub continues to paint and re-

paint combat scenes almost monotonously, with that kind of
purifying monotony that Clement Greenberg spoke of as es-
sential in the best modern abstract painting. There is the en-
actment of what Shatan calls a "code of *ancestor worship*" in
this repetition, the appeasement of the traditional spirit of
masculinity. Patriarchy is propitiated through ritual violence.
As Shatan writes, "grief became hardened into ceremonial
vengeance,"[30] enacted and reenacted ad nauseam. Golub's pic-
tures, then, celebrate the militant practices of a cult of cere-
monial violence; they are finally about male self-worship.

Shatan suggests that "centuries of industrial war wiped out
'feeling it like a man,'" where the old-fashioned, elevated
sense of "feeling it like a man" means experiencing war tragi-
cally.[31] In our time to know war as a tragedy, and so to grieve
openly about it, is to experience it from a feminine point of
view; Golub cannot allow himself such a perspective. Does that
mean that his art is not tragic? No, it means that it is all the
more tragic, excruciatingly tragic, because Golub implicitly
acknowledges himself as a victim of history. He records his-
tory in order to escape from it artistically, but he knows that
history is as real as art—more real, for it embraces art.
Golub's history paintings can do no more for him than give him
a little mental space from which to survey his own historical
annihilation.

History disintegrates Golub by making him almost uncon-
trollably aggressive and powerful. Freud has written that "the
limitation of aggression is the first and perhaps the hard-
est sacrifice which society demands from each individual";[32]
Golub's art will have lasting appeal because it ends society's
limitation of aggression (if only artistically). The work returns
the aggressive pursuit of power to the individual. Where other
art, more esthetically inclined, offers a satisfaction that sub-
stitutes for the erotic, Golub's provides a substitute aggres-
sion, which our age seems to need more than a vicarious expe-
rience of sex. This is why Golub's paintings are the art of our
time. More than any other art today, they share what has come
to be the insight of our post-Freudian age—in Anthony Storr's
words, "that power comes before pleasure," that "dominance-
submission purposes" are more primordial than sexual ones.[33]
Golub offers us the most primordial art of the postmodern
period.

NOTES

Introduction

1. Quoted in Renato Poggioli, *The Theory of the Avant-Garde* (New York: Harper & Row, 1971; Icon Edition), p. 9.

2. Ibid.

3. Clément de Ris regarded Courbet's *Burial at Ornans*, shown in the Salon of 1850, as "a blast in a cellar," a description equally applicable to many of Golub's paintings. De Ris wrote that in Courbet's painting "the pursuit of ugliness was carried so far that any sane person could not take this production seriously." Quoted by Elizabeth Gilmore Holt, *The Art of All Nations, 1850–73: The Emerging Role of Exhibitions and Critics* (Princeton: Princeton University Press, 1982), p. 95.

4. Clement Greenberg, "Avant-Garde and Kitsch," in *Art and Culture* (Boston: Beacon Press, 1965; Beacon Paperback), p. 4. Greenberg observes that "the birth of the avant-garde coincided chronologically—and geographically, too—with the first bold development of scientific revolutionary thought in Europe."

5. Quoted in Roland Barthes, *A Lover's Discourse* (New York: Hill and Wang, 1978; paperback), p. 23.

6. See Donald B. Kuspit, "Ryman, Golub—Two Painters, Two Positions," in *Art in America* 67, no. 4 (July–Aug. 1979): 88–90.

7. Barthes, *S/Z* (New York: Hill and Wang, 1974; paperback), p. 167.

Chapter One
The Dialectic of Identity

1. See, for example, Leon Golub, "The Visual Arts," in J. Miller and P. Herring, eds., *The Arts and the Public* (Chicago: University of Chicago Press, 1967), pp. 198–99.

2. Golub, "Statement," in *Exhibition of Paintings by Leon Golub and Nancy Spero* (Bloomington: Indiana University Art Center Gallery, 1958; exhibition catalogue), n. p.

3. Golub, "Statement," 1970. Unpublished. Part of a letter to Glenn Ross of the Philadelphia College of Art.

4. Golub, "Statement," 1958? Accompanying an exhibition at the Pasadena Art Museum.

5. Golub, "Statement," 1967. Unpublished.

6. Golub, "Statement," 1970.

7. Golub, "The Visual Arts," p. 199.

8. Golub, "Statement," 1967. Unpublished.

9. Golub, "Statement," *Exhibition of Paintings by Leon Golub and Nancy Spero*.

10. Golub has written two unpublished articles on Picasso—"Guernica, The Apocalypse of Saint-Sever," and "Guernica as Art History (II)."

11. Golub, "Guernica, The Apocalypse of Saint-Sever," p. 2.

12. Golub, "Buchenwald and Elugelab," 1954. Unpublished.

13. Golub, "Statement," 1958. Unpublished.

14. Golub, "Gigantomachies," 1968–69. Unpublished, p. 3.

15. Golub, "Statement," 1958.

16. Golub, "Gigantomachies," p. 2.

17. Ibid., p. 3.

18. Ibid.

19. Ibid., p. 4.

20. Golub, "Statement," 1958.

21. Golub, "Statement," 1958.

22. Golub, "The Visual Arts," p. 198.

23. Ibid.

24. Golub, "Gigantomachies," p. 4.

25. Golub, "Statement," 1967.

26. Golub, "The Visual Arts," p. 199.

27. See Leon Golub, "A Critique of Abstract Expressionism," in *College Art Journal* 14, no. 2 (Winter 1955): pp. 144–47.

28. Lawrence Alloway, "Leon Golub: The Development of His Art," in *Leon Golub, A Retrospective Exhibition of Paintings from 1947 to 1973* (Chicago: Museum of Contemporary Art, 1974; exhibition catalogue), n. p.

29. Heinz Kohut, *The Analysis of the Self* (New York: International Universities Press, 1971), p. 25.

30. T. S. Eliot, "Tradition and the Individual Talent," in *The Sacred Wood* (London: Metheun & Co., 1920), p. 49.

31. K. R. Eissler, *Leonardo da Vinci* (New York: International Universities Press, 1961), p. 17.

32. Eliot, p. 48.

33. Golub, interview with Irving Sandler for the Archives of American Art, October and November 1968, quoted in *Leon Golub, A Retrospective Exhibition of Paintings from 1947 to 1973*.

34. Golub, "Statement," 1954. Unpublished.

35. For a discussion of the role of the "great theme" in modern art see Donald Kuspit, "Uncivil War," in *Artforum* 21, no. 8 (April 1983): 34–43.

36. Alfred North Whitehead, "The Aims of Education and Other Essays, in *Alfred North Whitehead: An Anthology* (New York: The Macmillan Company, 1953), p. 98.

37. Kohut, *The Restoration of the Self* (New York: International Universities Press, 1977), pp. 299–300.

38. Harold Rosenberg, "The American Action Painters," in *The Tradition of the New* (New York: McGraw-Hill, 1965; paperback), pp. 23–39.

39. Charles Baudelaire, "The Salon of 1859," in *The Mirror of Art*, ed. Jonathan Mayne (Garden City, N.Y.: Doubleday & Co., 1956; Anchor Books), p. 224.

40. Golub, "2D/3D," in *Artforum* 11, no. 7 (March 1973): 60.

41. Golub, "Statement," 1978. Unpublished.

42. Golub, "Guernica, The Apocalypse of Saint-Sever," p. 1.

43. Quoted by Golub, interview with Irving Sandler.

44. Golub, "The Visual Arts," p. 199.

45. Ibid., p. 201.

46. Golub, "Statement," 1967.

47. Kenneth Burke, *A Rhetoric of Motives* (New York: Prentice-Hall, 1952), p. 22.

48. Ibid.

49. Ibid., p. 19.

50. Michael Fried, "Art and Objecthood," in *Minimal Art, A Critical Anthology*, ed. Gregory Battcock (New York: E. P. Dutton, 1968), pp. 116–47.

51. Golub, "Statement," 1958.

52. Walter Kaufmann, *Existentialism from Dostoevsky to Sartre* (Cleveland: World Publishing Co., 1956; Meridian Books), p. 21.

53. T. E. Hulme "Romanticism and Classicism" in *Speculations* (London: Routledge & Kegan Paul, 1936; 2nd ed.), p. 116.

Chapter Two
Measuring the Immeasurable Past

1. Heinz Kohut, *The Restoration of the Self* (New York: International Universities Press, 1977), p. 114.

2. Erwin Panofsky, "Albrecht Dürer and Classical Antiquity," in *Meaning in the Visual Arts* (Garden City, N.Y.: Doubleday & Co., 1955; Anchor Books), p. 238.

3. Joseph Gerard Dreiss, *The Art of Leon Golub: 1946–1978*, Ph.D.

dissertation, State University of New York at Binghamton, 1980, p. 86.

4. For a summary of Schilder's ideas, see Dreiss, pp. 77–80.

5. Quoted in Dreiss, p. 86.

6. Dreiss, pp. 87–88.

7. Leon Golub, "A Critique of Abstract Expressionism," in *College Art Journal* 14, no. 2 (Winter 1955), p. 146.

8. Kenneth Clark, *Rembrandt and the Italian Renaissance* (New York: W. W. Norton, 1968; paperback), p. 10.

9. Ibid., p. 170.

10. Harold Rosenberg, "De Kooning: 'Painting Is a Way,'" in *The Anxious Object* (New York: Horizon Press, 1964), pp. 118–19.

11. Charles Baudelaire, "On the Essence of Laughter," in *The Mirror of Art*, ed. Jonathan Mayne (Garden City, N.Y.: Doubleday & Co., 1956; Anchor Books), p. 144.

12. Quoted by Dreiss, p. 85.

13. Kohut, *The Analysis of the Self* (New York: International Universities Press, 1971), p. 25.

14. Golub speaks of the influence of "Mediterranean color" on his painting in "The Visual Arts," in *The Arts and the Public*, J. Miller and P. Herring, eds. (Chicago: University of Chicago Press, 1967), p. 202.

15. The critic Bernhard Diebold used this term to describe Oskar Kokoschka's plays. Quoted in Henry I. Schvey, *Oskar Kokoschka, The Painter as Playwright* (Detroit: Wayne State University Press, 1982), p. 35.

16. Maurice Denis, "Subjective and Objective Deformation" (1909), in *Theories of Modern Art*, ed. Herschel B. Chipp (Berkeley: University of California Press, 1968; paperback), pp. 105–107.

17. Alfred North Whitehead, *Process and Reality* (New York: Humanities Press, 1955), p. 36.

18. In an unpublished "Statement" of 1975 Golub describes himself as "increasingly interested in stating how control is vested in body structure" since the late '50s. In an unpublished "Statement" made at the College Art Association conference in 1973 he speaks of "how control is exerted or frustrated" psychosocially. In an unpublished 1980 "Statement" about *Mercenaries II* (1979) he remarks that in general his works in this series "comment on the irregular uses of power and control."

19. For example, in Golub, "The Visual Arts," p. 202.

20. Dreiss, pp. 153–54.

21. Ibid., p. 154.

22. Franz Schultz's term, in "Chicago," *Artnews* 57 (Feb. 1959), 49.

23. Leon Golub, "Guernica, The Apocalypse of Saint-Sever," unpublished, 1958, p. 1.

Chapter Three
Becoming an Artist

1. Leon Golub, "Statement," unpublished, 1954.

2. Harold Rosenberg speaks of De Kooning's attempt "to keep his art and his identity in flux" in "De Kooning: On The Borders of the Act," in *The Anxious Object* (New York: Horizon Press, 1964), p. 124.

3. Donald Kuspit, "Leon Golub's Murals of Mercenaries: Aggression, 'Ressentiment,' and the Artist's Will to Power," in *Artforum* 19, no. 9 (May 1981): 55.

4. Friedrich Nietzsche, *The Will to Power* (New York: Random House, 1968; Vintage Books), p. 452.

5. Ibid., p. 453.

6. Ibid., p. 450.

7. Ibid., p. 451.

8. Heinz Kohut, *The Analysis of the Self* (New York: International Universities Press, 1971), p. 210.

9. Ibid., p. 216.

10. Antonin Artaud, *The Theater and Its Double* (New York: Grove Press, 1958; paperback), p. 89.

11. Ibid., pp. 85–86.

12. Nietzsche, *The Will to Power*, pp. 446–47.

13. Kohut, *The Analysis of the Self*, p. 64.

14. Ibid., p. xiv.

15. Nietzsche, *The Will to Power*, p. 536.

16. Ibid., p. 449.

17. Leon Golub, "The Visual Arts," in *The Arts and the Public*, J. Miller and P. Herring, eds. (Chicago: University of Chicago Press, 1967), p. 202.

18. Kohut, *The Analysis of the Self*, p. 43.

19. Joseph Gerard Dreiss, *The Art of Leon Golub: 1946–1978*, Ph.D. dissertation, State University of New York at Binghamton, 1980, p. 108.

20. Kohut, *The Analysis of the Self*, p. 62.

21. Nietzsche, *The Will to Power*, p. 437.

22. Kohut, *The Restoration of the Self* (New York: International Universities Press, 1977), pp. 295–96.

23. Leon Golub, "Statement," presented at the College Art Association conference of 1957. Unpublished, p. 2.

24. Ibid.

25. Ibid., p. 4.

26. Ibid., p. 5.

27. Leon Golub, "Statement," 1958. Unpublished.

28. Golub, "The Visual Arts," pp. 201–202.

29. Leon Golub, "Statement," 1967. Unpublished.

30. Golub, "The Visual Arts," p. 196.

31. Leon Golub, "Guernica, The Apocalypse of Saint-Sever," unpublished, 1958, p. 7.

32. Quoted in Kristan Sotriffer, *Expressionism and Fauvism* (New York: McGraw-Hill, 1972), p. 14.

33. Henry I. Schvey, *Oskar Kokoschka, The Painter as Playwright* (Detroit: Wayne State University Press, 1982), p. 27.

34. Ibid., pp. 42–43.

35. Golub, "Statement," 1967.

36. Charles Baudelaire, "The Salon of 1846," in *The Mirror of Art*, ed. Jonathan Mayne (Garden City, N.Y.: Doubleday & Co., 1956), p. 44.

37. Nietzsche, *The Will to Power*, p. 88.

38. Ibid., p. 89.

39. Ibid., p. 86.

40. Artaud, *The Theater and Its Double*, pp. 49, 87.

41. John E. Gedo, *Beyond Interpretation* (New York: International Universities Press, 1979), pp. 1–14.

42. Quoted in Ernst Robert Curtius, *European Literature and the Latin Middle Ages* (New York: Harper & Row, 1952; Harper Torchbooks), p. 394.

Chapter Four
Masculine and Military Psychology

1. Edward Glover, *War, Sadism and Pacifism* (London: 1946), p. 31.

2. Chaim F. Shatan, "Bogus Manhood, Bogus Honor: Surrender and Transfiguration in the United States Marine Corps," in *The Psychoanalytic Review* 64 (1977): 594–95.

3. Ibid., p. 587.

4. Ibid., pp. 593, 596.

5. Ibid., p. 597.

6. Ibid., p. 599.

7. Chaim F. Shatan, "Militarized Mourning and Ceremonial Vengeance: Bogus Manhood and the Language of Grief," abstract of a paper presented at the Zurich Psychoanalytic Seminar on "War and Peace," April 23–24, 1983, p. 2.

8. Shatan, "Bogus Manhood, Bogus Honor," p. 586.

9. Ibid., p. 596.

10. Ibid., p. 604.

11. Marc Feigen Fasteau, "Vietnam and the Cult of Toughness in Foreign Policy," in *The Forty-Nine Percent Majority: The Male Sex Role*, ed. Deborah S. David and

Robert Brannon (Reading, Mass.: Addison-Wesley Publishing Co., 1976; paperback), p. 183.

12. Lucy Komisar, "Violence and the Masculine Mystique," in *The Forty-Nine Percent Majority: The Male Sex Role*, pp. 201–15.

13. Kate Millett, "Sex, War, and Violence in the Novels of Norman Mailer," in *The Forty-Nine Percent Majority: The Male Sex Role*, pp. 219–25.

14. Ruth E. Hartley, "Sex-Role Pressures and the Socialization of the Male Child," in *The Forty-Nine Percent Majority: The Male Sex Role*, p. 241.

15. Joseph Pleck, "My Male Sex Role—And Ours," in *The Forty-Nine Percent Majority: The Male Sex Role*, pp. 254–58.

16. Erich Auerbach, *Mimesis* (Garden City, N.Y.: Doubleday & Co., 1957; Anchor Books), p. 46.

17. Ibid., p. 47.

18. Ibid., p. 48.

19. Machiavelli, *The Prince* (New York: The New American Library, 1952; Mentor Books), p. 80.

20. Auerbach, pp. 48–49.

21. Ibid., p. 49.

22. Ibid., p. 50.

23. Max Kozloff, "Photography and Fascination," in *Photography and Fascination* (Danbury, N.H.: Addison House, 1979), p. 7.

24. Auerbach, pp. 50–51.

25. Ibid., pp. 51–52.

26. Ibid., p. 52.

27. Ibid., p. 55.

28. Shatan, "Bogus Manhood, Bogus Honor," p. 604.

29. Shatan, "Militarized Mourning and Ceremonial Vengeance," p. 3.

30. Ibid., p. 4.

31. Ibid.

32. Sigmund Freud, *New Introductory Lectures on Psycho-analysis* (New York: W. W. Norton & Co., 1933), p. 151.

33. Anthony Storr, *Human Destructiveness* (New York: Basic Books, 1972), p. 69.

WORKS

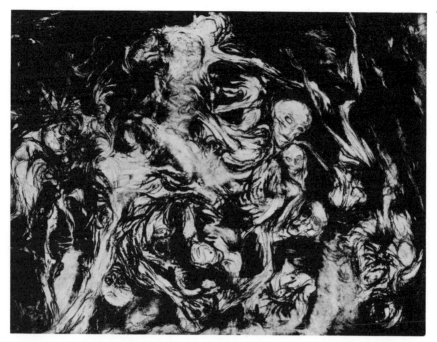

1 *Charnel House.* 1946
Lithograph, 15 × 19″
Collection of the artist

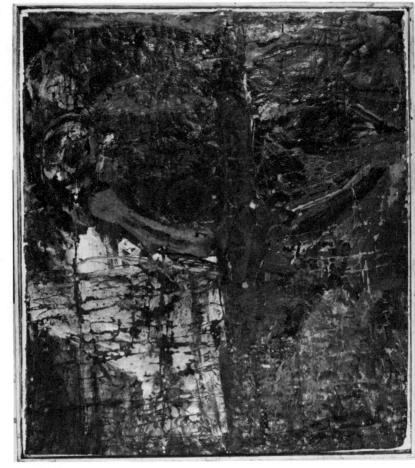

2 *Priests II* (current appearance)
Enamel and oil on canvas mounted on masonite, 42 × 39″
Collection of Philip Golub

3 *The Bug (Shaman).* 1952
Enamel and oil on canvas, 49 × 38″
Collection of Nancy Spero

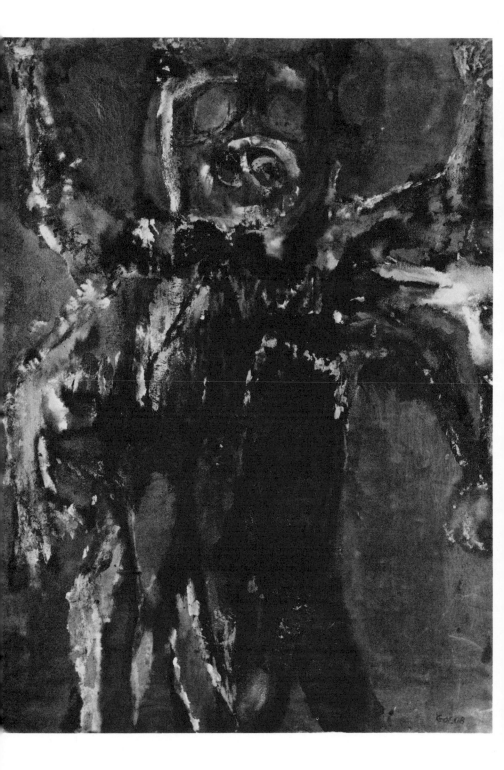

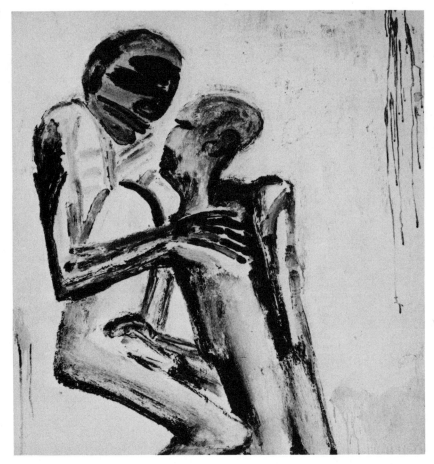

4 *The Prodigal Son.* 1952
Enamel and oil on canvas, 49 × 47″
Destroyed

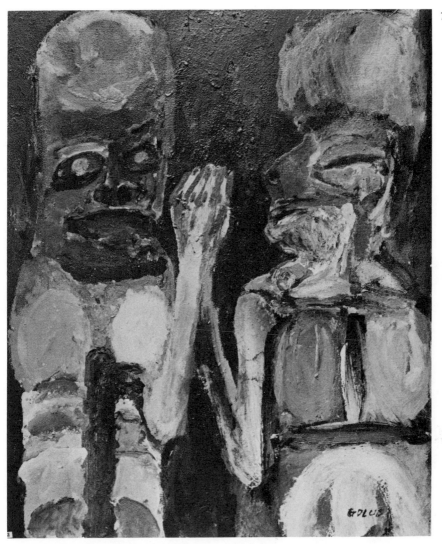

5 *Priests III.* 1952
Enamel and oil on canvas, 39 × 30″
Collection of Stephen Golub

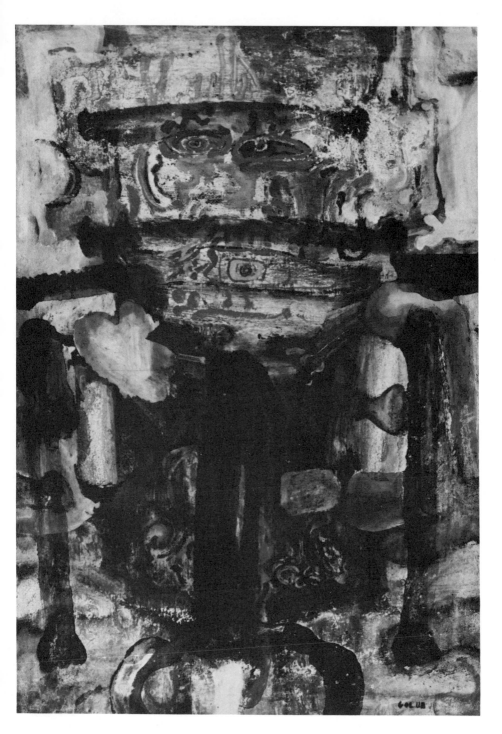

6 *In-Self III (Anchovy Man II).* 1953
Lacquer and oil on canvas, 36 × 25″
Collection of Nancy Spero

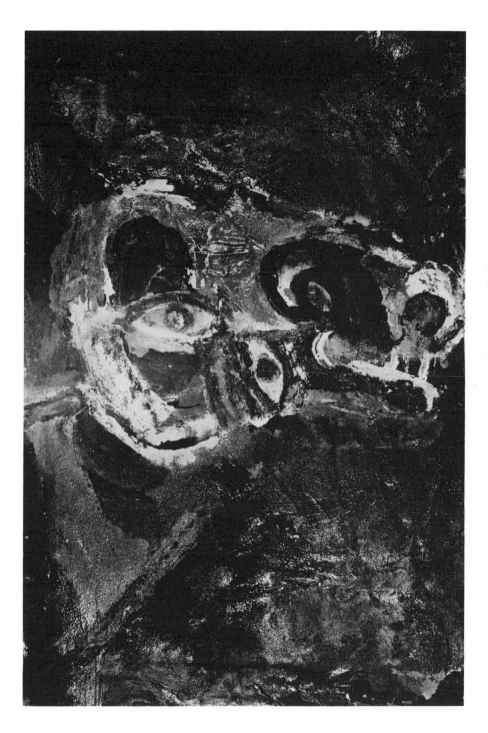

7 *Horse's Head.* 1953
Lacquer on canvas, 26 × 18″
Collection of Paul Golub

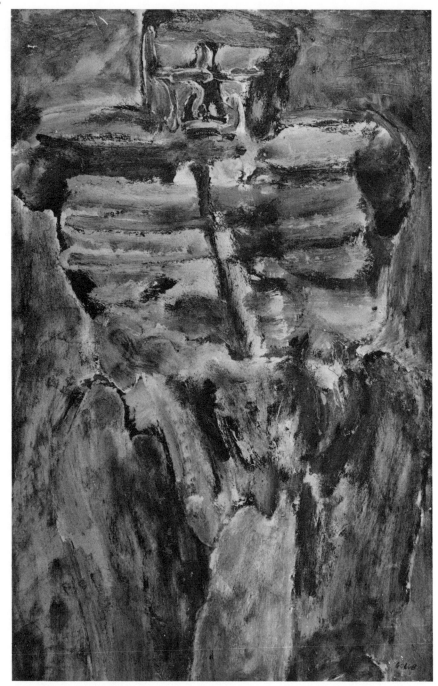

8 *Thwarted.* 1953
Lacquer and oil on canvas mounted on masonite, 47 × 31″
Collection of Nancy Spero

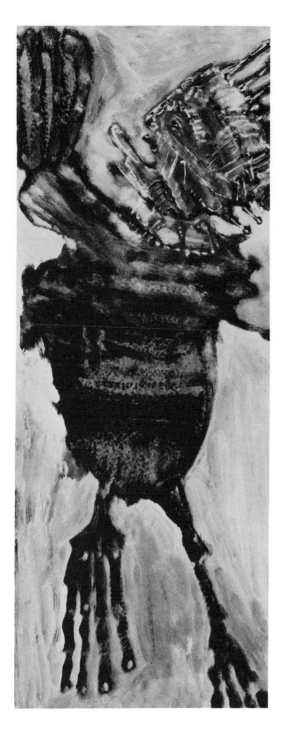

9 *Hamlet.* 1954
Lacquer on masonite, 52 × 24″
Collection of Peter Selz

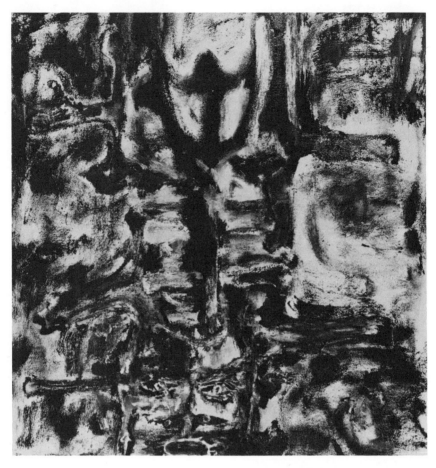

10 *The Skin (Crawling Man II).* 1954
Lacquer on canvas, 54 × 39″
Collection of Krannert Art Museum

11 *Burnt Man I.* 1954
Lacquer and oil on canvas, 46⅛ × 32″
Private collection

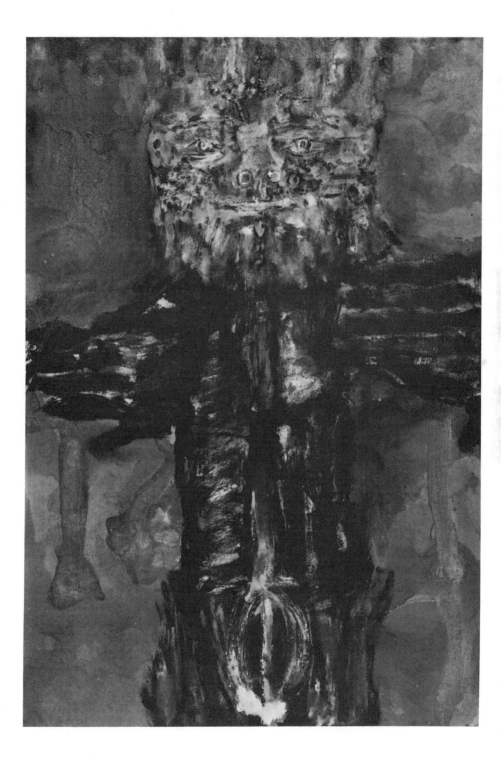

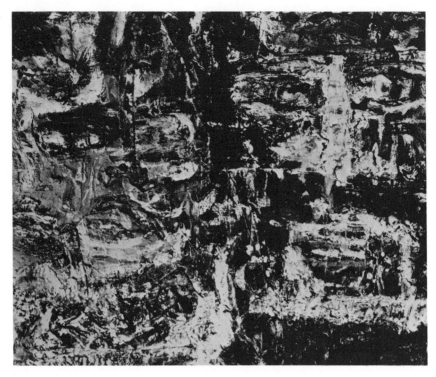

12 *The Inferno.* 1954
Lacquer, rubber, and strips of canvas, 31 × 37″
Collection of Paul Golub

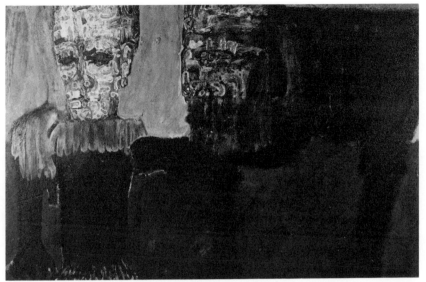

13 *Prodigal Sphinx.* 1954
Oil and lacquer on canvas, 33½ × 51″
Collection of Milton Brutten and Helen Herrick

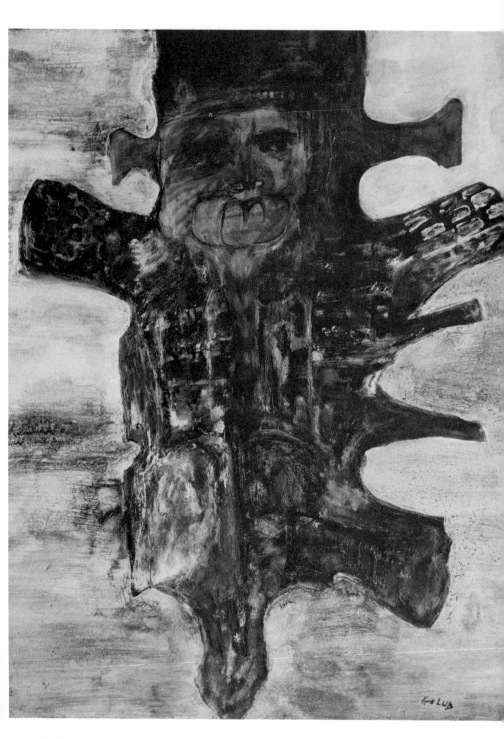

14 *Damaged Man.* 1955
Lacquer and oil on masonite, 48 × 36″
Collection of Gene R. Summers

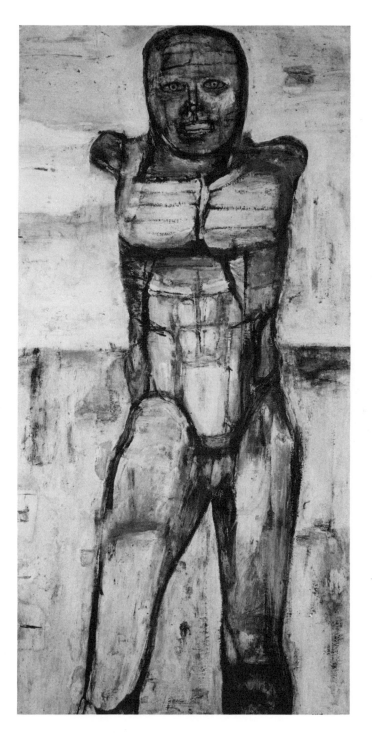

15 *Orestes.* 1956
Lacquer and oil on canvas, 82 × 42″
Collection of Lori and Alan Crane

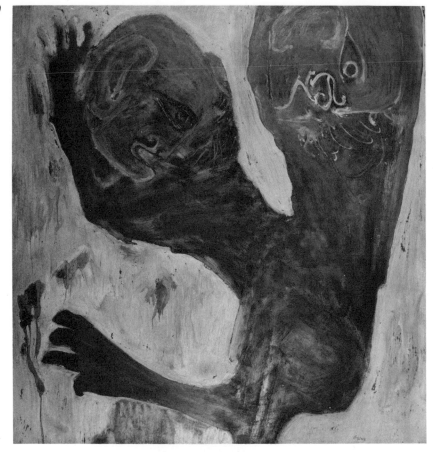

16 *Siamese Sphinx II*. 1955
Lacquer on masonite, 48 × 48″
Collection of Ulrich Meyer and Harriet Horwitz

17 *Greek Sphinx*. 1956
Drawing, sanguine on canvas, 45 × 31″
Collection of Ulrich Meyer and Harriet Horwitz

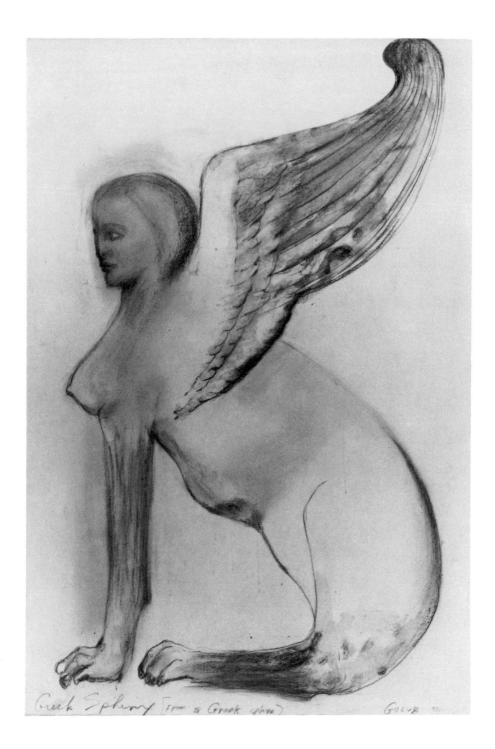

Greek Sphinx (from a Greek sphinx) GOLUB

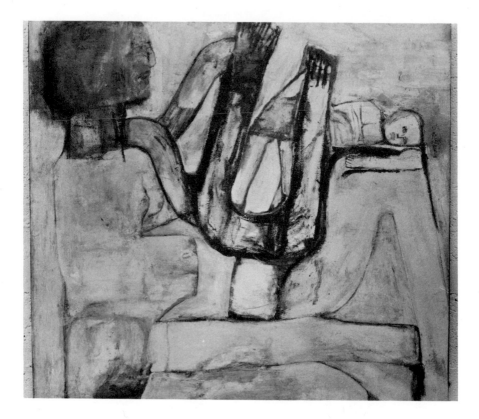

18 *Birth VII.* 1957
Lacquer and oil on canvas, 42 × 46″
Collection of Nancy Spero

19 *Philosopher I.* 1957
Lacquer on canvas, 80 × 46″
Collection of Ulrich Meyer and Harriet Horwitz

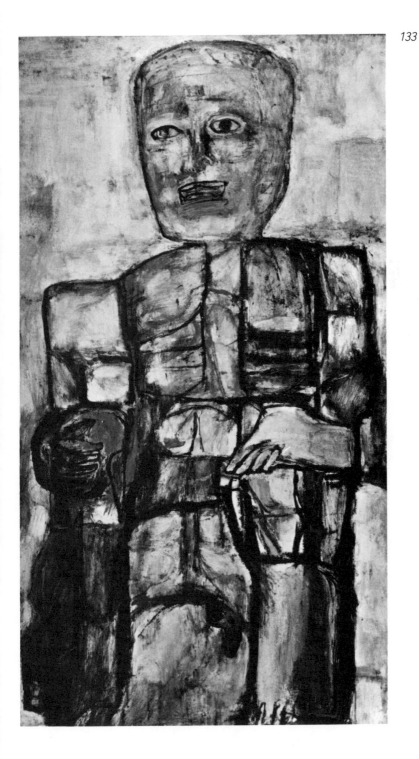

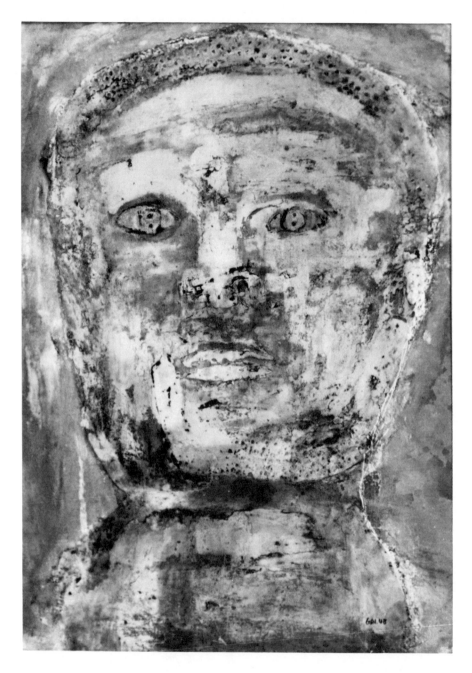

20 *Head XIII.* 1958
Oil, lacquer, varnish on canvas, 34 × 24½″
Private collection

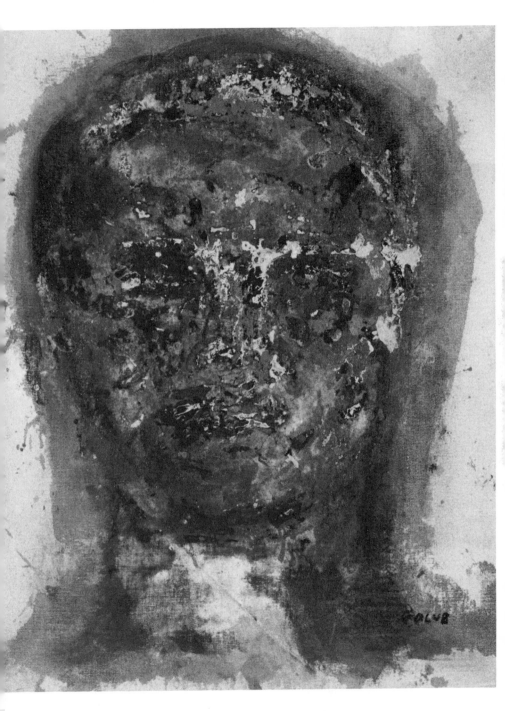

1 *Head XIV.* 1962
Lacquer on canvas, 24½ × 19″
Collection of Milton Brutten
and Helen Herrick

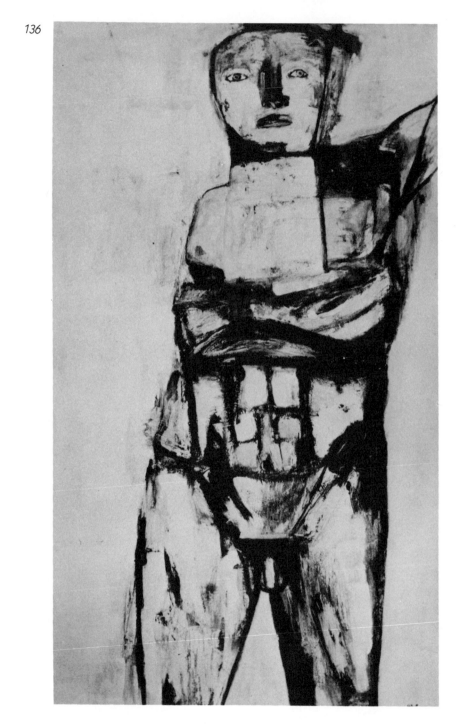

22 *The Victor.* 1957
Lacquer on canvas, 81 × 48″
Collection of George Danforth

23 *Colossal Torso*. 1959. Lacquer and oil, 120 × 80″. Collection of the artist

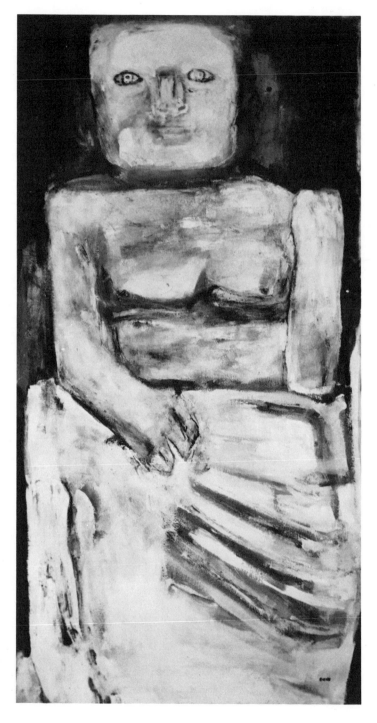

24 *Philosopher III.* 1958
Lacquer and oil on canvas, 80 × 41″
Collection of Stephen Golub

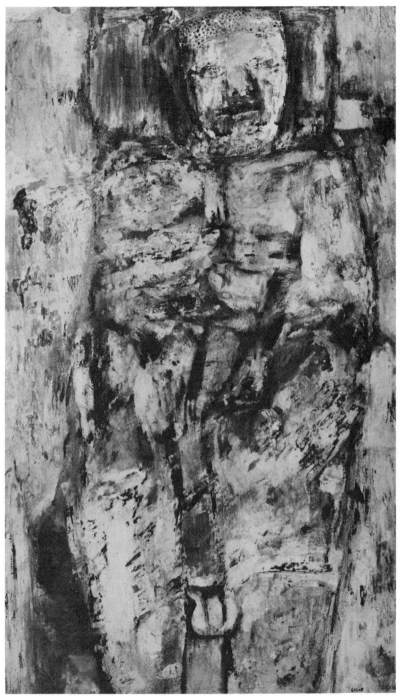

25 *Philosopher IV*. 1958
Lacquer on canvas, 81 × 47½″
Collection of Nancy Spero

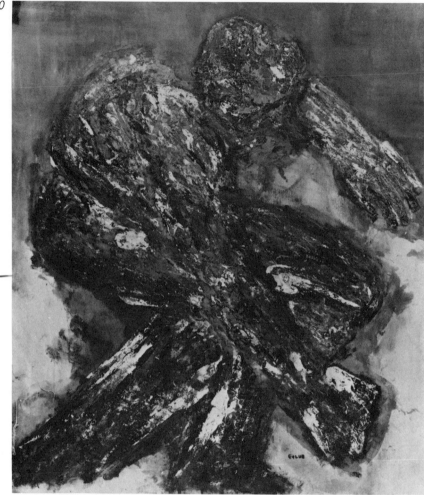

26 *Fallen Boxer.* 1961
Lacquer on canvas, 81 × 75″
Collection of Ulrich Meyer and Harriet Horwitz

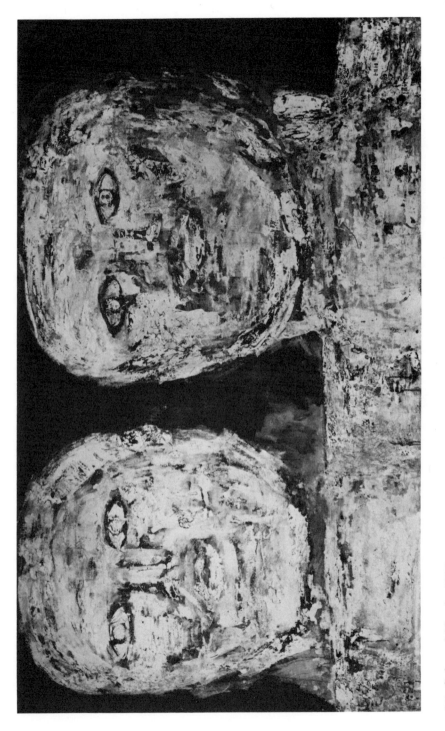

27 *Colossal Heads.* 1959. Lacquer on canvas, 84 × 131″. Collection of Ulrich Meyer and Harriet Horwitz

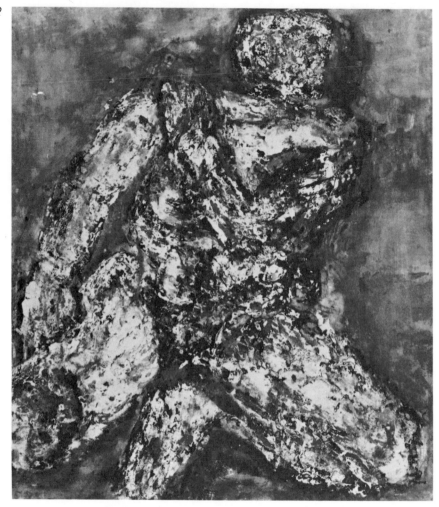

28 *Burnt Man*. 1960
Lacquer on canvas, 81 × 73″
Collection of Nancy Spero

29 *Combat I*. 1962
Acrylic on canvas, 92 × 81″
Collection of Gene R. Summers

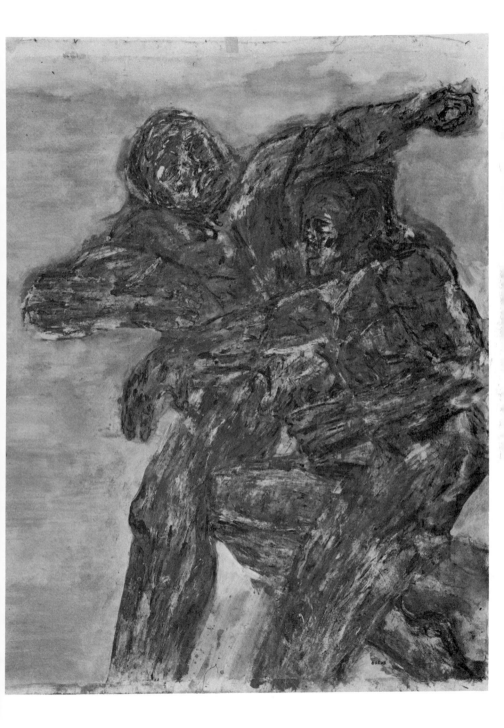

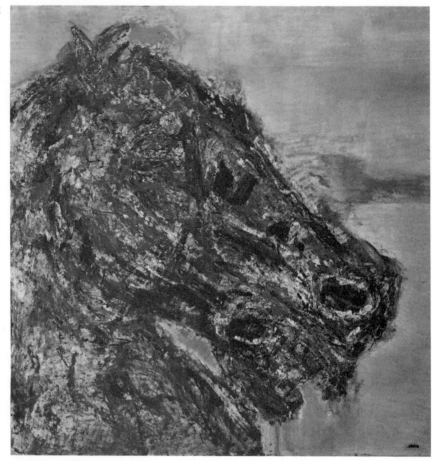

30 *Tête du Cheval.* 1963
Acrylic on canvas, 81 × 81″
Collection of Mr. and Mrs. Gerald Shapiro

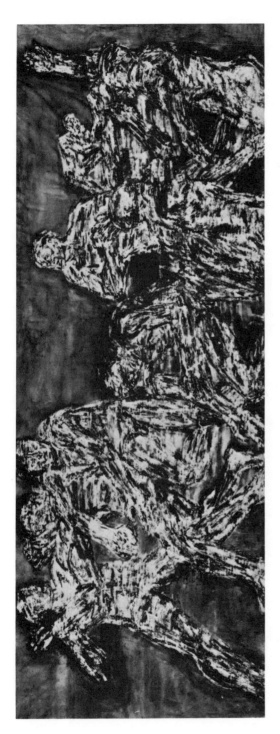

31 *Gigantomachy I*. 1965. Acrylic on canvas, 120 × 288″. Collection of Gene R. Summers

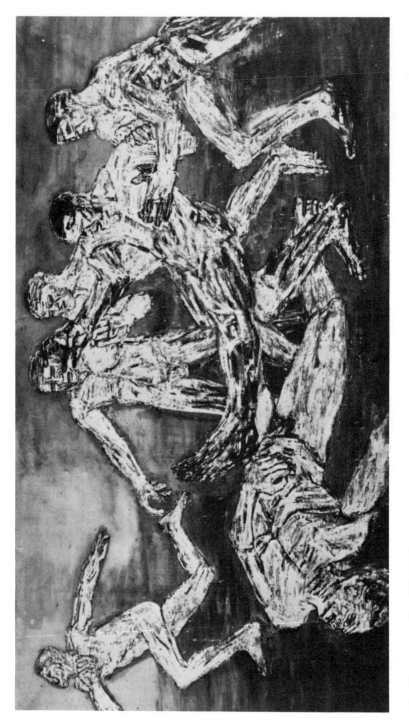

32 *Gigantomachy III.* 1966. Acrylic on canvas, 109 × 216″. Collection of Ulrich Meyer and Harriet Horwitz

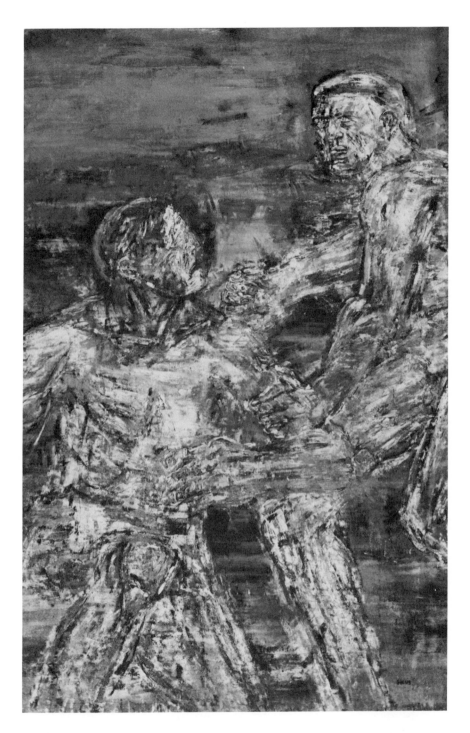

33 *Combat I.* 1965
Acrylic on canvas, 111 × 70″
Collection of Ira and Anita Kipnis

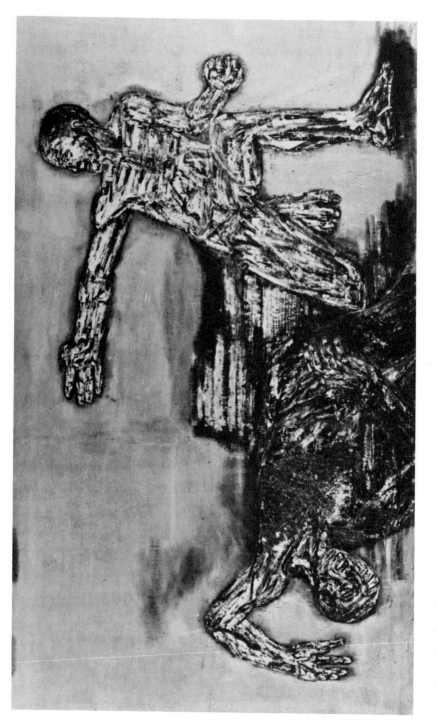

34 *Napalm I.* 1969. Acrylic on canvas, 120 × 192″. Collection of Paul Golub, Philip Golub, Stephen Golub, and Nancy Spero

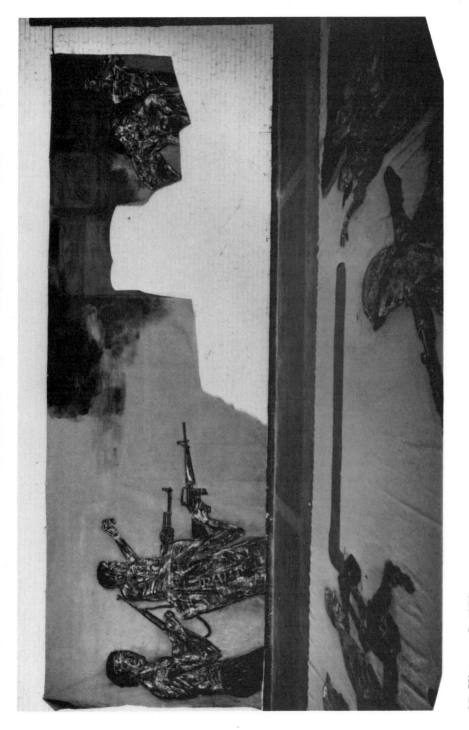

35 *Vietnam I*. 1972. Acrylic on canvas, 120 × 336″. Collection of the artist (*Vietnam III* on floor)

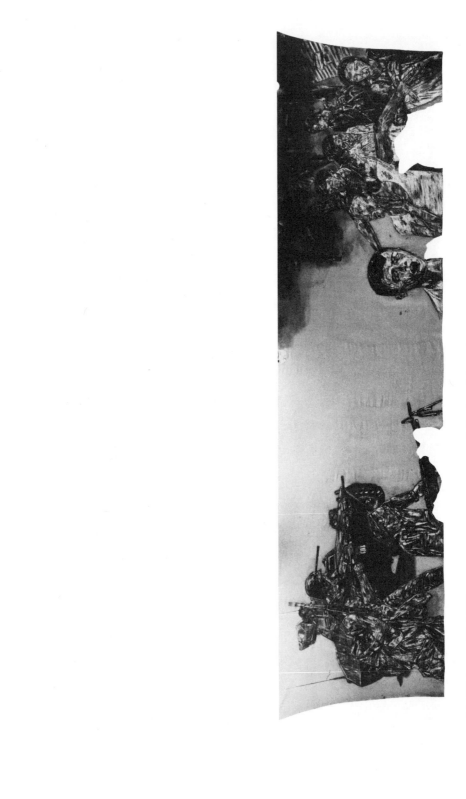

36 *Vietnam II*. 1973. Acrylic on canvas, 120 × 480″. Collection of the artist

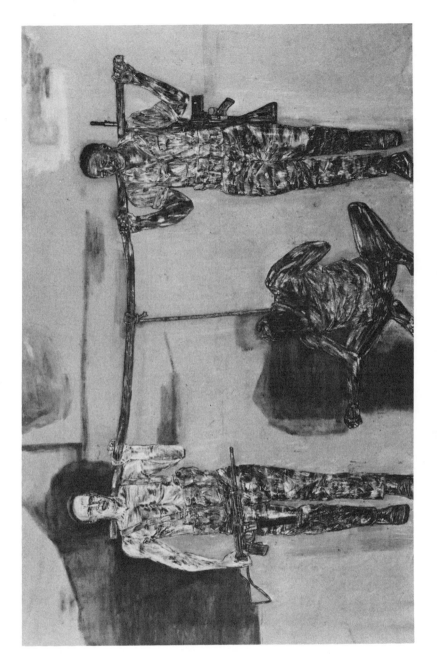

37 *Mercenaries.* 1976. Acrylic on canvas, 120 × 160″. Collection of Eli Broad Family Foundation

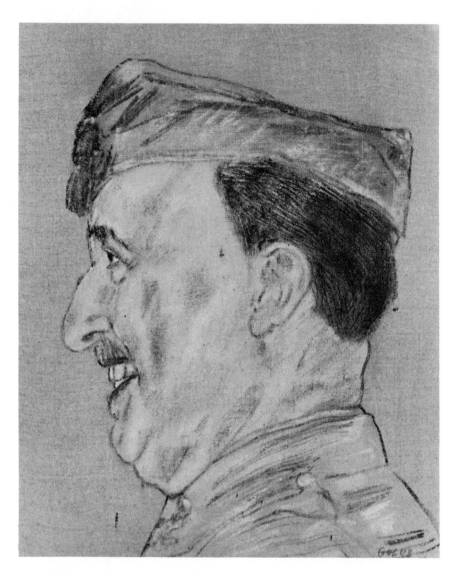

38 *Francisco Franco (1940).* 1976
Acrylic on canvas, 21 × 17″
Collection of Ulrich Meyer and Harriet Horwitz

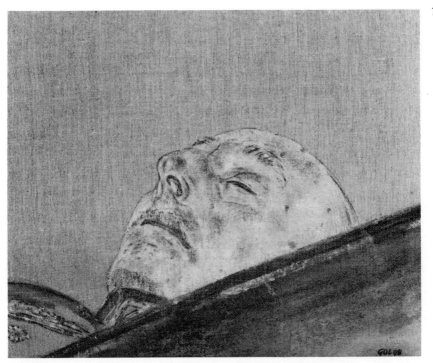

39 *Francisco Franco (in casket 1975).* 1976
Acrylic on canvas, 18 × 23"
Collection of Ulrich Meyer and Harriet Horwitz

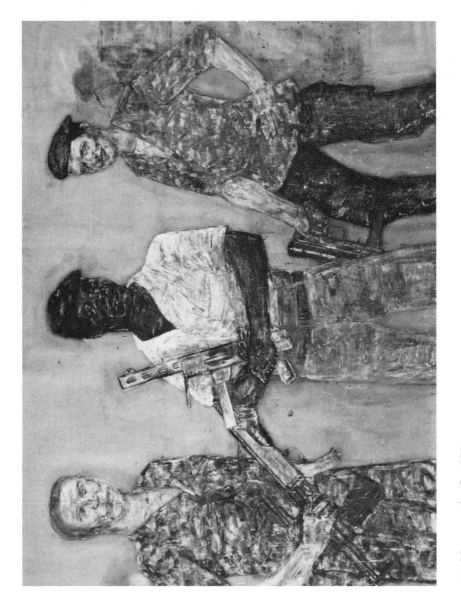

40 *Mercenaries I.* 1979. Acrylic on canvas, 120 × 166″. Saatchi collection

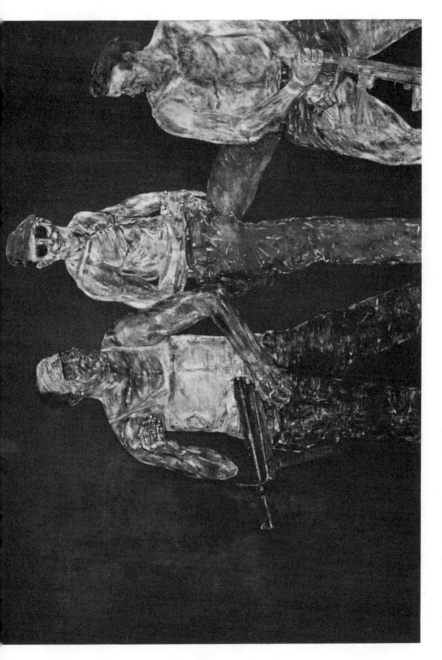

41 *Mercenaries II.* 1979. Acrylic on canvas, 120 × 172″. Collection of the Montreal Museum of Fine Arts. Purchase, Horsley and Annie Townsend Bequest

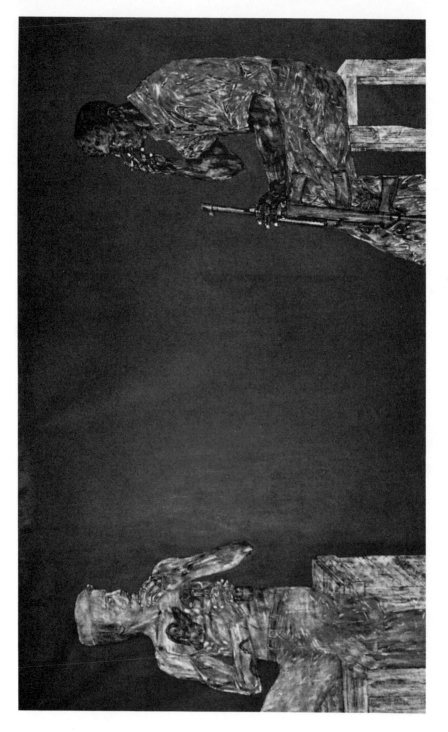

42 *Mercenaries III*. 1980. Acrylic on canvas, 120 × 198″. Collection of Eli Broad Family Foundation

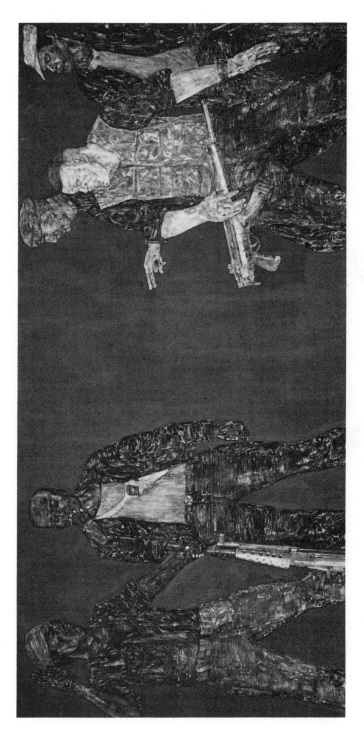

43 *Mercenaries IV*. 1980. Acrylic on canvas, 120 × 230″. Saatchi collection

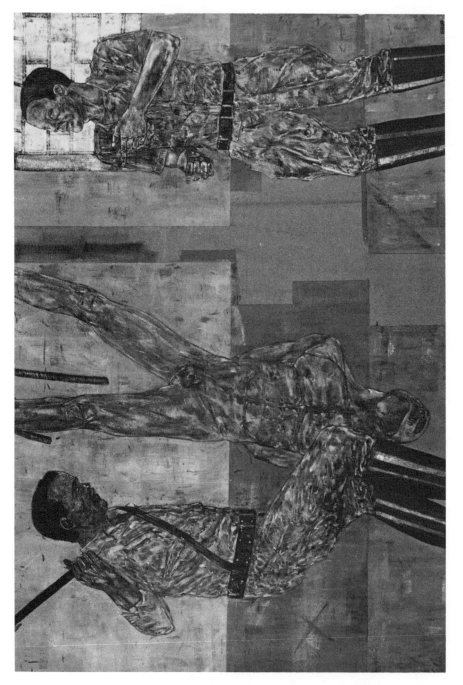

44 *Interrogation I.* 1981. Acrylic on canvas, 120 × 176″. Collection of Eli Broad Family Foundation

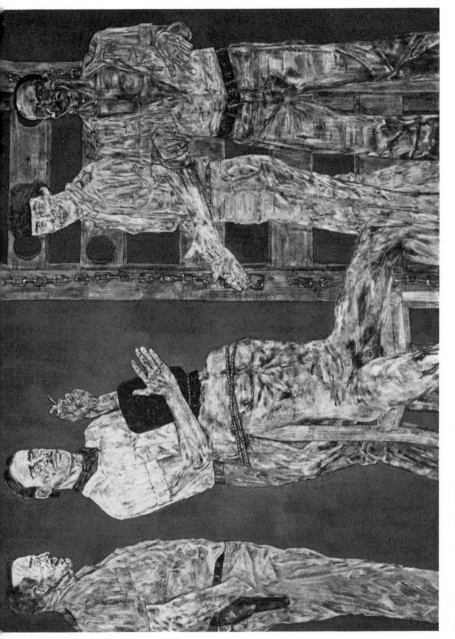

45 *Interrogation II*. 1981. Acrylic on canvas, 120 × 168″. Collection of the Art Institute of Chicago. Gift of the Society for Contemporary Art

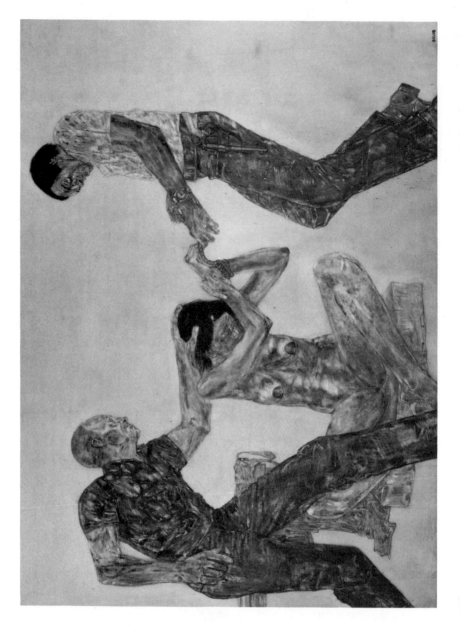

46 Interrogation III, 1981, Acrylic on canvas, 190 X 180". Collection of the artist

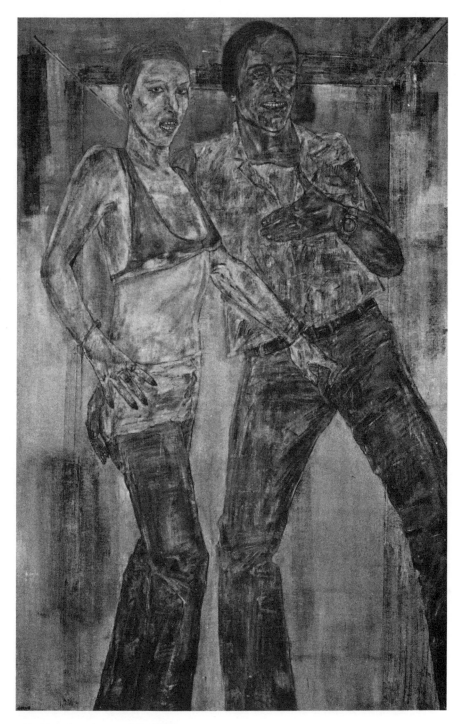

47 *Horsing Around I.* 1982
Acrylic on canvas, 120 × 80″
Collection of the artist

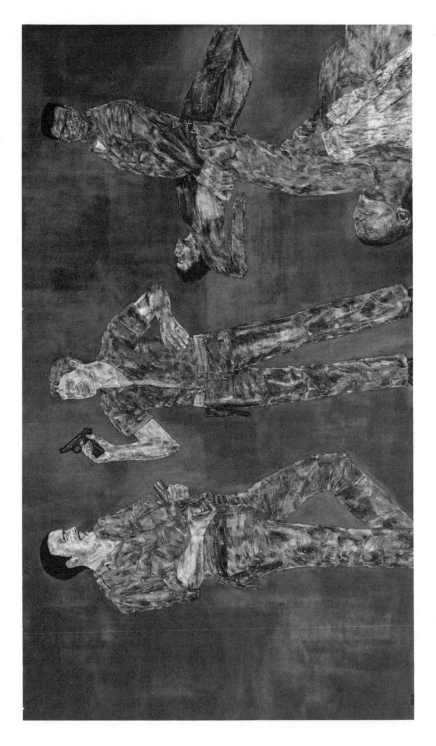

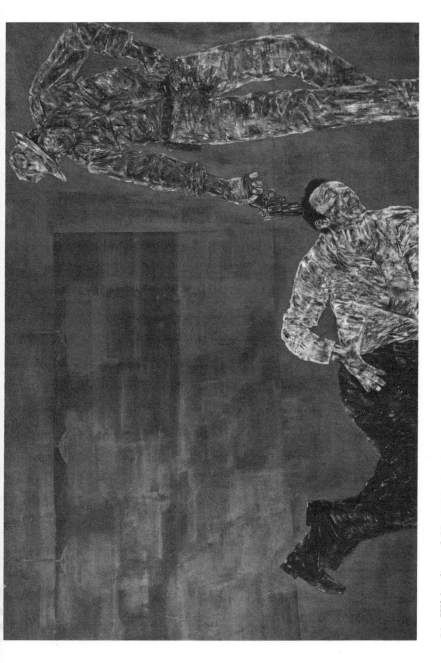

49 *White Squad II*. 1982. Acrylic on canvas, 120 × 187″. Collection of the Seattle Art Museum

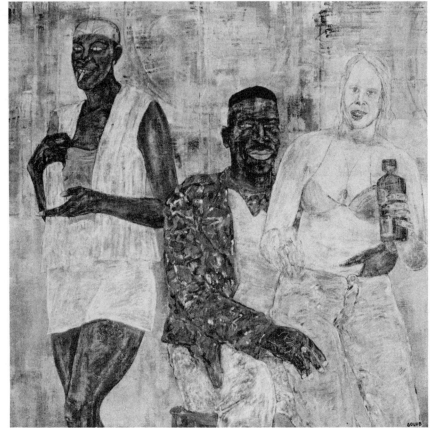

50 *Horsing Around III.* 1983
Acrylic on canvas, 88 × 90″
Collection of Eli and Edythe L. Broad

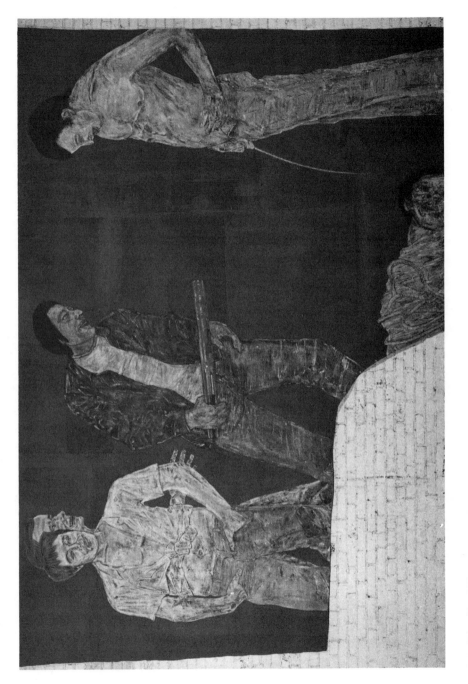

51 *Riot I*. 1983. Acrylic on canvas, 120 × 164″. Collection of the artist

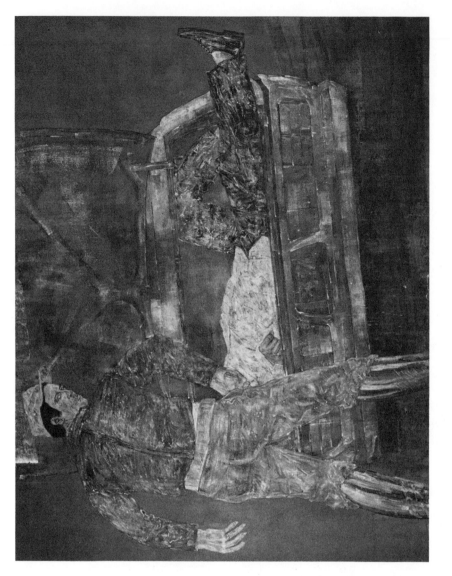

52 *White Squad IV (El Salvador).* 1983. Acrylic on canvas, 120 × 152″. Saatchi collection

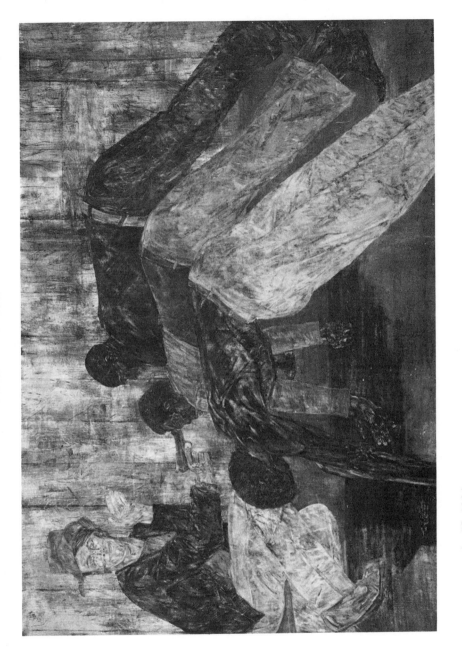

53 *Mercenaries V*. 1984. Acrylic on linen, 120 × 172″. Saatchi collection

CHRONOLOGY

1922
Born January 23, Chicago, Illinois.

1934–35
WPA art classes.

1938–40
Attends Wright Junior College, Chicago.

1939
Sees Picasso's *Guernica* (1937) on view at Arts Club of Chicago.

1940
Scholarship to the University of Chicago.

1942
B.A. Art History.

1942–46
U.S. Army, Corps of Engineers, Cartographer, England, Belgium, and Germany.

1946–50
The School of the Art Institute of Chicago.

1947
Starts Freudian analysis.

1948
Instrumental in organizing "Exhibition Momentum," which set up alternative exhibitions when the Art Institute excluded students from the annual juried Chicago and vicinity exhibitions.

1950
MFA (BFA 1949).
Chairman "Exhibition Momentum."
First solo exhibition, Contemporary Gallery, Chicago.
Starts teaching art at Wright Junior College (to 1955).

1950–51
Helps organize Contemporary Art Workshops, an alternate art school.
Completes psychoanalysis.
Experiments with seraping technique.
Begins "Priests," "Shaman," and "King" series. First "totemic" works.

1951
Marries Nancy Spero.

1952
George Wittenborn & Co., first solo exhibition (lithographs), New York.

1953
Starts teaching at University College, Northwestern University, Chicago.
Begins "Birth" and "In-Self" series.

1954
"Younger American Painters," The Solomon R. Guggenheim Museum, first museum exhibit.
Florsheim Memorial Prize, 61st American Exhibition, The Art Institute of Chicago.
Artists Gallery, first solo exhibition in New York.
Begins "Burnt Man" and "Sphinx" series.

1955
Allan Frumkin Gallery, Chicago, solo exhibitions, 1955–64.

1956
Pasadena Art Museum, first solo museum exhibition.
Sees Orozco's *Triumph of Prometheus*, Claremont, California.

1956–57
Golub and Spero paint on the island of Ischia and in Florence, Italy.

1957
Institute of Contemporary Arts, London, first solo European exhibition.
Begins "Athletes" and "Philosophers" series.

1957–59
Teaches at Indiana University, Bloomington, Indiana.

1958
Begins colossal heads.

1959
"New Images of Man," Museum of Modern Art, New York. A figurative exhibition that remained controversial for 20 years.
Allan Frumkin Gallery, New York, solo exhibitions, 1959–63.

1959–64
Golub and Spero work in Paris.

1960
Centre Culturel Americain, first solo exhibition in Paris.
Begins second "Burnt Man" series.
Ford Foundation Grant.

1961
Honorable Mention, 2nd Interamerican Biennial of the Academy of Fine Arts, Mexico City.

1962
Solo exhibitions at Galerie Iris Clert, Paris and Hanover Gallery, London.
Watson F. Blair Purchase Prize, 65th American Exhibition, The Art Institute of Chicago.
Switches from lacquer to acrylic paint.
Begins "Combat" series.

1964
Golub and Spero return to United States to live in New York.
Joins "Artists and Writers Protest" against U.S. involvement in Vietnam war.
First retrospective exhibition, Tyler School of Fine Art, Temple University, Philadelphia.

1965
Begins "Gigantomachies" series.
Tamarind Lithography Grant, Los Angeles.

1967
Participates in "Angry Arts Week" and other actions against the Vietnam war.
Cassandra Foundation Grant.

1968
Unsuccessful effort by "Artists and Writers Protest" to get Picasso to withdraw *Guernica* from Museum of Modern Art, New York, as an anti-Vietnam war protest.
Guggenheim Foundation Grant.

1969
Begins "Napalm" series.

1970–
present
Teaches at Rutgers, The State University of New Jersey.

1970
Participates in some actions of "Art Workers Coalition."

1970–71
National Gallery of Victoria, Melbourne, solo exhibition.

1972
Vietnam I, first overt use of weaponry and uniforms.

1973
Award, American Academy of Arts and Letters, National Institute of Arts and Letters.

1974
Works on Chile mural reconstruction, West Broadway, New York. Museum of Contemporary Art, Chicago, retrospective exhibition (the New York Cultural Center, 1975).

1976
Completes first *Mercenaries* painting.

1976-79
Paints political portraits. Returns to "Mercenaries" theme in summer 1979.

1982
Susan Caldwell Gallery, first solo gallery show in New York in twenty years.
Institute of Contemporary Arts, London, first museum exhibition of the recent "Mercenaries" and "Interrogations" series.
Honorary Doctor of Fine Arts, School of the Art Institute of Chicago.

1983
Appointed John C. Van Dyck Professor of Visual Art, Mason Gross School of the Arts, Rutgers University.
Active in "Artists Call Against U.S. Intervention in Central America."

1984-85
Retrospective organized by the New Museum of Contemporary Art, New York, traveling to the La Jolla Museum of Contemporary Art; The Museum of Contemporary Art, Chicago; Musée des Beaux-Arts de Montréal; the Corcoran Gallery of Art, Washington, D.C.; The Museum of Fine Arts, Boston.

SOLO EXHIBITIONS

1950
Contemporary Gallery, Chicago.

1951
Purdue University, West Lafayette, Indiana

1952
George Wittenborn & Co., New York

1954
Artists Gallery, New York
George Wittenborn & Co., New York

1955
Feigl Gallery, New York

1955–64
Allan Frumkin Gallery, Chicago

1956
Feigl Gallery, New York
Pomona College, Claremont, California
Pasadena Art Museum, Pasadena, California

1957
Institute of Contemporary Arts, London

1958
Leon Golub/Nancy Spero, Indiana University, Bloomington, Indiana

1959–63
Allan Frumkin Gallery, New York

1960
Centre Culturel Americain, Paris

1962
Galerie Iris Clert, Paris
Hanover Gallery, London

1963
Gallery A, Melbourne

1964
Tyler School of Art, Temple University, Retrospective Exhibition, Philadelphia
Galerie Iris Clert and Galerie Europe, Joint Exhibition, Paris

1966
Cliffdwellers, Chicago
University of Chicago, Retrospective Exhibition, Chicago

1968
Pro Grafica Arte, Chicago
10 Downtown, Studio Exhibition, New York

1970
LoGiudice Gallery, Chicago
Hayden Gallery, Massachusetts Institute of Technology, Cambridge, Massachusetts

1970–71
National Gallery of Victoria, Melbourne
Galerie Darthea Speyer, Paris

1972
Sloane/O'Sickey Gallery, Cleveland, Ohio
Herbert Lehman College, Bronx, New York
Bienville Gallery, New Orleans

1973
Musée de L'Abbaye Saint Croix, Sable d'Olonne

1974
Museum of Contemporary Art, Retrospective Exhibition, Chicago

1975
New York Cultural Center, Retrospective Exhibition, New York
New Jersey State Museum, Trenton, New Jersey

1976
Haverford College, Haverford, Pennsylvania
San Francisco Art Institute, San Francisco

1977
Bienville Gallery, New Orleans
Olympia Galleries, Philadelphia
Walter Kelly Gallery, Chicago

1978
State University of New York at Stony Brook, New York
Colgate University, Hamilton, New York

1979
Visual Arts Museum, School of Visual Arts, New York

1980
Protetch-McIntosh Gallery, Washington, D.C.

1981
Leon Golub/Nancy Spero, Swarthmore College, Swarthmore, Pennsylvania

1982
Susan Caldwell, New York (January and October)
Leon Golub/Nancy Spero, Tweed Arts Group, Plainfield, New Jersey
Kipnis Works of Art, Atlanta, Georgia
Young-Hoffman Gallery, Chicago
Institute of Contemporary Arts, London

1983
Matrix/Berkeley 58: University of Art Museum, University of California, Berkeley
Leon Golub/Nancy Spero, University of New Mexico, Albuquerque
Honolulu Academy of Arts, Honolulu
"Leon Golub: Mercenaries, Interrogations, and Other Works." Traveling: Sarah Campbell Blaffer Gallery, University of Houston, Texas; Portland Center for Visual Arts, Portland, Oregon; University of Arizona Museum of Art, Tucson, Arizona; Miami University Art Museum, Miami, Ohio; Atrium Gallery, University of Connecticut, Storrs, Connecticut; Everson Museum, Syracuse, New York
Leon Golub/Nancy Spero, Sarkis Galleries, Center for Creative Studies, College of Art and Design,· Detroit, Michigan

1984
Susan Caldwell, New York
Gallery Paule Anglim, San Francisco
Galerie Darthea Speyer, Paris

1984–85
New Museum of Contemporary Art, Retrospective Exhibition, New York. Traveling: La Jolla Museum, La Jolla, California; Museum of Contemporary Art, Chicago; Musée des Beaux-Arts de Montréal, Canada; Corcoran Gallery of Art, Washington, D.C.; Museum of Fine Arts, Boston

1985
Rhona Hoffman Gallery, Chicago
Barbara Gladstone Gallery, New York

SELECTED GROUP EXHIBITIONS

1947
1st Veterans Annual, School of the Art Institute of Chicago

1948–58
"Exhibition Momentum," Chicago, Roosevelt College and other locations

1954
Carnegie International, Pittsburgh
"Expressionism, 1900–1950," Walker Art Center, Minneapolis
"61st American Exhibition," Art Institute of Chicago
"Younger American Painters," Guggenheim Museum, New York, national traveling exhibition, 1955–1956

1955
Institute of Contemporary Arts, Houston
Whitney Museum of American Art, Annual Exhibition, New York

1956
Whitney Museum of American Art, Annual Exhibition

1957
University of Illinois, American Exhibition, Urbana
University of Nebraska, American Exhibition, Lincoln

1958
"Surrealist and Dada Sculpture," Arts Club, Chicago

1959
"Museum Directors' Choice," Baltimore Museum
"New Images of Man," Museum of Modern Art, New York
"63rd American Exhibition," Art Institute of Chicago

1960
University of Nebraska, American Exhibition

1961
University of Illinois, American Exhibition
University of Nebraska, American Exhibition
"Private Worlds," American Federation of Arts, traveling exhibition
2nd International Biennial, Academy of Fine Arts, Mexico City

1962
Annual, Corcoran Gallery of Art, Washington, D.C.
"The Figure," Museum of Modern Art, New York
"Huit Artistes de Chicago," Galerie du Dragon, Paris
"La Jeune Peinture Méditerranenne," Nice
"La Piccolo Biennale," Galerie Iris Clert, Venice
San Paolo Biennale
65th American Exhibition, Art Institute of Chicago

1963
"Art: U.S.A.: Now," national and international traveling exhibition through 1964
Bertrand Russell Peace Foundation Exhibition, Woburn Abbey
"Dunn International," Tate Gallery, London; Beaverbrook Art Gallery, New Brunswick, Canada
"Forum," Abbey Saint-Pierre, Ghent
"New Directions," San Francisco Museum
"Realités Nouvelles," Musée d'Art Moderne, Paris
University of Illinois, American Exhibition
University of Nebraska, American Exhibition

1964

American Academy of Arts and Letters, National Institute of Arts and Letters, New York
Carnegie International, Pittsburgh
Documenta III, Kassel
"The Figure since Picasso," Ghent
"Mythologies Quotidiennes," Musée d'Art Moderne, Paris
160th Annual, Pennsylvania Academy, Philadelphia
Prix Marzotto, European Community Prize Exhibition, traveled to Italy, France, England, etc., 1964–65

1965

The Figure International, American Federation of Arts, traveling exhibition through 1966
161st Annual, Pennsylvania Academy
"Il Presente Contestato," Museo Civico, Bologna
University of Illinois, American Exhibition

1966

"American Painting," Virginia Museum, Richmond
Los Angeles Peace Tower
"U.S.A.: Art Vivant," Musée des Augustins, Toulouse

1967

Carnegie International, Pittsburgh
Collage of Indignation, "Angry Arts," New York University
Il International der Zeichnung, Darmstadt
"Le Monde en Question," Musée d'Art Moderne, Paris
Prix Marzotto, European Community Prize Exhibition, traveled to Italy, France, England, etc., 1967–68
"Sources for Tomorrow," Smithsonian Institution, Washington, D.C., traveling exhibition through 1969

1968

"La Figuration depuis la Guerre," St. Etienne
"Mayor Richard Daley," Feigen Gallery, Chicago, New York, Cincinnati Museum, 1969
"The Obsessive Image, 1960–68," Institute of Contemporary Arts, London

1969

II Bienial International del Deporte en las Bellas Artes, Madrid
"Critic's Choice," New York State Council of the Arts, traveling exhibition through 1970
"L'oeil Ecoute," Avignon Arts Festival
Salon Comparaisons, Paris

1970

American Academy of Arts and Letters, National Institute of Arts and Letters, New York
"American Painting," Virginia Museum
"Flag Show," Judson Memorial Church, New York
"Peace Exhibition," Philadelphia Museum of Art

1972

Bertrand Russell Centenary Year Exhibition, Woburn Abbey
"Chicago Imagist Art," Museum of Contemporary Art, Chicago, New York Cultural Center, New York
Collage of Indignation II, New York Cultural Center, New York
"International Art Manifesto for the Legal Defense of Political Prisoners," Berkeley, San Francisco

1973

Bergman Gallery, Renaissance Society, University of Chicago
Fine Arts Center, New York Institute of Technology

1974

"Continuing Graphic Protest and the Grand Tradition," Pratt Graphic Center Gallery, New York, traveling exhibition

1976
"A Decade of American Political Posters: 1965–75," Westbeth Galleries, New York
"Exhibition of Liturgical Arts," 41st International Eucharistic Congress, Philadelphia
"The Michener Collection: American Painting of the 20th Century," University of Texas, circulated in U.S.A., Europe, and Latin America, 1966–76
150th Annual, National Academy of Design, New York
"Project Rebuild," Grey Gallery, New York University, Municipal Gallery and Museum of Modern Art, Udine, Friuli, Italy
"Visions; Distinguished Alumni Exhibition, 1945 to Present," School of the Art Institute of Chicago

1977
"Memorial to Orlando Letelier," Cayman Gallery, New York
"Paris—New York," Centre d'Art et de Culture Georges Pompidou (Centre Beaubourg), Paris

1979
"Centennial Exhibition," Art Institute of Chicago
"Harlem Renaissance Exhibit III," City College of New York
Koffler Foundation Collection, National Collection of Fine Arts, Smithsonian Institution, Washington, D.C.
"Political Comment in Contemporary Art," State University College at Potsdam, State University of New York at Binghamton, 1980

1980
"American Figurative Painting 1950–80," Chrysler Museum, Norfolk, Virginia
"Art of Conscience, the Last Decade," Wright State University, Dayton, Ohio, traveling exhibition 1981–82

"Mavericks (Aspects of the Seventies)," Rose Art Museum, Brandeis University, Waltham, Massachusetts

1981
"Crimes of Compassion," Chrysler Museum, Norfolk, Virginia
"Figure in American Art," Art Museum of Southwest Texas, Corpus Christi and the University of North Dakota, Grand Forks
"Figures: Forms and Expressions," Hallwalls, Buffalo
"Heads," P.S. 1, Institute for Art and Urban Resources, Long Island City, New York

1982
"American Figurative Expressionism 1950–60," Marilyn Pearl Gallery, New York
"Homo Sapiens," Aldrich Museum, Ridgefield, Connecticut
"Luchar!," Taller Latinoamericanos, New York
"Mixing Art and Politics," Randolph Street Gallery, Chicago
"The Monument Redefined," Gowanus Memorial Artyard, New York
"Painting and Sculpture Today," Indianapolis Museum of Art
"Photographers d'Artistes," Galerie France Morin, Montreal
"Selections from the Dennis Adrian Collection," Museum of Contemporary Art, Chicago
"Realism and Realities: The Other Side of American Painting, 1940–60," Rutgers University, New Brunswick, New Jersey; Montgomery Museum of Fine Arts, Alabama; University of Maryland, College Park

1983
"Art Couples III: Leon Golub and Nancy Spero," P.S. I, The Institute for Art and Urban Resources, Inc., Long Island City, New York

"Artists for Nuclear Disarmament,"
University of Vermont, Bur-
lington, traveling exhibition
"Hassam and Speicher Fund Pur-
chase Exhibition," American
Academy and Institute of Arts
and Letters, New York
"It Was a Time for Anger," P.S. I,
The Institute for Art and Urban
Resources, Long Island City, New
York
"New Work New York: Newcastle
Salutes New York," Newcastle
Polytechnic Gallery, England
"New York Painting Today," Carne-
gie Mellon Institute, Pittsburgh
1983 Biennial, Whitney Museum of
American Art, New York
"Peace on Earth: Pastorals and Poli-
tics," Tweed Arts Group, Plain-
field, New Jersey
"Portraits on a Human Scale," Whit-
ney Museum of American Art,
Downtown Branch at Federal Hill
National Memorial, New York
Resistance Festival for Nicaraguan
Artists, Danceteria, New York
"Sex and Violence," Contemporary
Arts Center, New Orleans
"Terminal New York," Harborside
Industrial Center (formerly
Brooklyn Army Terminal), New
York
"The War Show," State University of
New York at Stony Brook, New
York

1984
"Alternate Spaces," Museum of Con-
temporary Art, Chicago
"Art As Social Conscience," Edith C.
Blum Art Institute, The Bard Col-
lege Center, New York
"Artists Call Against U.S. Interven-
tion in Central America," Judson
Church, New York
Biennale de Paris, Grande Halle de
la Villette, Paris
"Brave New Works: Recent Ameri-
can Painting and Drawing," Mu-
seum of Fine Arts, Boston
"The Human Condition: San Fran-
cisco Museum of Modern Art Bien-
nial III," San Francisco
"The New Portrait," P.S. I, The In-
stitute for Art and Urban Re-
sources, Inc., Long Island City,
New York
ROSC 84, Guinness Hop Store, Dub-
lin, Ireland
"Content: A Contemporary Focus,
1978–84" Hirshhorn Museum and
Sculpture Garden, Smithsonian
Institution, Washington, D.C.
"Confrontations," Henry Art Gal-
lery, University of Washington,
Seattle
"Tradition and Conflict: Images of a
Turbulent Decade, 1963–73," Stu-
dio Museum, Harlem, New York
"Narrative Forms," Museo Tamayo,
Mexico City
"Art Against Apartheid," Henry St.
Settlement, New York

SELECTED BIBLIOGRAPHY

Articles, Books, Catalogs, and Reviews

Adrian, Dennis. *Leon Golub* (catalog poster of exhibition), Chicago: Lo Guidice Gallery, 1970.

———. "Leon Golub Returns Home in all his Crushing Power," *Chicago Daily News*, September 8, 1974.

———. *Leon Golub* (exhibition catalog), Trenton: New Jersey State Museum, 1975.

Alloway, Lawrence. *Leon Golub, Paintings from 1956–57*, Chicago: Allan Frumkin Gallery, 1957. Excerpt from 1957 text, reproductions, and cover published in *Big Table* 2 (Summer 1959).

———. *Leon Golub* (exhibition catalog), London: Hanover Gallery, 1962.

———. "Leon Golub Arts & Politics," *Artforum* 13, no. 2 (October 1974): 66–71.

———. "Leon Golub, the Development of His Art," *Leon Golub: A Retrospective Exhibition of Paintings from 1947 to 1973* (exhibition catalog), Chicago: Museum of Contemporary Art, 1974.

———. "Art," *The Nation*, February 19, 1977, 221–222.

Andersen, Wayne. *American Sculpture in Process: 1930–1970*, New York: New York Graphic Society, 1975, 136–140, 143–144.

Arac, Jonathan, ed. "Engagements: Postmodernism, Marxism, Politics," *Boundary 2*, vol. 11, no. 1 and 2 (Fall/Winter 1982–83).

Artner, Alan. "Linking Man to Myth in a Golub Retrospective," *Chicago Tribune*, September 9, 1974.

———. "Leon Golub Portraits Stage a Play of Power," *Chicago Tribune*, February 27, 1977.

Baigell, Matthew. "'The Mercenaries' An Interview with Leon Golub," *Arts Magazine* 55, no. 9 (May 1981): 167–169.

Bain, Lisa. "Openings/Leon Golub," *Esquire* (March 1984): 235.

Bird, Jon. "Leon Golub: 'Fragments of Public Vision,'" *Leon Golub, Mercenaries and Interrogations* (exhibition catalog), London: Institute of Contemporary Arts, 1982.

Brenson, Michael. "Art: From Leon Golub, Political Thugs Gallery," *New York Times*, February 10, 1984, C20.

———. "Can Political Passion Inspire Great Art?," *New York Times*, Arts and Leisure, April 28, 1984.

———. "Art: A Golub Retrospective at New Museum," *New York Times*, September 28, 1984, C29.

Brett, Guy. "Raunchy, Irritable, Mocking," *City Limits* (July 16–22, 1982): 47–48.

Brown, Daniel. "Leon Golub," *Dialogue* (May/June 1984): 19.

Bryant, Edward. *Portraits of Power* (exhibition catalog), Hamilton, New York: Colgate University, 1978.

———. "Leon Golub/Nancy Spero," *ArtSpace* (Spring 1983): 80–81.

Bull, Bart. "Golub's Didactic Warriors," *Express* [Berkeley, California], March 11, 1983, 6.

Canaday, John. "Leon Golub," *New York Times*, November 24, 1963.

Carroll, Paul. "Here Come the Chicago Monsters," *Chicago Perspective* (April 1964).

"Leon Golub," *Current Biography* 45, no. 8 (Aug. 1984): 20–23.

Dagbert, Anne. "Leon Golub,
Peintre," *Révolution*, [Paris], Oc-
tober 26, 1984.

Daniels, Kate and Richard Jones.
"Art and Guns," *Poetry East*
[Charlottesville, Va.], nos. 9–10
(Winter 1982/Spring 1983): 159,
284–286.

Danto, Arthur C. "Golub," *The Na-
tion*, November 17, 1984,
531–533.

Donohoe, Victoria. "Golub's Figures
Appear to Live in this World,"
Philadelphia Inquirer, February
8, 1976.

———. "Two Rare Artists Who Put
Their Politics . . .," *Philadelphia
Inquirer*, Weekend Section, No-
vember 13, 1981.

Dormer, Peter. "Art Lobby," *Art
Monthly* [London, England], Sep-
tember 1982.

Dreiss, Joseph. "Leon Golub's Gigan-
tomachies: Pergamon Revisited,"
Arts Magazine 55, no. 9 (May
1981): 174–176.

———. "Leon Golub," *Arts Maga-
zine* 56, no. 5 (January 1982): 10.

Elsen, Albert. *Leon Golub* (exhibi-
tion catalog), New York: Allan
Frumkin Gallery, 1959.

Feaver, William. "Leon Golub," *Sun-
day Observer* [London, England],
August 1, 1982.

Ferruli, Helen. "Leon Golub Talks of
Painting," *Art Insight* (Part 1),
Indianapolis: Indianapolis Insti-
tute of Art, May 1983.

———. "Leon Golub Discusses His
Art," *Art Insight* (Part 2), Indian-
apolis: Indianapolis Institute of
Art, June 1983.

Fournet, Claude. *Golub* (exhibition
catalog), Les Sables D'Olonne:
Musée de L'Abbaye, August–
September, 1973.

French, Christopher. "Leon Golub:
The Voice of Outrage," *Artweek*
14, no. 11, March 19, 1983, 1.

———. "The Propaganda of Pessi-
mism," *Artweek* 15, no. 13, March
31, 1984, 62.

Fuller, Peter. "Leon Golub," *Beyond
the Crisis in Art*. London: Writers
and Readers Publishing Coopera-
tive Ltd., 1980, 104–109. First
published as "Chicago for Real:
Leon Golub," *New Society* [Lon-
don, England], July 26, 1979,
198–199.

———. "Who Chicago," *The Naked
Artist*, London: Writers and
Readers Publishing Cooperative
Ltd., 1983, 125–140.

Gassiot-Talabot, G. "Les Giganto-
machies de Golub" (exhibition
newsletter), *Iris. time* no. 15,
Paris: Galerie Iris Clert, May 27,
1964.

———. "Golub: les mythes à l'heure
du napalm," *Opus International*
no. 23 (March 1971): 36–37.

Gerard, Michel. "Les reportages de
Golub," *Opus International* no. 93
(Spring 1984): 49–50.

Gordon, Mary. "Art and Politics,"
Strata 1, no. 2, New York: School
of Visual Arts, 1975.

Gumpert, Lynn and Ned Rifkin.
Golub (exhibition catalog), New
York: New Museum of Contempo-
rary Art, 1984.

Guthrie, Derek. "Art Politics and
Ethics: Interview with Leon Golub
and Nancy Spero," *New Art Ex-
aminer* 4, no. 7 (April 1977): 6–7.

Handy, Ellen. "Leon Golub," *Arts
Magazine* 58, no. 8 (April 1984):
40.

Hayes, John. "Massive Canvases Re-
cord 'Brute Facts and Brutal
Events,'" *Matchbox*, New York:
Amnesty International USA, Feb-
ruary 1983, 11.

Horsfield, Kate. "Profile: Leon
Golub," *Profile* 2, no. 2, [Chicago]:
Video Data Bank, School/Art In-
stitute of Chicago, March 1982.

Januszczak, Waldemar. "Prisoners of
a Tortured Conscience," *Man-
chester Guardian*, July 20,
1982, 10.

Kerrigan, Anthony. "Cronica de
Norte America," *Goya*, no. 7 [Laz-

aro Galdiano Museum, Madrid], July–August 1955.

Kind, Joshua. "Sphinx of the Plains: A Chicago Visual Idiom," *Chicago Review* 17, nos. 2–3 (1964).

Klein, Barbara. *Leon Golub: Paintings* (exhibition catalog), Cambridge, Mass.: Hayden Gallery, Massachusetts Institute of Technology, 1970.

Klekner, Ken and David Miller. "Spero-Golub, Art at the Speed of Life," *Grey City Journal Chicago Maroon* [Chicago], October 28, 1983.

Kozloff, Max. "The Late Roman Empire in the Light of Napalm," *Art News* 69, no. 7 (November 1970): 58–60, 76–78.

Kuspit, Donald. "Golub's Assassins: An Anatomy of Violence," *Art in America* 63, no. 3 (May–June 1975): 62–65.

———. "Leon Golub: Power to the Portrait," *Art in America* 67, no. 4 (July–August, 1979): 89–90.

———. "Art Couples" (exhibition statement), Institute for Art and Urban Resources at P.S. 1. Long Island City, N.Y., 1983.

———. *The Critic Is Artist: The Intentionality of Art*, Ann Arbor, Michigan: UMI Press, 1984. Chapter 25 first published as "Leon Golub's Murals of Mercenaries: Aggression, 'Ressentiment,' and the Artist's Will to Power," *Artforum* 14, no. 9 (May 1981): 52–57.

Kuspit, Donald and Rudolf Baranik. "Art and Politics: An Exchange," *Art in America* 63, no. 5 (September–October 1975): 36–37.

Larson, Kay. "Power's Ugly Face," *New York Magazine*, November 26, 1984, 116–117.

Leja, Michael. "Aspects of the 70's: Mavericks" (exhibition catalog), Waltham, Mass.: Rose Art Museum, Brandeis University, 1980, 4–6.

Levin, Kim. "Voice Centerfold: Art,"

Village Voice, January 21–26, 1982, 56.

———. "Power to the Painter," *Village Voice*, February 28, 1984, 95.

Linhares, Philip. *Leon Golub: Paintings 1966–76* (exhibition catalog), San Francisco: San Francisco Art Institute, 1976.

Lippard, Lucy R. "Making Manifest," *Village Voice*, January 27, 1982, 72.

Luhan, J. Michael. "Latin American Holocaust," *Penthouse* (September 1981): 52–53.

Malone, Patrick and Peter Selz. "Is there a New Chicago School?," *Art News* 54 (October 1955): 36–39.

McBride, Henry. "Americans Looking East, Looking West," *Art News* 53 (May 1954): 32, 54.

Melville, Robert. *Leon Golub* (exhibition catalog), London: Institute of Contemporary Arts, 1957.

Miller, James A. and Paul Herring. *The Arts and the Public*, Chicago: University of Chicago Press, 1967, 195–211, 223–224.

Newman, Michael. "Interview with Leon Golub," *Leon Golub, Mercenaries and Interrogations* (exhibition catalog), London: Institute of Contemporary Arts, 1982.

Padgham, Gay. "Killers Go Up Against the Wall," *Morning Star* [London, England], August 10, 1982.

Perreault, John. "Assassins," *Soho Weekly News*, April 10, 1975, 15.

———. "Realpolitick," *Soho Weekly News*, January 26, 1982, 24.

———. "Mercenaries and Interrogations," *Everson Museum of Art Bulletin*, May 1984.

Phillips, Tony. "Leon Golub: Portraits of Political Power," *New Art Examiner* 5, no. 4 (January 1978): 1.

Pincus-Witten, Robert. "Leon Golub," *Art International* 6, no. 1 (February 1962): 51–52.

———. "Golub on Three Levels" (exhibition newsletter), *Iris. time*, no. 15, Paris: Galerie Iris Clert, May 27, 1964.

———. "A Note on Golub," *Artforum* 6, no. 10 (Summer 1968): 46–47.

———. "Entries: Post-Epistemic Dilemma," *Arts Magazine* 56, no. 1 (September 1983): 110–112.

Pradel, Jean-Louis. *World Art Trends*, New York: Harry Abrams, 1983.

Ratcliff, Carter. "Contemporary American Art," *Flash Art* 108–16 (Summer 1982): 32–35.

———. "Expressionism Today: An Artists Symposium," *Art in America* 70, no. 11 (December 1982): 64.

———. "Theater of Power," *Art in America* 72, no. 1 (January 1984): 74–82, cover.

Roberts, John. "Leon Golub's Mercenaries and Interrogations," *Art Monthly* [London, England], September 1982.

Robins, Corinne. *Leon Golub* (exhibition catalog), Melbourne, Australia: National Gallery of Victoria, 1970–71.

———. "Leon Golub: The Faces of Power," *Arts Magazine* 51, no. 6 (February 1977): 110–111.

———. "Leon Golub: In the Realm of Power," *Arts Magazine* 55, no. 9 (May 1981): 170–173.

Robson, R. R. and J. C. Roth. "Revealing the Edges of Society," *Allegheny* 3, no. 2 (Spring 1983).

Rose, Barbara and Irving Sandler. "Sensibility of the Sixties," *Art in America* 55, no. 1 (January–February 1967): 55.

Rosenberg, Harold. "Aesthetics of Mutilation," *New Yorker*, May 12, 1975.

Samaras, Connie. "Nancy Spero and Leon Golub: An Interview," *Detroit Focus Quarterly* 2, no. 4 (December 1983).

Sandler, Irving. "An Interview with Leon Golub," *Arts Magazine* 44, no. 4 (February 1970).

———. "Interview: Leon Golub Talks with Irving Sandler," *Journal, Archives of American Art* 18, no. 1 (1978): 11–18.

———. *The New York School: The Painters and Sculptors of the Fifties*, New York: Harper and Row, 1978, 133, 135–136.

Schjeldahl, Peter. "Red Planet," *Village Voice*, October 26, 1982, 96, 111.

Schulze, Franz. "Chicago Letter," *Art International* 11, no. 1, January 20, 1967.

———. "One Man's Quest for a Symbol of our Time—Leon Golub's Fearsome Giants," *Chicago Daily News*, February 22, 1969.

———. *Fantastic Images: Chicago Art Since 1945*. Chicago: Follett Publishing Company, 1972, 40–49.

———. "Majestic Existentialism," *Art News* 73, no. 2 (October 1974): 87–88.

———. "Art," *Chicago Daily News*, March 4, 1977.

Schoenfeld, Ann. "Leon Golub," *Arts Magazine* 57, no. 4 (December 1982): 41.

Schwartz, Barry. *The New Humanism*. New York: Praeger Publishers, 1974.

Schwartz, Therese. "The Politicalization of the Avant-Garde," *Art in America* 59, no. 6 (November–December 1971): 96–105.

Selz, Peter. "A New Imagery in American Painting," *College Art Journal* 15, no. 4 (Summer 1956): 290–301.

———. *New Images of Man*, New York: The Museum of Modern Art, 1959.

———. *Leon Golub, Balcomb Greene* (exhibition catalog), Paris: Centre Culturel Americain, 1960.

———. *A Blunt View of Power and Violence on a Grand Scale* (exhibition catalog and University Bulletin), Berkeley: University Art Museum, University of California, March 1983.

Siegel, Jeanne. "Leon Golub/Hans Haacke: What Makes Art Politi-

cal?," *Arts Magazine* 58, no. 8 (April 1984): 107–110.

Silverthorne, Jeanne. "Leon Golub," *Artforum* 23, no. 4 (December 1984): 82.

Smith, Edith and Alan Fern. "Expressionism and Emotion in American Painting," *Chicago Review* 8, no. 3 (1954).

Speyer, A. James. *Leon Golub, Retrospective Exhibition* (exhibition catalog), Philadelphia: Tyler School of Fine Art, Temple University, 1964.

Spurling, John. "Larger than Life-Size," *New Statesman* 104, no. 2682, August 13, 1982.

Stevens, Mark. "Art on the Barricades," *Newsweek*, February 6, 1984, 70–71.

Stubbs, Ann. "Interview," *Fire in the Lake* 1, no. 4 (July–August 1976).

Tolone, Zoe. "Leon Golub's 'Mercenaries and Interrogations,'" *New Times* [Syracuse, New York], no. 689, May 30, 1984, 7–8, cover.

Taylor, John Russell. "An Ominous View of the March of Progress," *Times* [London, England], August 3, 1982.

Tully, Judd. "Flash Art Reviews," *Flash Art*, no. 106 (February–March 1982): 56.

———. "Leon Golub's Leftist Tatoo," *Art/World* 8, no. 5 (February 1984): 1,4.

Ullmann, Sabrina. "Leon Golub—The Aesthetics of Power," *Fresh Weekly* [Portland, Oregon], November 15, 1983, 10–11, cover.

Weller, Allan. *Art: USA Now*, Lucerne: C. J. Bucher, 1962.

Witz, Robert and Jewis, Joe. *Appearances* (Spring 1983): 12, 31–32, 73, 93–96.

ism," *College Art Journal* 14, no. 2 (Winter 1955): 142–147.

"Considerations on Contemporary Art," *Art League News* 3, no. 4 [Winnetka, Illinois], (December 1955).

"Exhibition catalog statement," Allan Frumkin Gallery, New York, New York, 1963.

"The Artist as an Angry Artist," *Arts Magazine* 41, no. 6 (April 1967): 48–49.

"Bombs and Helicopters, the Art of Nancy Spero," *Caterpillar* 1 (January 1967).

Review of *Styles of Radical Will* by Susan Sontag, *Caterpillar* 8/9 (October 1969): 127–128.

"Letter," *Artforum* 7, no. 7 (March 1969).

"Regarding the Lehman and Rockefeller Gifts to the Metropolitan Museum," *Artforum* 9, no. 3 (November 1970): 40–41.

"Utopia/Anti-Utopia," *Artforum* 10, no. 9 (May 1972): 33–34.

"2D/3D," *Artforum* 11, no. 7 (March 1973): 60–68.

"16 Whitney Museum Annuals of American Painting, Percentages 1950–1972," *Artforum* 11, no. 7 (March 1973).

"What Works?," *Art Criticism* 1, no. 2 (Fall 1979): 29–48.

"Too Much of What?," *Art Workers News* 10 (June 1981): 21.

"On Being T (Taken for Granted)," *New Art Examiner* (October 1981): 3.

"Interrogations, Mercenaries, White Squads," edited talk with Leon Golub, *FERRO-BOTANICA*, no. 3 (November 1982): 11–23.

The Flue 3, no. 1 (Winter 1983), Franklin Furnace Archive.

By Leon Golub

"A Law Unto Himself," *Exhibition Momentum—A Forum, 9 Viewpoints*, Chicago, Illinois, 1950.

"A Critique of Abstract Expression-

Other

Attica Book, Art Work by Black and White Artists; Writings of Prison Inmates. New York: Black Emergency Cultural Coalition and the Artists and Writers Protest, 1972.

184

Selected
Bibliography

Conspiracy—The Artist as Witness
(Print portfolio—12 artists). New
York: Center for Constitutional
Rights, 1972.
"Contemporary Sculpture Portfolio,"
Spirale 4 [Berne, Switzerland],
1954.
Peace Portfolio (16 artists, 18 poets).

New York: Artists and Writers
Protest, 1967.
The Mercenary Game, Documentary
film, Alain d'Aix, Jean-Claude
Burger, Morgan Laliberte. Pro-
duction: InformAction and The So-
ciété, The Radio Television du
Quebec, Canada, 1983.

INDEX

Photography Credits

Diana Church (works 38, 40, 43)
Bevan Davies (work 39)
Leonard De Caro (works 33, 36, 37)
D. James Dee (work 48)
Augustin Dumage (works 29, 30)
Solomon R. Guggenheim Museum
 (work 11)
David Reynolds (works 13, 17, 21,
 28, 32, 41, 42, 44, 47, 49, 50, 51,
 52, 53)
Malcolm Varon (work 34)
Zindman/Fremont (work 45, 46)

ABOUT THE AUTHOR

Donald Kuspit is the department chairman and professor of art history at the State University of New York at Stony Brook. He has a doctorate in philosophy from the University of Frankfurt (Germany) and in art history from the University of Michigan. He has received fellowships from the Ford Foundation, the Fulbright Commission, the National Endowment for the Arts, the National Endowment for the Humanities, and the Guggenheim Foundation, among others. In 1983 he received the Frank Jewett Mather Award for distinction in art criticism, given by the College Art Association. His energy and leadership in developing a postformalist criticism were cited. He is the editor of *Art Criticism*, a staff member at *Artforum*, a contributing editor at *Art in America*, and a regular contributor to *Arts Magazine*, *Artscribe* (London), *Wolkenkratzer* (Frankfurt), and *C Magazine* (Toronto). His previous books were entitled *Clement Greenberg, Art Critic* and *The Critic Is Artist: The Intentionality Of Art*. He is the editor of various series published by UMI Research Press, with topics including contemporary American art critics, art criticism, and art theory. He is a major American art critic.